RSAC

D1320539

CONSERVATION AT THE ART INSTITUTE OF CHICAGO

THE ART INSTITUTE OF CHICAGO

ISSN 0069–3235

ISBN 0-300-11342-0

2005 © The Art Institute of Chicago. All rights reserved. No part of the contents of this publication may be reproduced, stored in a retrieval system, or transmitted in any form or by any means, electronic, mechanical, photocopied recorded, or otherwise, without the written permission of The Art Institute of Chicago.

Executive Director of Publications: Susan F. Rossen; Editor of *Museum Studies*: Gregory Nosan; Designer: Jeffrey D. Wonderland; Production: Amanda W. Freymann; Photo Editor: Sarah Hoadley; Subscription and Circulation Manager: Bryan D. Miller.

This publication was typeset in Futura and Stempel Garamond; color separations were made by Professional Graphics, Rockford, Illinois. Printed by Meridian Printing, East Greenwich, Rhode Island.

Distributed by Yale University Press, New Haven and London.

This publication is volume 31, number 2 of *Museum Studies*, published semiannually by the Art Institute of Chicago Publications Department, 111 South Michigan Avenue, Chicago, Illinois, 60603-6404.

For information on subscriptions and back issues, consult www.artic.edu /aic/books/msbooks or contact (312) 443-3786 or pubsmus@artic.edu. Wholesale orders for should be directed to Yale University Press at (203) 432-0966.

This publication was made possible by a generous gift from The Fred and Susan Novy Family Foundation. Ongoing support for *Museum Studies* has been provided by a grant for scholarly catalogues and publications from The Andrew W. Mellon Foundation.

Unless otherwise noted, all works in the Art Institute's collection were photographed by the Department of Graphic Design, Photographic, and Communication Services, Lyn DelliQuadri, Executive Director, and are © The Art Institute of Chicago. Some images in this publication are subject to copyright and may not be reproduced without the approval of the rights holder. Every effort has been made to contact copyright holders for all reproductions.

Pp. 5–7: figs. 1–4, photos by Jeanine M. Wine; pp. 8–15: figs. 2–5, 7–8, 10, photos by Emily Heye; fig. 6, photomicrographs by Inge Fiedler; all diagrams and fig. 9 photo by Francesca Casadio; pp. 16–23: figs. 2, 6, 9, photos by Barbara Korbel; figs. 4–5, 7, photos by Karen Patzke; pp. 24–29: figs. 1–4, 9–10, photos by Kristi Dahm; fig. 6, © The State Hermitage Museum, St. Petersburg; fig. 7, Netherlands Institute for Cultural Heritage, Amsterdam/Rijswijk, the Netherlands, in loan to Stedelijk Museum De Lakenhal, Leiden, the Netherlands; fig. 8, Réunion des musées nationaux/Art Resource, NY; pp. 30–45: figs. 2, 10, 13b, 14a, © National Gallery, London; figs. 4, 13c, 13e, 15b, 17b, 18b, © Museo del Prado, Madrid; figs. 5, 12a–b, © Metropolitan Museum of Art, New York (fig 5 ©1989); fig. 7, drawing by Lorna A. Filippini; figs. 8, 12e, photomicrographs by Inge Fiedler; fig. 9, Reproduced by kind permission of the trustees of The Wallace Collection, London (X-radiograph by the National Gallery, London); figs. 11b–c, e, 12d, 14b, Department of Conservation, Art Institute of Chicago; fig. 13a, d, infrared reflectograms by Bonnie Rimer; fig. 20, © Institut Amatller D'Art Hispànic, Barcelona; figs. 21, 22b, © Cincinnati Art Museum (fig. 22b, photo by Frank Zuccari); pp. 46–49, 52–53: figs. 1, 4, 6–7, photos by Faye Wrubel; figs. 5, 8, photos by Cynthia Kuniej Berry; pp. 50–51: fig. 1, photomicrographs by Inge Fiedler; fig. 2, diagram by Francesca Casadio; pp. 54–59: figs. 3–6, photos by Lorna A. Filippini; pp. 60–65, 68–69: figs. 2, 11, 13, © 2005 Kunsthaus Zürich. All rights reserved; fig. 10, infrared reflectogram by Allison Langley and Julie Simek; fig. 12: computer overlay by Kristin Hoermann Lister; pp. 66–67: fig. 1, photomicrographs by Inge Fiedler; fig. 2, diagram by Francesca Casadio; pp. 70–73: figs. 1, 4, © Musée d'art et d'histoire, Ville de Genève, Cabinet des dessins; figs. 2–3, © 2005 Kunsthaus Zürich. All rights reserved; fig. 5, © Kunstmuseum Bern, Staat Bern; fig. 6, © A.N.L. Picture Archives, Vienna; pp. 74–79: figs. 2, 5, reprinted with permission of Joanna T. Steichen; fig. 4, © Arnold Newman/Getty Images; pp. 80–89: figs. 1, 2, courtesy of the University of Illinois Archives; figs. 3a, 12–13, photos by Barbara Hall; figs. 3b-c, photos by Herbert George; figs. 4, 6–11, photos by Robert A. Jones; fig. 5, diagram by Christian B. A. Goebel; pp. 90–95: figs. 5a, 6, photos by Melissa Buschey; figs. 7–8, photos by Kristi Dahm; pp. 96–102: figs. 1, 5, © 2005 Bruce Nauman/Artists Rights Society (ARS), New York (fig. 1, photo by Suzanne R. Schnepp); fig. 2a, courtesy *Evolution A/V Newsletter* (Jan. 1996); figs. 2b–c, courtesy Steffen Petter; fig. 3, © The George and Helen Segal Foundation/Licensed by VAGA, New York, NY; fig. 4, © Paik Studios; fig. 6, photo by Suzanne R. Schnepp; fig. 7, © Allison Rossiter, Courtesy Donald Young Gallery, Chicago.

Front cover: At top: details of p. 49, fig. 4; at bottom, from left: details of p. 95, fig. 7; p. 14, fig. 9; p. 31, fig. 1. Back cover: From left: details of p. 21, fig. 6; p. 84, fig. 4b; p. 49, fig. 5.

CONTENTS

708.17311 C765 2005
Conservation at the Art
Institute of Chicago.

4 **DIRECTOR'S FOREWORD**
JAMES CUNO

5 **INTRODUCTION**
ALLISON LANGLEY AND HARRIET K. STRATIS

8 **FROM THE MOLECULAR TO THE SPECTACULAR: A STATUE OF OSIRIS THROUGH THE EYES OF A SCIENTIST, A CONSERVATOR, AND A CURATOR**
FRANCESCA CASADIO, EMILY HEYE, AND KAREN MANCHESTER

16 **BINDING BEAUTY: CONSERVING A COLLECTION OF JAPANESE PRINTED BOOKS**
BARBARA KORBEL AND JANICE KATZ

24 **TARNISHED BY TIME: THE TECHNICAL STUDY AND TREATMENT OF A REDISCOVERED OLD MASTER DRAWING**
KRISTI DAHM

30 *SAINT JOHN IN THE WILDERNESS*: **OBSERVATIONS ON TECHNIQUE, STYLE, AND AUTHORSHIP**
FRANK ZUCCARI, ZAHIRA VÉLIZ, AND INGE FIEDLER

46 **CONSERVATION/REVELATION: HENRI DE TOULOUSE-LAUTREC'S** *BALLET DANCERS* **FINDS RENEWED HARMONY**
FAYE WRUBEL AND FRANCESCA CASADIO

54 **PIECEWORK: CONSERVING THE FLORENCE ELIZABETH MARVIN QUILT**
LORNA A. FILIPPINI AND CHRISTA C. MAYER THURMAN

60 **HODLER'S** *TRUTH*
KRISTIN HOERMANN LISTER, WITH CONTRIBUTIONS BY SHARON L. HIRSH, FRANCESCA CASADIO, AND INGE FIEDLER

74 **"TREATED BY STEICHEN": THE PALLADIUM PRINTS OF ALFRED STIEGLITZ**
DOUGLAS G. SEVERSON

80 **TIME AND TIDE: RESTORING LORADO TAFT'S** *FOUNTAIN OF TIME*—**AN OVERVIEW**
BARBARA HALL AND ROBERT AARON JONES

90 **UNDER A WATCHFUL EYE: THE CONSERVATION OF SOVIET TASS-WINDOW POSTERS**
HARRIET K. STRATIS AND PETER ZEGERS

96 **ON TIME: APPROACHES TO THE CONSERVATION OF FILM, VIDEOTAPE, AND DIGITAL MEDIA**
SUZANNE R. SCHNEPP

103 **GUIDE TO TECHNICAL TERMS**

104 **NOTES**

DIRECTOR'S FOREWORD

JAMES CUNO, PRESIDENT AND ELOISE W. MARTIN DIRECTOR

The Art Institute of Chicago takes seriously its mission to collect, research, preserve, and display representative examples of the world's artistic legacy for the benefit of the public. This is a grave responsibility, and nothing we do is more important. Critical to this enterprise are the efforts of our conservators, who collaborate with our curators to assess the condition and likely authenticity of prospective acquisitions; research the physical properties of objects already in our collection while preserving their integrity and beauty; and consult on the proper environmental conditions for the presentation of works from our collection at the Art Institute and on loan elsewhere. This issue of *Museum Studies* is the first to focus on conservation, and I am very pleased that we that we are able to share information about our conservators' work with the wide audience of museum members, scholars, and students who make use of this important publication.

While a significant aspect of the Art Institute's life for nearly half a century, conservation has in recent years assumed a central place in its activities. We now have conservation professionals working in seven different areas: books, objects, paintings, photographs, prints and drawings, textiles, and conservation science. This last and newest area, the Conservation Science Department, is devoted to analyzing the material properties of works of art, their chemical components and physical structures, and the effects of aging or chemical changes on their appearance. We were able to establish the department two years ago thanks to a $2,750,000 grant from The Andrew W. Mellon Foundation; as Allison Langley and Harriet Stratis discuss in the introduction that follows, an additional gift has allowed us to extend our scientific research capabilities by collaborating with scientists at Northwestern University. The Mellon Foundation is a leader in funding conservation science, and we are very proud indeed to benefit from their generosity.

Every issue of *Museum Studies* comes into being through the efforts of myriad individuals, and this one was no exception. Susan F. Rossen, Harriet K. Stratis, and Frank Zuccari believed passionately in this project's importance, championing it from the start. The editorial assistance of Katie Reilly, Brandon Ruud, and Ginny Voedisch was indispensable, as was the work of Sarah Hoadley, who, with the help of Shaun Manning, obtained many of the images included here. Amanda Freymann oversaw the issue's production with care and infinite flexibility, and designer Jeff Wonderland found, as he always does, an ingenious way of presenting the subject at hand. We are also grateful to the Department of Graphic Design, Photographic, and Communication Services, especially Caroline Nutley, Loren McDonald, and Christopher Gallagher; the staff of Professional Graphics, Rockford, Illinois; and Meridian Printing, East Greenwich, Rhode Island. We deeply appreciate the financial assistance of The Fred and Susan Novy Family Foundation, which helped make this issue more expansive and beautiful than it might otherwise have been. Thanks are due above all, however, to the authors, who collaborated with one another and with *Museum Studies* editor Gregory Nosan to create a publication that is at once accessible and challenging, a record of important work well done.

INTRODUCTION

ALLISON LANGLEY AND HARRIET K. STRATIS

The conservators at the Art Institute of Chicago are pleased to present the first issue of *Museum Studies* devoted to conservation-related topics. The following essays offer a behind-the-scenes view of our work at the museum, where staff with diverse areas of expertise treat and research objects of every age, medium, and origin. The articles themselves range from detailed descriptions of restoration practices to broader discussions of the materials and techniques used by artists from a particular time and place.

Conservators, trained in both art and science, collaborate with other museum professionals to interpret the origin and history of artworks; evaluate and improve their condition; and prepare them for future handling or exhibition. While restoring and stabilizing fragile works are among the most important—and perhaps the most well known—of every conservator's responsibilities, we also commonly undertake in-depth research projects. Working with curators and scientists, our role is to investigate and interpret the physical components of an object and help put the information we gather into a historical context. Known as technical studies, conservators' analyses of materials and techniques have become increasingly important to understanding and caring for works of art. Each treatment or research project begins as a kind of detective story: every object has a past waiting to be uncovered through intimate examination.

Presented according to the date of the objects they explore, the essays that follow showcase a rich range of materials: books, paintings, works on paper, photographs, sculptures, textiles, and "video art" or time-based media. The museum's distinguished collecting history is demonstrated as well, from the Japanese books acquired in the first half of the twentieth century to more recent arrivals such as an Egyptian statue of Osiris and *Truth*, a painting by the Swiss artist Ferdinand Hodler. Several of the works discussed—the seventeenth-century Sevillian masterpiece *Saint John in the Wilderness* and Henri de Toulouse-Lautrec's *Ballet Dancers*—will be familiar to regular visitors to the Art Institute's galleries. Other objects, however, will surprise. The museum's substantial holdings of Old Master drawings, American quilts, Alfred Stieglitz photographs, and Soviet propaganda posters are important resources for scholars but less likely to be on continuous view due to the number and, quite often, the fragility, of the works they contain. Two articles describe unusual, important collaborative efforts between the Art Institute's conservators and outside specialists: we play an important role in caring for a number of Chicago's large outdoor sculptures thanks to the Ferguson Monument Fund and are breaking ground in the preservation of an increasingly large collection of works on film, videotape, and digital media.

The motivations for the conservation projects presented here vary as widely as their topics. While the compromised appearance or structure of an individual work often spurred us to investigate or treat it, the study and stabilization of groups of objects were triggered by changes in the use of a collection, a renewed scholarly interest, or occasionally the discovery of a cache of previously unknown materials. In describing their efforts, conservators mention a number of examination techniques that we use to look beyond the surface of an artwork; X-radiography, infrared reflectography, surface monitoring with colorimeters, densitometers, and spectrophotometers, and the microscopic observation of small samples are all methods that have been employed for many years. The use of newer technologies including Fourier transform infrared spectroscopy, X-ray fluorescence, and Raman spectroscopy, for instance, can also lead us to a deeper understanding of a work's material nature and, ultimately, its meaning.

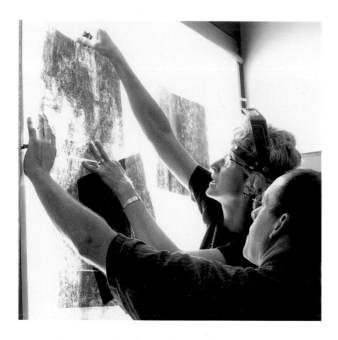

FIGURE 1. Conservator Cynthia Kuniej Berry and Conservation Technician Kirk Vuillemot examine X-radiographs of the heads of the promenading couple in Georges Seurat's *A Sunday on La Grande Jatte—1884* (1884–86).

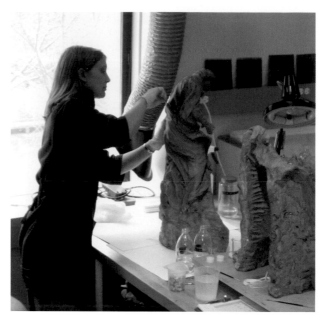

FIGURE 2. Associate Conservator of Objects Emily Heye cleans Fillippo Parodi's *Pietà* (c. 1686) in the objects conservation studio.

While their conclusions vary, each essay illustrates the beneficial results of undertaking a thorough examination of a work's materials and history. Understanding an artist's technique helps interpret his or her intent and thus guides treatments designed to improve appearance. Knowing the material structure of an art object, and the effects of time on this structure, are essential when planning to store, handle, and exhibit the piece in the future. Some of the conservation projects discussed remain open ended: large collections continue to be treated and evaluated, and questions remain to be answered about the attribution and dating of individual works. Ultimately all of the research presented here will aid scholars from a variety of fields thanks to the documentation, digital imaging, and electronic databases they have generated.

Pioneered nearly fifty years ago by the eminent painting conservator Louis Pomerantz, conservation at the Art Institute has grown to include a large, diverse group of specialists (see figs. 1–3). Currently there are nineteen conservators and scientists on staff, along with three contract conservators. They are joined by three Andrew W. Mellon fellows, recent graduates of conservation training programs who work at the museum for one to four years, mentored by conservators of paintings, paper, and photography. Since Pomerantz's time, the practice of conservation has also matured, reflecting the increasingly sophisticated approaches of the wider profession. The last half century has brought advances in all areas of treatment: conservators have at our disposal better tools for examining and analyzing works of art; a broader range of materials to use during treatment and a better understanding of their characteristics; and new means of documenting and sharing our work, thanks to computers and digital technology. We are also ever more sensitive to the artist's hand and original intent, and the effects of a work's history and treatment on its appearance and interpretation. While conservators have long chosen our methods and materials based on their compatibility with an object as well as their long-term stability and reversibility, the profession has seen an increasing trend toward treatments that involve minimal intervention. Now, we often aim to alter the physical components of an artwork as little as possible while assuring its stability and improving its appearance.

Our efforts have been further advanced by the rapid growth and development of the museum's Conservation

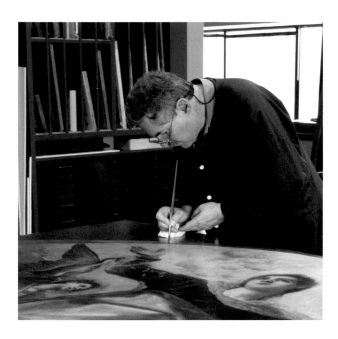

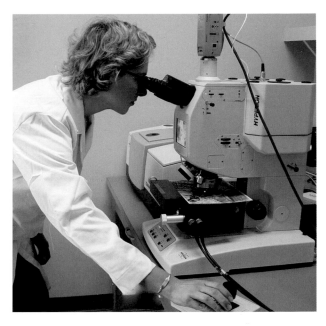

FIGURE 3. Executive Director of Conservation Frank Zuccari in-paints El Greco's *Assumption of the Virgin* (1577).

FIGURE 4. Andrew W. Mellon Conservation Scientist Francesca Casadio examines a pastel drawing nondestructively with the help of the museum's new FTIR microscope.

Science Department, which was established in 2003 thanks to the generous financial support of The Andrew W. Mellon Foundation. Since then, the Department of Conservation and Andrew W. Mellon Conservation Scientist Francesca Casadio have worked to create a state-of-the-art analytical laboratory and initiate an active research program (see fig. 4). Currently the foundation is funding a model effort with Northwestern University that aims to encourage collaborative research projects and a series of seminars in conservation science with the goal of strengthening the field's presence in the United States. In addition, the Community Associates of the Art Institute of Chicago and the Barker Welfare Foundation have made important contributions to the purchase of indispensable analytical instruments.

Art Institute conservators and conservation scientists also play an increasingly active role in museum exhibitions and publications. Most recently, our research was featured in the exhibitions and catalogues *Van Gogh and Gauguin: The Studio of the South* (2001) and *Seurat and the Making of "La Grande Jatte"* (2004). The Art Institute hosted an important conservation conference in 1999, the papers from which were published in *The Broad Spectrum:*

Studies in the Materials, Techniques, and Conservation of Color on Paper (2002). Currently conservators are working on catalogues for the collections of modern European paintings, works on paper, and sculptures, and Northern European paintings before 1600.

Although the articles in this publication can focus on only a small number of projects, we hope they demonstrate the challenges and the pleasures we experience working closely with objects and our ongoing commitment to caring for and studying the museum's extensive holdings. At the Art Institute, conservators continue to search for new ways to ensure the collection's future by expanding our research capabilities, maintaining stable exhibition and storage practices, collaborating with scholars from other institutions and disciplines, and engaging contemporary artists in conversations about their work. We hope this special issue of *Museum Studies*, in telling the stories of extraordinary artworks and the devoted people who work to preserve them, will encourage readers to stroll through the museum's galleries with a new appreciation for the stories and secrets behind each artwork they encounter.

FROM THE MOLECULAR TO THE SPECTACULAR: A STATUE OF OSIRIS THROUGH THE EYES OF A SCIENTIST, A CONSERVATOR, AND A CURATOR

FRANCESCA CASADIO, ANDREW. W. MELLON CONSERVATION SCIENTIST
EMILY HEYE, ASSOCIATE CONSERVATOR OF OBJECTS
KAREN MANCHESTER, ELIZABETH M. McILVAINE CURATOR OF ANCIENT ART

The search for ancient artworks to add to the museum's permanent collection rarely yields a treasure that is as strikingly beautiful and charmingly seductive as this exquisite statue of Osiris, the Egyptian god of the underworld (fig. 1).[1] Many public and private holdings contain similar statues of Osiris and related gods, but this example is remarkable for the range and vibrancy of its colors.[2] Its acquisition presented us with an excellent opportunity to extend our knowledge of materials and techniques from the well-researched ones of the Pharaohnic era of ancient Egyptian art (3100–332 B.C.) to those of the Late Ptolemaic period (fourth–first centuries B.C.), which are less thoroughly documented.

Our work builds upon the renewed interest in Egyptian painting materials and technology, sparked in recent years by the availability of advanced scientific instrumentation in many museums and research institutions. Scientists, through chemical analysis, shed light on which minerals and products of early synthetic chemistry were used to enrich the artist's palette. Conservators look at how an artwork is made and how its materials change over time; assess the presence and extent of modern restorations; and determine the most appropriate way to ensure the sculpture's long-term well-being. Curators utilize examples of vivid polychrome art such as this statue to interpret the importance and symbolism of color in ancient Egyptian civilization. These three approaches are synergistically integrated at the Art Institute, and each discipline reinforces the other.

This statue represents Osiris in his typical guise as a mummy. It was carved from three pieces of wood that were assembled, covered with a preparation layer, and brightly painted. The deity wears a striped, tripartite wig cover painted to emulate blue lapis lazuli and yellow gold; this is capped by a *shuty*, or crown, which consists of two tall plumes atop green, undulating ram horns. Since the skin of gods was believed to be gold, the figure has a gilt face that also features wide, staring eyes and a false beard attached to the chin. The god's body was painted to suggest a red shroud overlaid with an intricate, netlike gar-

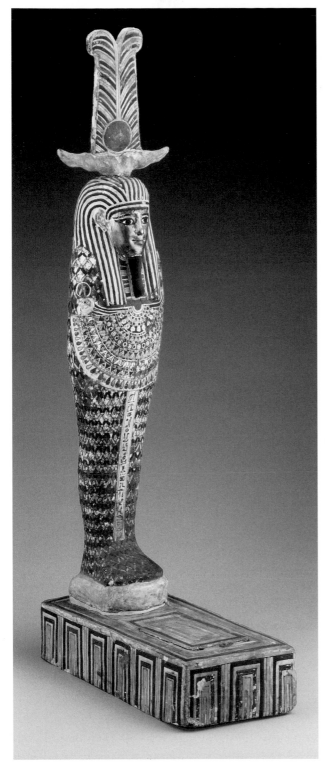

FIGURE 1. *Statue of Osiris*. Egyptian, Ptolemaic Period (4th–1st century B.C.). Wood with ground layer, pigment, gilding, and textile; h. 62.9 cm (24 ¾ in.). Gift of Phoenix Ancient Art, S.A., 2002.542.

ment made of both tubular and round beads. Draped across his torso is a broad collar, a type of adornment made from strings of brightly colored beads with floral ornaments; its clasps are carefully drawn heads of falcons. The figure rests on a deep rectangular base, which is decorated on the top with colorful concentric rectangles and similar rectilinear patterns on the sides. Into the top surface was cut a covered receptacle that once held an amulet, corn mummy, or a piece of papyrus bearing a passage from the Book of the Dead. Columns of hieroglyphs on the front and back of the statue state, most notably, that it was made for a woman named Osiris-ir-des, whose name translates as "Osiris is the one who made her." The text also contains a formulaic plea (see fig. 2) that Osiris provide "bread, beer, and every good and pure thing" to sustain her for all eternity.[3] Figures of Osiris were placed in tombs because they were believed to aid the deceased on the journey into the afterlife.

Sometimes objects remain in galleries for decades, carefully guarding the secrets of their manufacture and past history. In the case of the Osiris, our in-depth examination was prompted by its precarious state of conservation on arrival. The sculpture has survived for many centuries despite what conservators call "inherent vice," a situation that arises when separate components of an artwork react differently to varying environmental conditions, sometimes undermining its structural stability. In this case, the statue's wood substrate expands and contracts with changes in the moisture of the surrounding air. Its painted surface, however, remains stiff and brittle, like an eggshell, largely unaffected by changes in humidity. The paint surface is particularly vulnerable to physical damage in areas where a gap has developed between it and the support below (see figs. 3–4).

At some point the original join between the figure and the base must have failed as a result of repeated expansion and contraction, since we discovered that a modern adhesive cushion of fibrous material mixed with a resin had been inserted into this space to fix the figure in place and help it stand straight. The open join had then been smoothed over with new plaster to simulate an unbroken connection between the components. Vibrations in transit had caused this new plaster to crack and more surface fragments to detach (see fig. 5).

We immediately focused on supporting vulnerable areas of painted surface by filling gaps beneath the paint

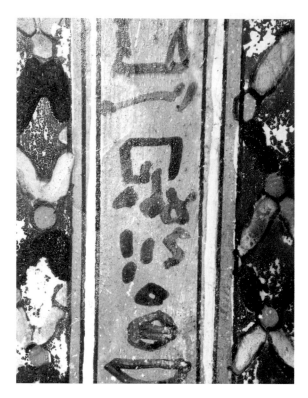

FIGURE 2. Detail of the statue's back, showing the deep yellow color of the wash applied in the inscription area and in the stripes on the sides. The hue is much more intense on the back than on the front, which would have been more exposed, indicating the light-sensitivity of the yellow pigments used.

with an adhesive bulked with wax.[4] We reattached loose fragments and camouflaged some of the larger or more obvious paint losses with tinted Japanese tissue adhered with methylcellulose, an easily reversible water-based adhesive (see fig. 5).

We discovered that a large piece of plain-weave linen —possibly original—remains adhered to the tenon, and we can only presume that the fabric was placed there to help the tenon fit snugly into the square mortise of the base.[5] To retain access to this interesting feature, we removed the modern adhesive/filler between the figure and the base, and instead designed a removable shim that would stabilize and straighten the figure but also allow easy separation for future study. We also removed the new plaster material from around the feet to reveal as much of the original yellow-painted surface as possible.[6]

Once the major structural problems were repaired and areas of fragile paint consolidated, our close study of the statuette could begin. First we examined its construc-

tion and painting technique. We confirmed from X-radiographs that the body is made of a single piece of wood and that the feathered crown is attached with a dowel to the top of the head.[7] The base is also constructed of a sin gle piece of wood. The interior of the base compartment still shows the sharp chisel marks made across the grain.[8]

Every type of support requires a particular preparation technique and choice of materials; in the case of this figure, the preparation layer, consisting mainly of calcium carbonate with very little acacia gum binder, was applied in a single, rather thick layer that forms a direct support for the paint itself (see fig. 6).[9] The paint layers above are generally very thin and consist of almost pure pigments. The Egyptian palette (called *sesh*) used to decorate objects of religious significance was charged with important color symbolism, and artists adopted a polychromatic scheme in which they juxtaposed pure pigments while reserving color shading and mixing for naturalistic scenes of everyday life.

The artist laid out the basic diagonal design of the complicated beadwork with fine black lines drawn directly onto the preparation layer. In the broad collar (see fig. 7), he delineated the curved zones and outlined the round and teardrop-shaped beads in black. The red, brownish yellow, greenish blue, and dark blue paints were then applied to fill in the shapes, clearly overlapping their black borders.[10] There are two exceptions to this order, both involving paints made with a brilliant white pigment. For a reason that remains unknown, the artist painted the bright white rosettes and lotus flowers directly on the ground layer and then gave them their final shape with black outlines (see fig. 8).

The white pigment is much brighter than the ground layer and has been identified as huntite. A calcium and magnesium carbonate mineral, huntite was quarried in southern Egypt and Sudan and has only recently been correctly identified as forming part of the palette of Egyptian painters.[11] It was particularly prized because of its extreme brightness and minute particle size, which produces superior handling properties and a very smooth painted finish.[12] The results of a survey conducted by the Metropolitan Museum of Art, New York, aimed at assessing the presence of huntite on objects in their collec-

tion of polychrome artifacts, suggested that its use may have decreased after the Twenty-Third dynasty (756–714 B.C.). That study sampled eleven Ptolemaic or Roman objects with white pigments, and none contained huntite.[13] The mineral's appearance on the Art Institute's Osiris, then, is an important addition to the body of knowledge about its use over time, particularly in respect to the Ptolemaic period.

The pale blue beads, which display a color under the microscope that is clearly a mixture of blue and white pigment (see fig. 9), were also painted first before being outlined carefully in black. Analysis revealed that the paint is composed of finely ground blue and huntite. This pigment, known as Egyptian blue, is present in its pure form in the striking stripes on Osiris's wig cover. In these areas it is so coarsely crystalline that it sparkles in the light on close examination, and it is thickly applied to form small mounds on the surface (see fig. 6). The Egyptian name for the pigment, *iryt hsbd*, literally means "artificial lapis lazuli," underscoring the importance of color symbolism in ancient Egypt, where pigments were named to reflect the sacred stones and precious metals they were meant to represent.

Egyptian blue is the first synthetic pigment ever manufactured and should be regarded as a prominent symbol of the talent for innovation that characterized the culture that created it. The ancient Egyptians fruitfully exploited the advances in their thriving glassmaking and metallurgy industries to produce a blue color so intense and resistant to fading by light that it has had no synthetic equal until modern times. The recipe for the manufacture of the pigment very likely came to the West through the writings of the Roman historian Vitruvius. In his book *De Architectura*, he recommended preparing a mixture of sand, soda, and copper compounds, grinding it together with water, and then forming it into balls that were allowed to dry and later heated in a kiln.[14] He neglected, however, to mention that in order to obtain Egyptian blue one needs a source of calcium carbonate, as was provided by the calcareous sand that was an available raw

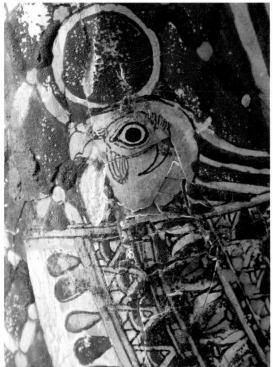

FIGURE 3. Detail of the statue's left side, showing how much the wood beneath this area has shrunken away from the preparation layer, leaving the thin surface unsupported and very fragile.

FIGURE 4. Detail of the falcon head ornament at Osiris's right shoulder, revealing how the unsupported surface has fractured and fragments were re-adhered to the surface in a previous conservation treatment. The buckled surface just above and to the left of the fractured zone is an example of the type of area that Art Institute conservators were able to support from below with a waxy fill material.

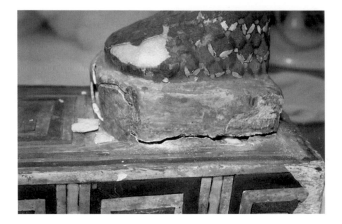

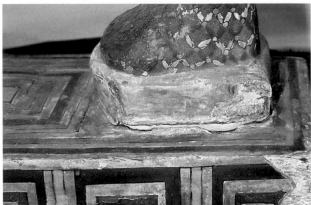

FIGURE 5a–b. a): At left, the previously repaired join of the foot to the base, which had fractured during shipment to the Art Institute; b): At right, the same area after repair at the museum: paint fragments were re-adhered, fragile paint at the edges of the base was stabilized; excess restoration plaster was removed from the area to expose original pigment; and a removable cushion was fabricated to allow the figure to stand securely upright. The old loss of paint at the top of the foot was cosmetically blended with surrounding layers by adding a piece of tinted Japanese tissue.

material at the factory near Naples where he witnessed the process. This omission, repeated by medieval transcribers, meant that those attempting the synthesis obtained only green frit, a copper silicate, instead of the calcium copper silicate that was intended. The secret of producing Egyptian blue thus remained buried for centuries, forcing medieval and Renaissance artists to make their blues by grinding the much more costly semiprecious stones azurite and lapis lazuli.[15]

The brilliant red pigment of Osiris's shroud is cinnabar, a sulfide of mercury that is a rather late addition to the Egyptian palette. Egypt had a long history of using red ocher (an iron oxide mixed with clay) and later realgar (an arsenic sulfide) for its reds. The presence of cinnabar attests to the influence of the classical world on the traditions of Ptolemaic artists. Cinnabar was a precious commodity, sold at a rather exorbitant price by the Romans, who had control over the mines in Spain; but Egyptians could also obtain it through commerce with the Greeks, who were exploiting quarries as early as the seventh century B.C.[16] For reasons that have not yet been understood, some of the thickly applied patches of cinnabar have cracked into a network of tiny islands, and these have flaked away from the surface, allowing the white ground layer to show through.

The analysis of the bright yellow paint yielded a more accurate understanding of the original appearance of the statue's polychrome decoration. It is helpful in this context to keep in mind that the majority of Egyptian

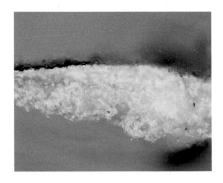

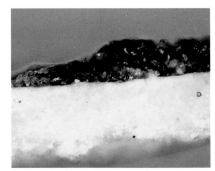

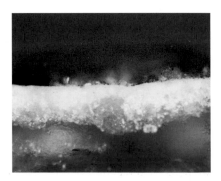

FIGURE 6a–c. Representative cross sections illustrate the relative thinness of the pigmented layer in repect to the ground. a): At left, the yellow layer with traces of the black outline; original magnification 100 x; b): At center, coarse crystals of Egyptian blue, the only pigment applied very thickly; original magnification 100 x; c): At right, red cinnabar—note the grains of sand embedded in the pigment layer; original magnification 200 x.

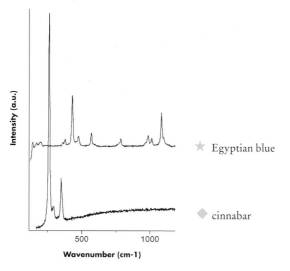

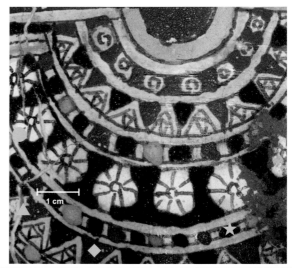

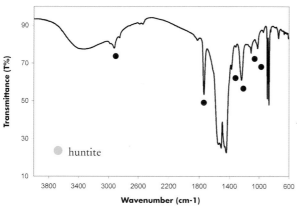

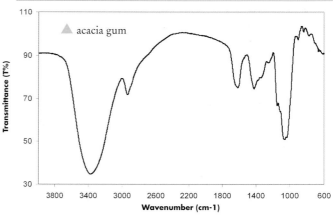

FIGURE 7. Detail of the central portion of the chest; note the presence of sandy encrustations. Analysis of minute paint samples allowed Art Institute researchers to determine the exact nature of the materials used to paint the surface. At top are Raman spectra confirming the presence of Egyptian blue and cinnabar particles. FTIR analysis, as seen in the spectra at bottom, identified the paint binder as acacia gum (at right) and the white pigment as huntite (at left; this appeared along with traces of polyvinyl acetate [PVA], a modern restoration material, the peaks of which are indicated with dots).

pigments—and nearly all of those detected in this statue—are made out of minerals and salts, inorganic compounds that have generally survived in a very good state of preservation. However, if degradation takes place, it involves a chemical transformation of the specific pigments originally used by the artists into different materials with different colors. Therefore the color scheme that we perceive today may deviate from the original artist's intention. On the statue of Osiris, this sort of alteration can be observed in areas painted in yellow (see fig. 10).

The yellow pigment, which we identified as pararealgar, an arsenic sulfide, is present not only in the stripes of Osiris's wig cover but also in the round separator beads of his netlike shroud, on the plumes of his headdress, and in the yellow stripes on the base. It was also used, quite surprisingly, as a semitransparent layer on the inscription (see fig. 2).[17] While realgar occurs naturally as an orange-red mineral, it is known, when exposed to light, to easily decompose to the orange-yellow pararealgar through a rearrangement of its atoms into a different structure. Scholars agree that ancient artists may have intentionally exposed realgar to solar radiation in order to obtain this intense yellow-orange color. It remains challenging, however, to determine if its use in Egyptian painting is intentional or if we are witnessing a form of decay; judgments can be made only on a case-by-case basis. In the case of

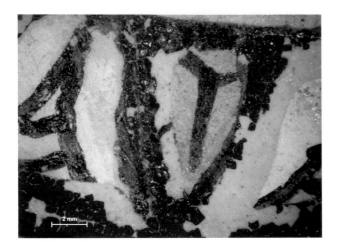

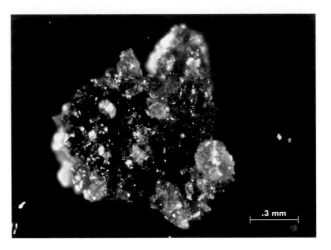

FIGURE 8. Detail showing huntite, the intense white pigment used for the open lotus-flower beads on either side of the light blue center bead, which was painted with a mixture of finely ground Egyptian blue and huntite. Both types of beads were painted directly onto the ground layer before being outlined in black. Note the as-yet-unexplained crackled appearance of the bright red pigment, cinnabar.

FIGURE 9. An Egyptian blue crystal.

the Art Institute's Osiris, it is important to note that no traces of realgar have been found mixed with pararealgar. We have reason to believe that in this case pararealgar was used as a pigment in its own right. One has also to consider that some of the areas decorated with the pigment are situated directly adjacent to spots painted with bright red cinnabar, an unreasonable choice if the intended original color had been the orange-red of realgar.

Over time, and through light-induced oxidation, pararealgar itself fades to the white oxide arsenolite. While areas that have retained their bright yellow color were found to contain the yellow pigments pararealgar and its relative, orpiment,[18] our investigation of samples from the faded areas has revealed that most of the transparent, light yellow or whitish particles are indeed composed of arsenolite, together with traces of elemental sulfur byproduct.[19] If we look at the less faded areas on the back of the statue, we can see this original color on the wig cover and the inscription and better understand why the Latin term for orpiment is "auripigmentum"—gold paint.

Notwithstanding the antiquity of the objects we study, we must always bear in mind that the analysis we perform is of their modern condition. In fact, once an artwork has left the hands of its makers, it collects to itself the signs of time's passage, as well as all tangible marks of its personal history of burial, exchange, collection, display, and conservation, up to the very moment we begin to examine it. We were fortunate to find some well-preserved areas on the Osiris sculpture that were not affected by the earlier application of conservation materials and therefore free from contamination by modern additions.[20] This allowed us to detect traces of the paint binder in the brilliant cinnabar pigment coloring the shroud and positively identify it as a plant gum, namely that of the acacia tree.[21] Acacia gum was easily available to the Egyptians, who would collect the sap after incising into the bark and branches of *Acacia leguminousae* trees. The sap is readily soluble in cold water and was widely used for tempering paint. At present, analytical data on Egyptian binding media are very scarce, and this new information constitutes a valuable addition to current scholarship.

While conducting our in-depth investigation of several areas on the feathers, body, and base, we encountered tantalizing clues about the age of the paint layers. One of these came when we detected calcium oxalate, a natural degradation product that is believed to form either by chemical oxidation or by the bacterial degradation of organic materials (such as the paint binder) in the presence of a source of calcium. Although it has been observed especially on outdoor sculpture and historic architecture, findings on museum objects are more rare. Since this degradation process occurs very slowly, taking

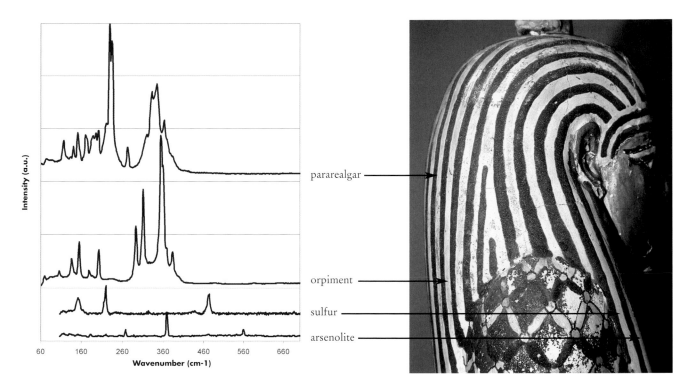

FIGURE 10. Detail of the tripartite wig cover, showing how the yellow pigments pararealgar and orpiment have converted to the lighter arsenolite and sulfur toward the front; corresponding Raman spectra of the original and faded materials are displayed. To limit further fading, the sculpture is now exhibited under lowered lighting conditions.

place over several decades on objects conserved indoors, it would be nearly impossible to forge.[22]

Our knowledge of the colors used in ancient times is derived from three main sources: ancient texts and literature, findings of pigments and colorants in archaeological digs, and the painted objects themselves. Ancient Egypt was the cradle of a true polychromatic revolution that represents a quantum leap from the prehistoric age, in which artists were strictly limited to four colors—black, white, and red and yellow ochers. Ingenious artists and artisans, the Egyptians were fast to exploit their lands' rich mineral ores and their own technologies in order to add colors to their palette. Their talent, and their success, is fully reflected in the decoration scheme of this exquisite statue, whose precious and expensive colors may point to a commission by a wealthy patron.

There are questions that remain unanswered, however. Sand has become embedded in various places without a clear pattern, and the layer of cinnabar paint has taken on a distinctive crackled appearance, also appearing globular in places (see fig. 6). We could perhaps explain these characteristics if we were to learn the history of the piece after it had left the hands of its makers. In general, however, the condition of the statuette is remarkable, considering it is over two thousand years old.

The value of a technical analysis such as the one presented here lies in the advances we can make to our collective understanding of Egyptian painterly knowledge, especially in regard to the less extensively documented polychromy of the Ptolemaic period. This statue of Osiris, when seen through the eyes of a scientist, enlarges our appreciation of Egyptian culture's chemical sophistication. When viewed by a conservator, the figure reveals its physical structure and how well it has survived for over two millennia. And to the curator, this important point of contact with ancient materials, methods, and practices remains first and foremost a beautiful artwork for display and enjoyment in the museum's gallery of Egyptian art.

BINDING BEAUTY: CONSERVING A COLLECTION OF JAPANESE PRINTED BOOKS

**BARBARA KORBEL, COLLECTIONS CONSERVATOR,
RYERSON AND BURNHAM LIBRARIES
JANICE KATZ, ASSISTANT CURATOR OF JAPANESE ART**

The inhabitants of Japan's large premodern cities were highly literate consumers of printed illustrated books.[1] Elegant limited editions of classic courtly tales began to be produced in 1608 and were the first signs of a print revolution that eventually reached all levels of society. By the late seventeenth century all manner of publications had appeared, including lists of the most stylish courtesans of the pleasure quarters, detailed travel guides, dime-store novels, erotica, encyclopedias, drawing instruction manuals, and deluxe poetry compilations.

Japanese *ehon* (picture books) are generally comprised of woodblock-printed sheets of *kōzo* paper.[2] Both illustrations and text, which was carved to mimic calligraphic writing, could be cut onto the same woodblock, which was printed in black ink only; as full-color printing developed, several blocks were used for each page. Although it is difficult to estimate, editions probably ranged from about three hundred to a few thousand copies. The blocks could be reused if a book was a suc-cess, and print runs of several thousand were not un-known. Titles, volume numbers, and page numbers often appear on the outer edge of each sheet. A book might have a preface at the beginning and a colophon at the end listing the publisher or the owner of the woodblocks (akin to the holder of the copyright) and a date.[3] An inter-esting feature of many printed books is the inclusion of several sheets of advertisements for forthcoming publica-tions. Aside from providing a fascinating view into the publisher's business, these additions can help date a book even when the piece itself carries no indication of when it was made.

It could be extremely profitable to be a publisher in premodern Japan, and the cities of Edo (now Tokyo), Kyoto, and Osaka in particular were filled with these entrepreneurs. In the last thirty years of the eighteenth century alone, the number of new books available per year doubled, reaching close to eight thousand titles.[4] Often the publishers, aside from engaging the services of

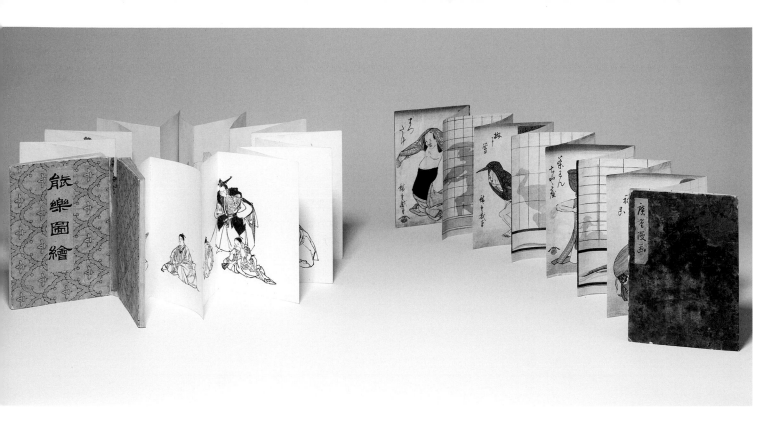

FIGURE 1. Visible here are two types of accordion bindings. At left, in *sempūyō* style, is Kawanabe Kyōsai (Japanese, 1831–1889), *Nogaku Zue* (Pictures of Nō Plays), 1899. At right, in *orihon* style, is Utagawa Hiroshige (Japanese, 1797–1858), *Sokkyō Kageboshi Zukushi* (Collection of Improvised Silhouette Plays), n.d.

an artist or designer, block carver, printer, and binder, sold the books in their own shops. Most of these businesses also published single-sheet prints, employing the same artists to produce them. Indeed, many designers of these prints got their start illustrating books, and even when an artist achieved fame, he may have continued to design books as well.

Traditional Japanese books are markedly different from their Western counterparts in both materials and structures. The most obvious difference is an almost exclusive reliance on *washi*, or paper, in their creation. The raw materials and methods used in Japanese paper-making result in a paper that is long-fibered and free of damaging chemical residues common in the manufacture of many Western papers. The Japanese book demonstrates its flexibility and strength in a variety of bindings that use folding and sewing techniques that are separate and distinct from the European tradition.[5]

While many binding styles of varying complexity have evolved alongside one another, five styles appear frequently in the Art Institute's collection of Japanese printed books. The simplest of these, developed during the Heian period (A.D. 794–1185), is the *orihon*, in which long sheets of paper are folded back and forth, accordion style.[6] Separate covers attached to the front and back pages allow readers to examine a book page-by-page or to unfold it and view it in its entirety. A variation on this accordion structure is the *sempūyō*, or flutter book, made with a single cover that extends from the front page across the spine to the back. Restrained only at the spine edge, it is more limited in its movement than the *orihon* and can be read page-by-page or viewed in the round. Both of these binding styles (see fig. 1) evolved from the earliest form of the Japanese book, the scroll. The *detchōsō*, or *kochōsō* (butterfly book), also appeared during the Heian period. In this binding style, single text sheets are folded in half (image side in), then stacked and glued along the

FIGURE 2. These three books illustrated by Torii Kiyonaga (1752–1815) all display Chinese-style four-hole "pouch bindings."

spine edge. When opened, the pages in this book-shaped structure resemble a butterfly's wings, giving it its name.

Arguably the most familiar type of Japanese book-binding is the *fukuro toji*, or pouch binding. In this style, single printed sheets are folded in half (image side out) and stacked with the folds positioned at the fore edge of the book. The text is bound with twisted paper cords at two stations along the spine edge, creating a pouch from each page. The covers, soft and usually unpatterned, are made from coarse, recycled paper and finished with a thin layer of finer dyed paper; these are sewn onto the binding with tinted silk thread, and a printed title slip is pasted onto the cover (see fig. 2). The most common sewing patterns have four holes (the Chinese style) or five holes (the Korean style), although variations can feature as many as twelve holes that produce decorative designs, each with its own name and application. While another style of pouch binding, the *yamato*, shares an identical inner binding, a flat cord is used in place of the sewing thread to hold the covers to the text. In all of these variations, the inner binding remains a separate, stable component even if the outer stitching fails and the covers detach.

The Art Institute's collection, which contains books from the beginnning of the print revolution in seventeennth-century Japan through the 1920s, is one of the foremost in the United States and constitutes a vital resource for the study of all facets of premodern Japanese culture. The core of the holdings was among the museum's first acquisitions of Japanese art, coming as a gift from one of its greatest early patrons, the businessman and philanthropist Martin A. Ryerson. Ryerson devoted much of his time to Chicago's cultural institutions, serving as a trustee of the Art Institute from 1880 and as president from 1925 to 1926, funding space for its library in 1901. He pursued wide-ranging tastes in art, building collections of Indian jewelry, European painting, Japanese paintings and prints, and Asian and Egyptian textiles. He donated his Japanese books to the museum in stages between 1913 and 1931, giving most of them in 1926.

Ryerson placed great importance on having comparative reference material for artists to study the visual products of other cultures, and his interest in Japanese illustrated books should be seen in this light. Indeed, woodblock-printed publications were not only popular in Japan but were also an enormous influence on Western artists, particularly painters working in France. Édouard Manet and Vincent van Gogh, for instance, had acquired prints from the famous Paris dealer Hayashi Tadamasa. Katsushika Hokusai's *Hokusai Manga,* its pages crowded with witty sketches of people, animals, and landscapes, was among the earliest volumes to make their way to Europe, where it was hailed as a masterpiece of graphic art.

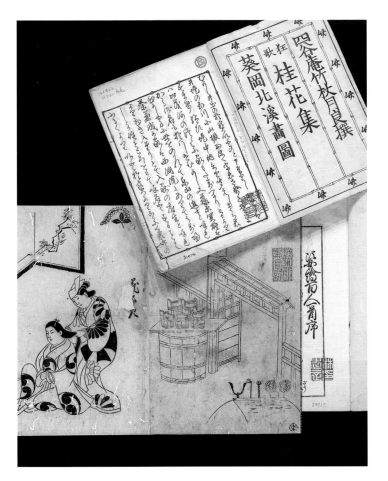

FIGURE 3. Shown here are three books from the Art Institute's collection, all stamped with collectors' marks. At lower left and right are Torii Kiyonobu (Japanese, 1664–1729), *Keisei Ehon* (Albums of Courtesans), 1700; and Hishikawa Moronobu (Japanese, 1618–1694), *Fūryū Sugatae Hyakunin Isshu* (The Fanciful Portraits of Hyakunin Isshu), 1695, bearing the collectors' marks of Emile Javal and Hayashi Tadamasa, respectively. At top is Totoya Hokkei (Japanese, 1780–1850), *Kyōka Keikashi* (Collection of Kyōka on the Moon), 1829, which is stamped with the mark of Louise Norton Brown.

Ryerson purchased his books from various sources. While the earlier provenance of the Ryerson collection has gone largely unrecorded, the publications themselves often carry collectors' seals (see fig. 3). These inform us that the majority came from Louise Norton Brown, who was the author of *Block-Printing and Book Illustration in Japan from the Earliest Period to the Twentieth Century* (1924), the first book on the subject of *ehon* in English. Brown included hundreds of titles in her extensive index, including those in her personal collection. She also listed,

for the benefit of collectors, bookstores where they might purchase *ehon* in Japan—places where, it seems, English-speaking guides may not readily direct foreigners.

By the late 1920s, Ryerson had donated approximately fifteen hundred volumes to the museum. It was during this period that he realized the importance of publishing a complete catalogue of the collection. Written by University of Chicago scholar Kenji Toda, *Descriptive Catalogue of Japanese and Chinese Illustrated Books in the Ryerson Library of the Art Institute of Chicago* (1931) contains title translations, bibliographic information, descriptions of contents, and explanations of illustrations, as well as information about the history of the Japanese print. This, along with the number and richness of the books themselves, helped the collections become an important, well-used resource for students of Japanese art and culture.[7]

In 1939 the Art Institute received 227 more books from the Frederick W. Gookin estate. Gookin was a consultant to the distinguished Chicago collector of Japanese prints, Clarence Buckingham, and a curator at the Art Institute from 1914 into the 1930s. He left a career in banking to become an advisor on Japanese art and was the organizer of (as well as a lender to) the museum's 1908 exhibition of Japanese prints that included works from the collections of both Buckingham and Frank Lloyd Wright. Aside from those of Ryerson and Gookin, other volumes have been added as gifts or purchases over the past decades.

In July 1999, the conservation staff of the museum's Ryerson and Burnham Libraries surveyed the museum's collection of Japanese illustrated books. While these holdings in their entirety originally resided in the library, over the years they were transferred to the Department of Asian Art, where staff and outside scholars are able to examine them easily alongside the rest of the museum's Japanese printed material. As part of the Ryerson Library's general collections, the books exhibited the standard marks of library ownership: accession and catalogue numbers had been inscribed in each, and bibliographic notes, book-

FIGURE 4. Wraparound cardboard covers, embrittled by age, previously housed items in the collection.

FIGURE 5. One quarter of the Martin A. Ryerson Collection—approximately 400 titles—is housed in pamphlet bindings manufactured in the 1920s and 1930s. Shown here is a pamphlet cover into which multiple volumes were glued.

embrittled, offering little protection.[8] Fortunately, they were also made before the proliferation of pressure-sensitive tapes and polymer-based adhesives, which are more permanent in their applications than their water-soluble counterparts. The remaining books were housed in original Japanese boxes, or *chitsu*, that were structurally sound but varied in condition from good to fragile.

Although there was no way of knowing what state the books were in before the Art Institute acquired them, it was evident that decades of handling by previous owners, library patrons, and curatorial staff had resulted in the sort of physical damage typically associated with use. Half of the volumes exhibited split folds, torn pages, loose plates, and worn title strips. On another third, covers were damaged, abraded, and stained, and in a few they were missing altogether.

While all fields of conservation share an inviolable commitment to work toward the long-term preservation of cultural property, the principles and practice of book conservation differ from those of all other media in one very important way: books are, by nature, tactile objects that are meant to be used. It is only by opening a publication's covers and exploring the contents that we can fully appreciate its value. For this reason, it is the preservation of the binding—the mechanical structure that responds to the act of turning the pages—that lies at the heart of book conservation.

Three months after beginning to examine the sample volumes, conservators presented a written report and treatment proposal to the Department of Asian Art. This plan focused on reversing the library's processing additions, repairing bindings, and stabilizing damaged materials for future use by scholars. The final stage involves rehousing the volumes to reflect the original Ryerson and Gookin collections. Throughout the first three years of the project, the conservation process has remained the same.

plates, and shelf location labels were pasted to the covers.

To ensure that the books stood upright in the stacks, earlier librarians had reinforced the flexible paper bindings in two ways: half of the volumes were housed in cardboard wrappers (see fig. 4) and another quarter were bound in pamphlet covers that were glued directly to the delicate silk stitching threads (see fig. 5). Purchased in the 1920s and 1930s, prior to the introduction of lignin-free products, these enclosures were acidic and severely

After first evaluating each volume, conservators create a treatment proposal and add it to a searchable electronic database. Beginning treatment on the book itself, they remove commercial covers and wrappers, and lift bookplates, labels, and residual adhesives using a poultice of methylcellulose (see fig. 6).[9] Next, they relocate to separate files any notes, papers, or other inclusions that may be compromising the binding structure. The most unusual of these to date were thirty-five dried gingko leaves deliberately placed into the folded areas of a pouch binding. While the leaves may have been slipped in for their insecticidal properties, their presence remains a mystery.

In the following stage of work, covers are cleaned and pencil marks, with the exception of original library notations, are erased. Conservators mend small tears with Japanese paper and paste, humidify and flatten folds and creases, and replace weak and broken sewing with silk thread to match the original as closely as possible. They then make new covers to replace those that are missing or offer additional protection to those that are extremely worn.

Once the treatment of individual volumes is complete, the construction of protective wrappers begins.[10] In order to arrive at a case design that would be aesthetically compatible with the collection, only traditional Japanese models were considered. The primary reason for choosing the simplest wraparound case, the *maru chitsu*, from the variety of designs that exist is the large number of cases—approximately eighteen hundred—that need to be built.[11] Considering the margin of error possible in a project of this size, the conservation team has relied on twenty-first-century technology to assist in the production of the historic cases. Using the original dimensions of a book and a worksheet developed on Microsoft Excel that automatically calculates the dimensions for the five

FIGURE 6. Conservation Technician Christine Fabian removes binder's tape from one of the Art Institute's Japanese printed books.

FIGURE 7. In an effort to distinguish between the two main gifts that make up the collection, two different Japanese book cloths were selected to cover the cases. The Frederick W. Gookin Memorial Collection is seen in gold, while the Martin A. Ryerson Collection is housed in green. In rare instances in which a multivolume set is composed of works in both collections, a band is used across the spine as a visual indicator.

boards and three liners needed to complete each case, they are able to produce *chitsu* much more efficiently and without mathematical mistakes.

The need for efficient production also affected decisions about materials and adhesive. While wheat starch paste is used almost exclusively in the craft of Japanese box making and bookbinding, it also dries very slowly.[12] Selected in its place was a fast-drying polyvinyl acetate (PVA), a vinyl resin similar in application to common white glue. Two Japanese book cloths (made from a blend of rayon and silk, and backed with paper) are being used to cover the cases, while a machine-made Western paper (more compatible with PVA than Japanese paper) is being used to line them. Traditional bone clasps secure and complete each case (see fig. 7).

At this time, all 227 books that make up the Gookin collection have been treated, rehoused, and relocated to a permanent storage area in the Department of Asian Art. While an additional 332 items from the Ryerson collection have also been conserved, approximately 1372 titles remain. The Department of Asian Art has begun cataloguing the collection electronically in both Japanese and English. This computer database, which contains new scholarship on the titles in our possession, owes its success to dedicated volunteers who grapple patiently with the complexities of cataloguing the material in depth.

Research on Japanese illustrated books has seen a steady increase since the 1980s. In recent years the Art Institute has welcomed countless scholars and students from Japan, the United States, and elsewhere to study our collection. Seldom does a specialist visit us without making a startling discovery of rare or previously unseen material. Works by Katsushika Hokusai, for example, comprise a full 10 percent of the Art Institute's holdings of Japanese printed books. Within that number resides the collection's rarest volume, Hokusai's *Miyakodori* (Bird of the Capital), illustrated with multicolored images of scenes in and around Edo, all printed with great sensitivity and skill (see fig. 8). Each illustration is accompanied by two or three short *kyōka* poems at the top.

FIGURE 8. Katsushika Hokusai (Japanese, 1760–1849). *The Komagata Ferry*, from the *Miyakodori* (Bird of the Capital), 1802. The Art Institute's complete copy of the *Miyakodori* is one of only two known to exist.

FIGURE 9. Utagawa Hiroshige. From *Sokkyō Kageboshi Zukushi* (see fig. 1)

Hokusai had achieved such fame as an artist that the texts seem to act as accompaniments to the exquisite images, rather than the other way around. The Art Institute's volume is one of only two surviving complete copies among the four known to exist.

The conservation and cataloguing of this important collection will almost certainly take another six to seven years to complete. Within that time, as we continue to uncover (and discover) the collection, we know we will be challenged by the delicate materials that we will treat and be inspired by the exquisite examples of printing and artistry that each individual volume displays. We also know that there will be moments of pure delight, as when we found Utagawa Hiroshige's playful *Sokkyō Kageboshi Zukushi* (Collection of Improvised Silhouette Plays; see fig. 9).

TARNISHED BY TIME: THE TECHNICAL STUDY AND TREATMENT OF A REDISCOVERED OLD MASTER DRAWING

KRISTI DAHM, ASSISTANT CONSERVATOR OF PRINTS AND DRAWINGS

William Frank Gurley, an accomplished businessman with deep interests in art and science, gave the Art Institute almost eight thousand European and American drawings, which included a donation in honor of his mother in 1922 and a bequest in 1943. This staggering collection, filling scores of boxes, formed the early foundation of the Art Institute's holdings of Old Master drawings. Unfortunately, there remains little or no documentation of the works, which vary in age, condition, and quality.

By the 1950s, scholars worldwide recognized the Leonora Hall Gurley Memorial Collection, as it is known, as a vast, unexplored resource. Since that time, identifying the drawings has been an enormous, ongoing task involving curators and other authorities in the field. With experts' eyes they have progressed, working their way through the boxes and attributing authorship to the sheets they contain. Great strides in attribution were made during research for the 1997 catalogue *Italian Drawings before 1600 in The Art Institute of Chicago*, as scholars identified the hands of masters including Federico Barocci and Raphael.

In 1988 Egbert Havekamp Begemann, a renowned scholar of Northern drawings, found within one of the Gurley boxes a large sheet folded into thirds. He opened it to discover an elaborate rendering, executed in pen and brush and brown inks, of Moses drowning the Egyptian army (fig. 1). The large support was constructed of five sheets of paper pasted together lengthwise. Begemann noted that the artist had applied white gouache, or opaque watercolor, extensively, painting over parts of the drawing in order to change the design; this is a technique commonly used by the Old Masters.

The drawing, forgotten for decades, was dirty, creased, torn, and patched with odd papers and tapes. Water had stained the background and blurred some of the ink, and much of the white gouache had turned dark gray due to the exposure of the lead white pigment to the atmospheric pollutant sulphur. This unintended transformation from white to gray undermined the artist's modeling of forms, leaving some passages almost illegible. Despite the sheet's compromised appearance, Begemann

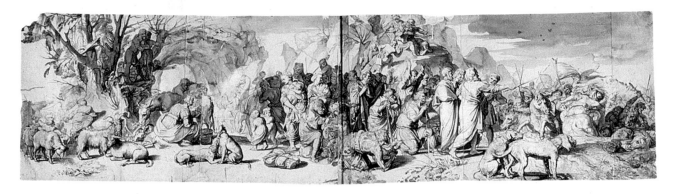

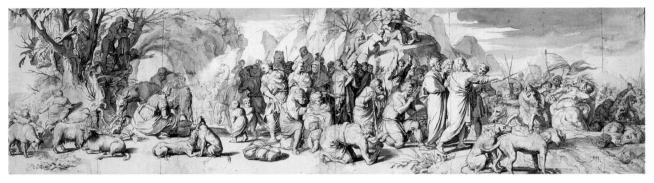

FIGURE 1. Circle of Pieter Lastman (Dutch, 1583–1633). *Moses Drowning Pharaoh's Army*, 1600/50. Pen and brown ink and brush and brown wash, heightened with lead white, on cream laid paper, pieced; 26 x 97.5 cm (10 ¹/₄ x 38 ³/₈ in.). Leonora Hall Gurley Memorial Collection, 1993.248.104. Before treatment, with darkened lead white gouache obscuring figures in the central foreground; a deep vertical crease at center; a water stain visible as a curving brown line just to the left; and numerous losses repaired with plain paper.

FIGURE 2. After conservation treatment, with the darkened gouache reverted to white; the center crease flattened; the water stain diminished; and the losses filled with toned paper.

knew that its large size, ample detail, and multiple alterations signaled its identity as an ambitious working drawing. He recognized with excitement the dramatic gestures and expressions, and delicately rendered figures and animals, characteristic of the circle of Pieter Lastman.

Working in Amsterdam, Lastman was a leading history painter specializing in biblical, historical, and mythological subjects. In his dramatic narrative compositions, which are crowded with figures and animals, he incorporated Italian Renaissance motifs that he adopted during his years of study in Italy.[1] Lastman ran a thriving studio where he trained many pupils including the young Rembrandt van Rijn, and his popularity motivated many imitators to mimic his style. While the artist certainly produced scores of drawings during his lifetime, very few survive, and only fourteen are generally accepted as his own. His legacy is represented at the Art Institute by the etchings *Judah and Thamar* (n.d.) and *Sophonisba Receiving the Poisoned Cup* (n.d.), as well as by an oil painting, *The Preaching of Saint John the Baptist* (1627).[2]

An attribution of this large sheet to Lastman's circle would be an important addition not only to the strength of the Art Institute's collection but also to the wider study of Northern drawings. Any ascription, however, must be supported by more evidence than visual analysis alone, and this drawing has no signature, date, or documentation and has served as the design for no known paintings, prints, or tapestries. In recent years, though, I have assembled a body of evidence through conservation treatment, technical study, and art-historical investigation that has allowed me to speculate on the drawing's purpose and better comprehend the nature of the artist's changes in the design. As we shall see, these combined to produce a profile of the artist against which I could reassess—and perhaps challenge—the possible attribution to Lastman's circle.

Before my research could proceed, treatment was required to stabilize the damaged drawing. I first removed extraneous papers and tapes from the verso, repaired tears, and filled losses using matching paper toned with

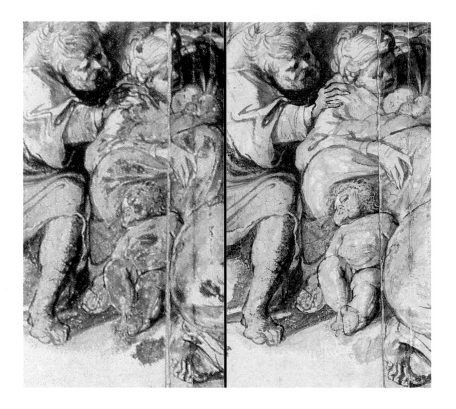

FIGURE 3. The design's legibility was restored through the reversion of the darkened lead pigment back to white, as illustrated by these details of the same area taken before (left) and after (right) treatment.

watercolor. I was also able to reduce the appearance of a large, distracting water stain, visible as a brown ring at the center of the sky (see fig. 1). Next, I eliminated creases by humidifying and flattening the drawing between soft sheets of blotting paper. Tiny ink losses along the former folds were then in-painted.[3] Finally, I was able to revert all the darkened gouache to white through the use of hydrogen peroxide–induced oxidation, which involved brushing its surface with a gel made from hydrogyen peroxide and methylcellulose (see fig. 3).[4] This last step restored the balance of light and shadow to the drawing, rendering fine details legible again. Now the eye no longer stumbles through damage and discoloration. Instead, the intricacies of the artist's design emerge, underscoring the chaotic terror of the drowning army and the Israelites' amazement upon witnessing their salvation (see fig. 2).

During treatment, a watermark was found in the second sheet from the right, near the figure of Moses, which pointed to the paper's date and country of origin.[5] The design, known as a Strasbourg Bend, appears as a shield with a double band, surmounted by a fleur-de-lis, with the number 4 and the initials *WR* underneath (see fig. 4). Watermark reference books link the Strasbourg Bend to a paper made in Holland, and papers with the same mark are known to have been used for documents produced as early as 1595 and in prints by Rembrandt and his followers dating from between 1639 and 1653.[6]

With the conserved drawing securely placed in early-seventeenth-century Holland, I then began searching for drawings, paintings, and prints that could have served as models. There are no depictions of this subject known in Lastman's oeuvre. The closest precedent is Andrea Andreani's 1589 woodcut (see fig. 5) after Titian's 1549 woodcut *Pharaoh's Army Drowned in the Red Sea*.[7] In both works the drowning army appears as a turbulent mass on the right, and the Israelites in procession occupy the left. Moses, extending his staff over the water, divides the two groups. While the artist appears to have used Andreani's print as a point of departure for his own design, he rotated the composition ninety degrees, placing the viewer inland to face the caravan of Israelites from the side with the sea and army beyond. He also borrowed many motifs directly from Andreani, including the crisscrossing battle trappings on the back of a horse; a mother nursing a child with a rectangular package nearby; and a boy climbing toward a broken tree trunk. Italian prints were popular and widely collected among Northern artists, and it is possible that the creator of this work, inspired by Andreani's version, was working out a design for his own print.

Andreani's woodcut is 13.8 cm wider and 30.5 cm taller than the Art Institute's drawing. While the dimensions of the sheet's original support are unknown, evidence suggests that it was once larger. Abruptly cropped

design elements at each edge indicate that the drawing was trimmed at some point, perhaps to remove damage or to fit it into an album. An original paper strip along the back-right edge, and a thin layer of adhesive with paper remnants along the back-left edge both indicate that the support was originally extended in both directions. Missing portions may have included more of the army and the distant village, representing Egypt, seen in Andreani's print. The artist might have intended this work to approximate the woodcut in width, but the drawing's compressed compositional space suggests that it was never meant to approach its height.

While the influence of Andreani's woodcut is clear, other figures and animals strongly resemble stock types that are found repeatedly in Lastman's painted oeuvre and suggest that the artist studied these works closely either as a student or serious follower. For example, the half-kneeling figure behind Moses, his arms placed reverently across his chest, is of the same type found in Lastman's *Abraham on the Road to Canaan* (fig. 6). The donkey and goat on the far left also resemble those in the same painting. Another of Lastman's canvases, *The Raising of Lazarus* (fig. 7), includes a similar figure of a half-clothed, muscular male crouching in the central foreground. The man

located at the painting's right edge provides a precedent for figures in the drawing, who appear in the emotional crowd with wide eyes, open mouths, and waving hands. The strategy of packing the drawing full of extra figures and animals was probably also adopted from Lastman's compositions.

While the artist found inspiration for many of his figures in Lastman's paintings, that of Moses is almost identical to one appearing in a drawing (fig. 8) that Peter Paul Rubens made after *Israelites Collecting Manna*, a now-lost painting from the School of Raphael.[8] The similarity cannot be coincidental: either the artist traveled to Italy and inspected the painting firsthand, or he remained in Holland and saw Rubens's or another artist's copy. Both Lastman and Rubens were in Italy during the first decade of the seventeenth century and, as young artists, would have reverently studied the works of Raphael and his followers. It is well documented that Lastman copied the Italian masters and collected drawings and prints in Italy.[9] It is entirely possible that he sketched *Israelites Collecting Manna* and transported the image back to his workshop in Amsterdam, where it served as a model for the Art Institute's drawing.

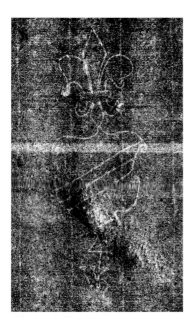

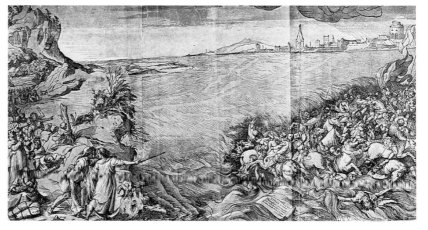

FIGURE 4. A similar Strasbourg Bend watermark recorded in a beta-radiograph from Rembrandt van Rijn's etching *Jan Cornelius Sylvius, Preacher*, 1646. Clarence Buckingham Collection, 1938.1808.

FIGURE 5. Andrea Andreani (Italian, 1540–1623). *Pharaoh's Army Drowned in the Red Sea*, 1589. Woodcut; 56.7 x 113 cm (22 ¹/₈ x 44 ¹/₂ in.). Published in Caroline Karpinski, ed., *Italian Chiaroscuro Woodcuts*, The Illustrated Bartsch 48 (New York: Abaris Books, 1983), p. 19, fig. 6(25).

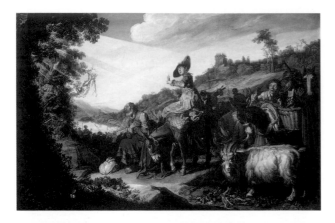

FIGURE 6. Pieter Lastman. *Abraham on the Road to Canaan,* 1614. Oil on canvas; 72 x 122 cm (28 ³/₈ x 48 in.). State Hermitage Museum, St. Petersburg.

FIGURE 7. Pieter Lastman. *The Raising of Lazarus,* 1622. Oil on panel; 63 x 97.5 cm (24 ³/₄ x 38 ³/₈ in.). De Lakenhal, Leiden.

FIGURE 8. Peter Paul Rubens (Flemish, 1577–1640). *Moses Ordering the Israelites to Collect Manna,* 1600/08. Pen and brown ink heightened with white, on paper; 23.5 x 40.1 cm (9 ¹/₄ x 15 ³/₄ in.). Musée du Louvre, Paris.

In this work, the artist seems to have assembled his composition as a collage of elements plucked from drawings, paintings, and prints. Perhaps in an effort to make this arrangement more innovative, and therefore more distinctively his own, he later whited out areas, altering the design. These applications of gouache indicate major compositional changes and are found, from left to right, near the boy and goats; on either side of the rock arch; around the boys on top of the central rocks; and near the two dogs by the water's edge. Smaller touches of gouache mark other, more minor revisions.

In my attempts to obtain views of the artist's initial designs, I used both transmitted light and an infrared camera. At left, near the grazing donkey, transmitted light uncovered an earlier drawing of a small child feeding the animal, which stands with its head raised (see fig. 9). On the far left, where a boy begins to climb up toward the trees, the infrared camera revealed a grainy image of two different boys, situated higher (fig. 10). One, drawn in profile, faces right, while the other leans on a long stick visible to the left. The artist appears to have made both of these changes in order to accommodate the trees, the figures on the ledge, and the rock arch, which he added together at a later point. Microscopic examination of the ink and gouache layers supports this.

Before the introduction of this design passage, the composition would have been dominated by the central, friezelike figural group and the towering rocks behind it. Judging from the alterations, the artist seems to have been attempting to introduce depth into the uniformly shallow space, which was closed off by the rock formation. The new rock arch provided a vantage point toward which he could direct the receding caravan of oxen and camel carts (also later additions). Likewise, he included the trees and figures on the ledge in order to establish a middle ground between the foreground figures and the arch. Transmitted light also shows another earlier detail: the presence of one small dog at the right, where two bigger dogs currently stand. By adding the large animals, the artist was probably aiming to make the soldiers and horses visually recede into the sea. While he presumably added the smaller adjustments to balance the larger changes within the composition, his more extensive alterations point to his persistent drive to create a satisfying design.

To date, the combination of conservation treatment and art-historical research has helped us recover a greater sense of this ambitious artist, who challenged himself by manipulating and recombining existing imagery into an innovative, dramatic design. When considered in tandem, technical and art-historical evidence do indeed support Begemann's initial attribution of this sheet to one of Peter Lastman's students or other followers, who would have worked in Holland during the first half of the seventeenth century. The artist may have been one of many, successful in his time, whose name has been lost from the historical record. Until further evidence emerges, the author of this dynamic drawing will remain elusive.

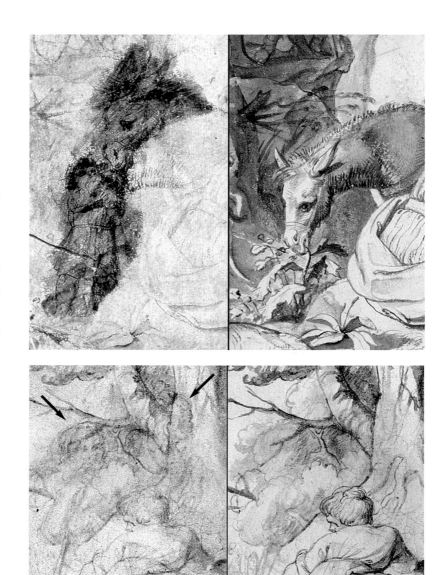

FIGURE 9. At left, transmitted light reveals an earlier design of a boy feeding a donkey with its head raised. At right, the same detail seen in normal light shows that the artist painted over the boy and lowered the donkey's head.

FIGURE 10. At left, arrows indicate the heads of two boys in the preliminary design, seen in infrared light. At right, the same area seen in normal light reveals how the artist painted over the boys and replaced them with one new figure.

SAINT JOHN IN THE WILDERNESS: OBSERVATIONS ON TECHNIQUE, STYLE, AND AUTHORSHIP

FRANK ZUCCARI, EXECUTIVE DIRECTOR OF CONSERVATION
ZAHIRA VÉLIZ, INDEPENDENT ART HISTORIAN AND ART CONSERVATOR
INGE FIEDLER, CONSERVATION MICROSCOPIST

When the magnificent painting *Saint John in the Wilderness* (fig. 1) entered the Art Institute's collection in 1957, it was attributed to Diego Velázquez.[1] Thirty-five years earlier, August L. Mayer had so ascribed the work largely on the basis of its stylistic characteristics and quality, comparing it to Velázquez's *Saint John the Evangelist on Patmos* (fig. 2) and its pendant, *The Virgin of the Immaculate Conception*, both in the National Gallery, London.[2] Mayer estimated the date of the painting to be between 1619 and 1620, placing it in the early, Sevillian phase of the artist's career, before he moved to Madrid as court painter to King Philip IV of Spain.[3] The compelling image, with its beautiful and confident technique, has led many experts to attribute it to Velázquez.[4] However, past opinions about this attribution have been less than unanimous, and while a few contemporary scholars have accepted the Art Institute's *Saint John* as an early work by the Spanish master, most have rejected it.[5] Indeed, in 1990 the Art Institute revised the painting's cataloguing description to "Spanish, Seville" to better reflect scholarly uncertainty.[6]

Methodology and Approach

Over the last twenty years, research on Velázquez has been enriched by important studies of his working methods, based on the detailed examination and analysis of his paintings.[7] This approach, which has come to be known as technical art history, is an important development that has allowed truths about the material nature of artworks to contribute to the study of images. A variety of methods are used to analyze the substances out of which a picture is created—the support, the ground, and the pigments—providing a basis for comparison to other paintings. X-radiography, which records the variations in density within a painting's structure, reveals the artist's brushwork and manner of expressing form and may, in addition, show compositional changes that reveal how a picture was planned and revised. Infrared reflectography, another invaluable tool, exploits the ability of infrared light to penetrate materials. When applied to paintings, this reveals underlying features like underdrawings and pentimenti. Through technical study, it is possible to

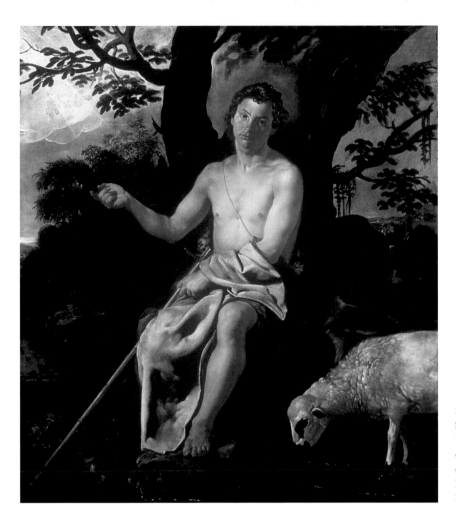

FIGURE 1. Spanish, Seville. *Saint John in the Wilderness*, 1623/30. Oil on canvas; 175.3 x 152.5 cm (69 x 60 in.). Gift of Barbara Deering Danielson, 1957.563.

develop a profile of the methods and materials that an artist employed as well as to gain insight into the creative process. As a methodology, technical art history can inform and expand traditional connoisseurship, which aims to put fine observations of form, color, and figure morphology into the context of an artist's development. Nevertheless, it must be understood that within a given period and locale, the raw materials that an artist employed would have been just as available to any of his or her contemporaries. Beyond that, artists trained within a single studio would have used very similar painting techniques, at least in the early stages of their careers. One must therefore always consider whether a given practice is unique to an artist or common to many at a specific time and place.

To date, most technical studies have focused on the canonical paintings of major figures, and the work of many lesser artists has yet to be carefully examined.[8] This holds true in regard to Velázquez and his contemporaries: while much is known about Velázquez's technique, little

has been published on the artists with whom he worked, including his teacher, Francisco Pacheco, his fellow student Alonso Cano, and others. In terms of our exploration of the Art Institute's *Saint John in the Wilderness*, in which we'll revisit the question of the painting's authorship, this presents both a potential opportunity and a unique challenge.[9] We can begin with Velázquez, conveniently, because we know most about him and also because his name has long been associated with this picture; but the technical information that we have about his work also seems to apply in many ways to that of his fellow artists in early-seventeenth-century Seville, whose canvases we have also taken into consideration. In an attempt to refine our sense of who painted this work, we have examined a number of paintings and their X-radiographs, including one work by Pacheco and eight by Cano.[10] A number of other Spanish paintings from the 1620s have been evaluated microscopically but without comparative X-rays.

FIGURE 2. Diego Rodríguez de Velázquez (Spanish, 1599–1660). *Saint John the Evangelist on Patmos*, c. 1618. Oil on canvas; 135.5 x 102.2 cm (53 3/8 x 40 1/4 in.). National Gallery, London.

FIGURE 3. Diego Rodríguez de Velázquez. *The Kitchen Scene,* 1618/20. Oil on canvas; 55.9 x 104.2 cm (21 7/8 x 41 1/8 in.). Robert Waller Memorial Fund, 1935.380.

Velázquez's Technique

Born in 1599 in Seville, Velázquez, an artist of precocious talent, began his training in 1609 in the studio of Francisco Herrera the Elder but in 1610 entered the studio of Pacheco, who became his early artistic mentor and ultimately his father-in-law. Pacheco, under whose tutelage Velázquez learned the fundamentals of painting technique and artistic theory, wrote the treatise *Arte de la pintura*, posthumously published in 1649, which gives insight into the sort of instruction he gave the young artists in his atelier.[11] Velázquez shared Seville's rich cultural environment with a number of notable contemporaries, the best known being Alonso Cano and Francisco Zurbarán.

During his Sevillian phase, Velázquez produced masterly examples of paintings known as *bodegones*, which depict picturesque characters in taverns and shops engaged in common activities involving food, drink, and household objects. Two such examples are *The Kitchen Scene* (fig. 3) and *The Waterseller of Seville* (1623; Wellington Museum, London).[12] Religious commissions dominated the output of all the city's artists, and Velázquez also completed some major sacred paintings, such as *Saint John the Evangelist on Patmos*, *The Virgin of the Immaculate Conception*, *The Adoration of the Magi* (fig. 4), and *The Supper at Emmaus* (fig. 5). In works such as *Kitchen Scene with Christ in the House of Martha and Mary* and *Kitchen Maid with the Supper at Emmaus*, he combined religious and genre elements.[13] The artist's acute eye for portraiture was not to find full scope until he reached the court in Madrid, but his aptitude for this genre was certainly in evidence in likenesses such as that of the poet Luis de Góngora y Argote and the Sevillian cleric Cristóbal Suárez de Ribera (fig. 6).[14]

In all these works, Velázquez's materials are surprisingly limited.[15] In his Sevillian period, Velázquez employed canvases of two distinct types. Most were commonly available fabrics of a plain weave in the range of nine to twelve threads per centimeter with threads of variable thickness.[16] A smaller number of works were painted on a canvas of thirteen to sixteen threads per centimeter and woven in a diamond pattern.[17] *The Supper at Emmaus* is painted on such a material, with a pattern dis-

tinctly visible in an X-ray (see fig. 12e).[18] There is some indication that this type of canvas, known as *mantelillo*, was used for particularly significant works, although it is not entirely clear that it would have had any specific technical or aesthetic advantages.[19] However, when a large (often important) painting was commissioned, *mantelillo*, which was wider than ordinary linen, might have allowed the artist to have an unseamed canvas, or, if really large, one with fewer seams.[20] *Saint John* was painted on *mantelillo* linen canvas with an elaborate woven pattern. Lorna A. Filippini, former Associate Conservator of Textiles at the Art Institute, identified it as an elaborately patterned composite point twill-weave fabric of thirteen to fourteen threads per centimeter in the warp (horizontal to the painting) and fifteen to sixteen threads per centimeter in the weft (fig. 7).[21] Similar canvases were used by artists throughout Spain; however, Velázquez appears to have abandoned patterned canvases after moving to Madrid. Thus the use of a patterned canvas for this work is consistent with his Sevillian works but not his later paintings.

Another technical feature that distinguishes the Sevillian paintings of Velázquez from his later works is the use of a single layer of brown-colored ground to prepare his canvases; this is most likely the material that Pacheco referred to in his treatise as *barro de Sevilla*, or "clay of

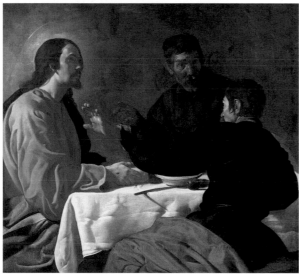

FIGURE 4. Diego Rodríguez de Velázquez. *The Adoration of the Magi*, 1619. Oil on canvas; 203 x 125 cm (79 ⅛ x 49 ¼ in.). Museo del Prado, Madrid.

FIGURE 5. Diego Rodríguez de Velázquez. *The Supper at Emmaus*, 1622/23. Oil on canvas; 123.2 x 132.7 cm (48 ½ x 52 ¼ in.). Metropolitan Museum of Art, New York, Bequest of Benjamin Altman, 1913 (14.40.631).

FIGURE 6. Diego Rodríguez de Velázquez. *Cristóbal Suárez de Ribera*, 1616. Oil on canvas; 207 x 148 cm (81 ½ x 58 ¼ in.). Museo de Bellas Artes, Seville.

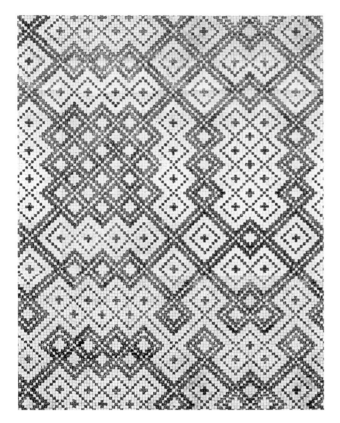

FIGURE 7. *Saint John in the Wilderness*, diagram of the canvas weave.

Seville."[22] He employed the same type of ground consistently in all of his Sevillian paintings but abandoned it after his permanent move to Madrid.[23] Detailed analysis of the ground from *Saint John* reveals that it is consistent with the *barro de Sevilla* contained in Velázquez's paintings, and that it is very similar to the grounds of the Art Institute's *Kitchen Scene* (see fig. 8) as well as other early works.[24] This further confirms the painting's place of origin as Seville.[25] In the course of our research, we also analyzed ground samples from three paintings by Cano.

While this limited sampling is insufficient to establish a pattern of usage, these samples proved to be quite different from one another. The artist used a brown ground for *The Vision of Saint John the Evangelist* (fig. 9) and *Christ Bearing the Cross* (1635/37; Worcester Art Museum); however, he applied the ground in a single layer for the former and in two distinct layers for the latter. A light gray ground was used for *Saint John in the Desert* (see fig. 21).[26]

Velázquez used a relatively small number of common pigments throughout his career. These included various earth pigments such as iron oxide browns, oranges, reds, and yellows; blues made from azurite, smalt, and occasionally lapis lazuli; organic red lake, vermilion, and red lead; lead-tin yellow and yellow lake; and greens mixed with yellow and blue pigments and occasionally verdigris. He also employed an organic brown and a variety of carbon blacks including bone, charcoal, and lamp black.[27] In his painting technique, the artist generally avoided elaborate glazing and layering of colors, searching instead for simplicity and directness. This inclination is confirmed by the structure of his early paintings, which often consist of one paint layer, rarely of more than two.

The pigments identified in the Chicago *Saint John* are fully in line with those found in confirmed works by Velázquez.[28] The relatively limited number of pigments found in the painting is noteworthy, and many of the ways in which they are disposed is consistent with Velázquez's practice. In *Saint John*, the artist combined iron oxide reds with lead white to make flesh tones along with limited amounts of vermilion, which he deployed mainly to accent the saint's face. He added smalt with lead white for the sky and used a simple mixture of lead white and red lake for the pink highlights, along with an almost

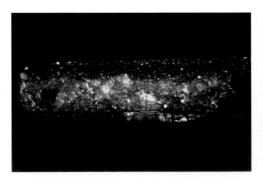

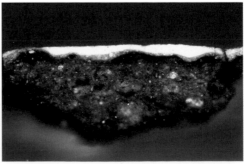

FIGURE 8a–b. a): At left, *Saint John in the Wilderness*, cross section of the rock in the bottom-left foreground, showing the brown-colored ground; original magnification 200 x; b): At right, *The Kitchen Scene*, cross section of the light gray cloth showing the brown-colored ground; original magnification 100 x.

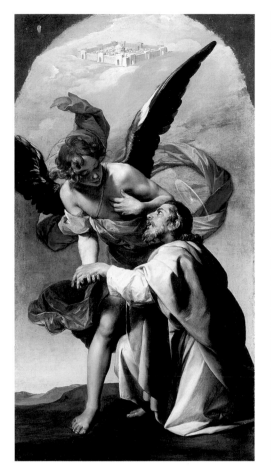
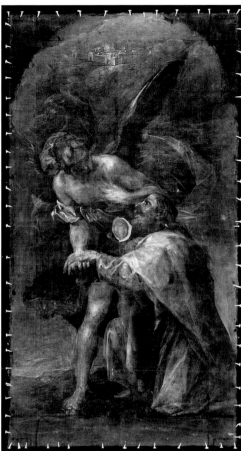

FIGURE 9a–b. a): At left, Alonso Cano (Spanish, 1601–1667). *The Vision of Saint John the Evangelist*, 1635/37. Oil on canvas; 83 x 44 cm (32 ¹/₈ x 17 ³/₈ in.). Wallace Collection, London; b): At right, a view of the painting in X-ray.

pure red lake for the shadows of the rose-colored drapery. The painter employed azurite alone or mixed it with yellow ocher (and possibly a yellow lake) in the foliage and relied on mixtures of blue and yellow to make greens; green pigments themselves are absent. In dark passages, the artist used iron oxide browns and possibly some organic brown, as well as charcoal and bone black. Also noteworthy was the discovery of small amounts of calcium carbonate (either in the form of calcite or chalk) and other transparent whites in most of the paint mixtures.

Cross sections taken from *Saint John* reveal mostly simple structures of one or two paint layers over the ground. More complex samples come from the foliage areas and the passages where the artist made changes to the original composition. Examination also revealed that the artist applied select areas of underpainting: he added a lead white underlayer over the ground in the sky area and laid down a dark, brownish black underlayer over the

ground in parts of the landscape. There was no underlayer in the figure or drapery—the skin tone and red lake layers were painted directly over the brown ground.

In contrast to later works such as *Las Meninas* (1656; Museo del Prado, Madrid), which are celebrated for their painterly mastery, Velázquez's early pictures are characterized by their strong expression of volumes and emphasis on elegant, precise contours.[29] These qualities are evident throughout his Sevillian canvases as well as in his early Madrid works.[30] In radiographic images they are emphasized because the low X-ray density of the earth pigment ground allows the painted image to be more readily legible. The decisive depiction of volumes is something that Velázquez excelled at from the very beginning of his career, and his skill clearly translates into X-ray images, in which forms appear sculptural and highly nuanced.[31]

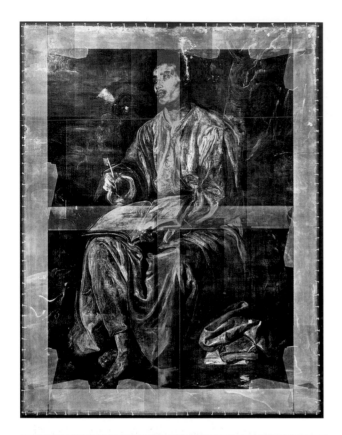

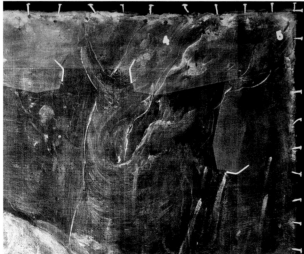

FIGURE 10a–b. a): At top, *Saint John the Evangelist on Patmos*, X-ray showing strong volumetric form and graphic contour outlines; b): At bottom, X-ray detail showing outlines along the contours of the tree.

Edges of forms, which Velázquez typically rendered with very precise contours, are often outlined with fine graphic lines applied directly on the ground layer, below the visible paint; these usually appear opaque in X-radiographs. Painted with a small pointed brush, the lines are very thin, consistent in width, and frequently quite long. Because they appear more prominently in larger works, it is possible that they may be associated with a technique used to transfer the composition from a cartoon to the canvas. Also visible in X-rays, and similar in appearance to these fine lines, are ridges of paint formed along the edges of larger brush strokes. Distinguishing these two types of lines can be difficult because the graphic lines are normally covered by subsequent paint layers, and the paint ridges may in some cases coincide with the graphic lines. Together, however, the graphic lines and the paint ridges reflect the artist's effort to define contours with precision (see fig. 10). They also produce a very characteristic appearance in X-rays that is a consistent feature in Velázquez's Sevillian paintings and in his Madrid works until the 1630s.[32]

X-radiographs of *Saint John* provide some of the most useful technical information bearing on the authorship of the painting. There are two crucially important points of consistency with the established characteristics of Velázquez's early technique: the low X-ray density of the ground, which allows the painted image to stand out very clearly, and the strong emphasis on contours and in particular the use of the very fine, precise, yet fluid graphic contour lines just described. The volumetric forms are clearly defined with a striking economy of means that few artists have mastered to such a degree (see figs. 11a–b). Graphic contour lines, applied in radio-opaque pigments, are discernable in a number of locations throughout the picture, including along the saint's torso and under his outstretched arm (see fig. 11c). A particularly clear graphic line, visible both on the surface of the picture and in X-ray, describes the edge of the lamb's foreleg (see figs. 11d–e). Also evident are the built-up edges of broader brush strokes that appear in the X-radiograph as dense white lines, one of which is clearly seen below the saint's outstretched hand. Such lines are also evident in the fingers of that hand and in the saint's feet; these seem con-

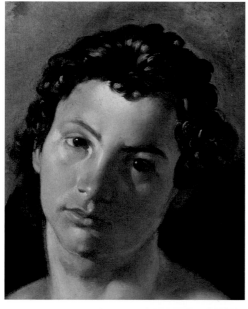
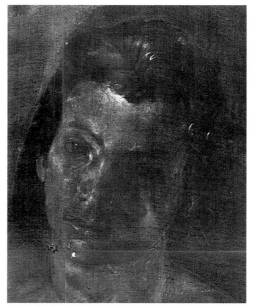

sistent in handling with similar examples in the feet of the figure in *Saint John the Evangelist on Patmos* and in Christ's hands in *The Supper at Emmaus* (see figs. 12a–e).

One of Velázquez's most persistent and idiosyncratic habits was that of wiping his brush on the yet unpainted areas of his canvas as he worked. He may have done this either to adjust the amount of paint on his brush or as a way of checking his colors. The resulting clusters of seemingly random brushstrokes would have been covered as the painting was completed and can in some cases be viewed only by X-ray or infrared imaging. These unusual brush markings are so common in the works of Velázquez, yet extremely rare in general, that their presence may be considered something of a hallmark.[33] Unlike the use of graphic lines, which disappeared from Velázquez's work in the early 1630s, the brush wipings feature well into his maturity.[34]

FIGURE 11a–e. *Saint John in the Wilderness.* a): At top left, detail of head, showing expert handling of paint and strong volumetric form; b): At top right, X-ray detail of head, showing strong volumetric form; c): At center, X-ray detail of torso; d): At bottom left, detail of lamb showing graphic contour line along leg; e): At bottom right, X-ray detail of lamb showing graphic contour line along leg.

Perhaps the most intriguing technical evidence in support of Velázquez's authorship of the museum's *Saint John* is the presence of brush wipings in various locations. Infrared reflectography reveals a cluster of these marks in the lower-right quadrant of the picture (see fig. 13a). These are remarkably similar to brush wipings in paintings by Velázquez, including those in the upper-right quadrant of *Saint John the Evangelist on Patmos* (see fig. 13b). The brush markings in the two paintings are clustered in the same way, and in both works they are slightly angled from right to left. One especially calligraphic mark in *Saint John* is very like one found in a later work, *Los Borrachos* (see figs. 13c–e). Also visible in *Saint John the Evangelist* are two brush marks along the left edge that are similar to brush markings revealed in X-rays of the Chicago picture (see figs. 14a–b). Another such mark, with an up-and-down gesture, is visible in normal light in an area of the red robe (see fig. 14c).

FIGURE 12a–e. a): At top left, *The Supper at Emmaus*, detail of Christ's hand; b): At bottom left, X-ray detail of Christ's hand showing fine lines along the edges of fingers and the pattern of the *mantelillo* canvas weave; c): At top right, *Saint John in the Wilderness*, detail of outstretched hand with graphic contour line below; d): At center right, X-ray detail of hand showing fine lines along the edges of the fingers; e): At bottom right, cross section taken from contour line below hand, showing a raised, tan colored line with a thin, dark blue-gray covering layer; the ground and canvas fibers are also present; original magnification 100 x.

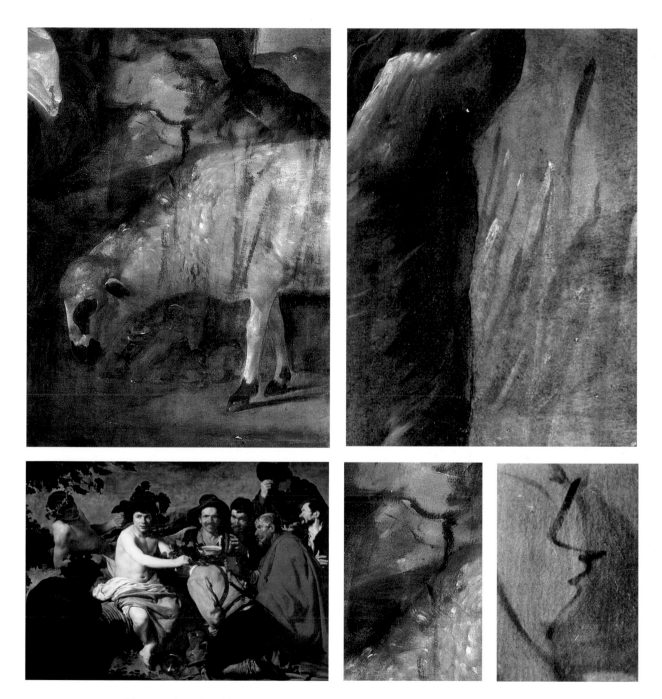

FIGURE 13a–e. a): At top left, *Saint John in the Wilderness*, infared reflectogram detail of the lower right, showing a cluster of brush markings; b): At top right, *Saint John the Evangelist on Patmos*, detail of upper right, showing brush markings; c): At bottom left, Diego Rodríguez de Velázquez. *Los Borrachos*, 1628/29. Oil on canvas; 165 x 225 cm (65 x 88 ¹/₈ in.). Museo del Prado, Madrid; d): At bottom center, *Saint John in the Wilderness*, infared reflectogram detail of the red robe at right, showing calligraphic mark; e): At bottom right, *Los Borrachos*, infared reflectogram detail of brushstroke under the mantle of the figure holding the glass, showing calligraphic mark.

Style and Its Implications

As we have seen, the technical evidence from *Saint John in the Wilderness* shows striking and consistent similarities with the materials and methods of well-studied early works by Velázquez, effectively establishing the painting's origin in Seville in the first third of the seventeenth century. Furthermore, comparison with Velázquez's painting technique suggests that the Chicago work must be either by this master or by someone closely associated with him and working in the same time and place in a virtually identical way. As has been noted, some of Velázquez's media and painterly characteristics are not necessarily unique to him, but common to the Sevillian artistic environment in which he circulated. The use of graphic lines, for instance, has been observed in the paintings of other artists such as Pacheco, Cano, Francisco Herrera the Elder, Jusepe Leonardo (who worked in close association with Velázquez at the Madrid court), Luis Tristán, and Francisco Zurbarán. What is distinctive about Velázquez's use of this technique, however, is the boldness, precision, fluidity, and X-ray opacity of the lines and contours, traits that are consistently present in the X-radiographs of Velázquez paintings we have examined and largely lacking in those of works by, for instance, Cano.[35] However, it is not just technical evidence, but also the small details of style, design, and composition, that we must take into account as we attempt to refine our sense of which Sevillian artist—or artists—was responsible for this work.

FIGURE 14a–c. a): Above, *Saint John the Evangelist on Patmos*, X-ray detail of lower left, showing two brush markings; b): At top right, *Saint John in the Wilderness*, X-ray detail of upper left, showing brush markings; c): At bottom right, *Saint John in the Wilderness*, detail of red drapery at right, showing a light-colored brush mark with an up-and-down gesture.

FIGURE 15a–b. a): At top left, *Saint John in the Wilderness*, detail showing rocks and plants; b): At bottom left, *Adoration of the Magi*, detail showing rocks and plants.

FIGURE 16a–b. a): At top right, *Saint John in the Wilderness*, detail showing trees and foliage; b): At bottom right, *Cristóbal Suárez de Ribera*, detail of landscape.

On the one hand, many of the details in the Chicago *Saint John* are perfectly consistent with Velázquez's early paintings. For instance, the rocks and plants in the foreground of the picture are represented in a stylized manner, with white outlines along the edges very like those in *The Adoration of the Magi* (see figs. 15a–b).[36] The forms of the trees and the treatment of foliage with exquisitely deft touches of color, moreover, strongly resemble those in the landscape visible through the window in *Cristóbal Suárez de Ribera* (see figs. 6, 16a–b), while the tendrils of the vines in the foreground also appear in similar form in *Los Borrachos* (see figs. 17a–b). In addition, the very fine white highlights along the edges of the water in the foreground pool recall those in the still-life elements of *The Kitchen Scene*. Saint John's rose-colored robe, meanwhile, is constructed in rounded forms that give it a weight and substance characteristic of Velázquez's work and are also visible in the blue garment of the foreground figure in *The Adoration of the Magi* (see figs. 18a–b).

FIGURE 18a–b. a): At top center, *Saint John in the Wilderness*, detail of rose-colored robe; b): At top right, *Adoration of the Magi*, detail of blue robe.

FIGURE 17a–b. a): At top left, *Saint John in the Wilderness*, detail of vines; b): At bottom left, *Los Borrachos*, detail of vines.

In terms of its overall composition and mood, however, the Chicago *Saint John* does not fit easily among Velázquez's early Sevillian works, particularly *Saint John the Evangelist on Patmos* (fig. 2). Like the saints in drawings by his teacher, Pacheco, Velázquez's Evangelist sits in his own, strangely illuminated space and seems placed upon, rather than inserted into, the landscape setting. Moreover, the distance is great between the tense, muscular figure in *Saint John the Evangelist on Patmos* and the languid, more idealized figure in the Art Institute paint-

ing. The Evangelist seems electrified by the experience of receiving divine illumination, his eyes riveted by his holy vision, while Saint John the Baptist is reflective and almost melancholy as his gaze meets the viewer's.

However dissimilar it may be from *Saint John the Evangelist on Patmos* in particular, the Chicago *Saint John* is still, in a broader sense, very much a product of a Sevillian artist working in the period between 1610 and 1640, when it was conventional to represent saints within a landscape, seated before a substantial tree trunk with a distant view beyond.[37] Such images are characterized by a firm delineation of contours and an equally strict decorum in the representation of the saint.[38] Just as they would have employed the same materials, members of Pacheco's closely collaborative circle often borrowed ideas and reworked one another's compositions, making their paintings occasionally difficult to distinguish.[39] At times, they actually cooperated on the same projects: while the remarkable *Christ Attended by Angels* (1616; Musée Goya, Castres) was signed by Pacheco, at least two or three hands are evident in the huge picture, which was painted during the year in which both Velázquez and Alonso Cano were apprentices in Pacheco's studio.[40]

This tradition of collaboration, combined with the Chicago *Saint John*'s use of space and the melancholy expression of its figure, suggest the participation of an alternative—or additional—artist in the same circle: Alonso Cano.[41] Lifelong friends, Cano and Velázquez would have met during their early professional life in Seville, and their closeness in age and training provide sufficient grounds for marked similarities in their early painting methods. For a period in 1616 and 1617, both were apprenticed to Pacheco, and documents reveal close family ties both in Seville and in Madrid, where the two artists eventually established themselves.[42] By the 1630s, Velázquez and Cano had evolved perfectly distinguishable ways of painting; but ten or fifteen years earlier, when they were most closely associated, this was by no means clearly the case.[43] The problem of interpreting technical consistency has arisen before in the study of paintings ascribed to Velázquez, notably in the reattribution of *The Immaculate Conception* (1620/21; private collection, Paris) to Cano. On that occasion, Alfonso Pérez Sánchez argued that, despite technical characteristics identical to those observed in documented works by Velázquez, the painting was attributable to the young Cano on stylistic grounds. A similar dilemma exists with the Chicago *Saint John*. Once again, the technical characteristics are consistent with those observed in early Velázquez, yet, stylistically, the work diverges from our concept of this master's work.[44] If we look beyond Velázquez for another known Sevillian artist who was capable of the refined execution and sophisticated compositional ability this work displays, Alonso Cano is really the only possibility. His earliest painting, and the one that compares most closely to Velazquez's early work, is *Saint Francis Borgia* (fig. 19).

It is perhaps Cano's mastery of perspective that accounts for the sophisticated integration of figure and surroundings in the Art Institute's *Saint John in the Wilderness*. Before his time with Pacheco, Cano was taught by his father, an architect and designer of altarpieces. He left Pacheco's studio after only eight months, in early 1617, about the same time that Velázquez qualified as a master painter. At that point, according to his first biographer, the young Cano retired "to his father's house, where he devoted himself to the virtuous study of sym-

metry and to the scrutiny of anatomy."[45] It is perhaps this study that informed the Chicago picture, in which the saint's pose centers on converging diagonals that extend to the outer boundaries of the composition. The viewer's eye easily reads the depth described by the line of the reed cross, and the turned torso and tilted head lead to the tree trunk that completes the diagonal to the top right. The unified treatment of space in this painting signifies a knowledge of linear and aerial perspective that simply is not a concern in reliably autograph works by Velázquez from this period.[46] In contrast, *Saint John the Evangelist on Patmos* seems assembled, with the figure placed before an indistinct horizon and the pose compellingly but randomly arranged, without reference to a unifying perspective system.

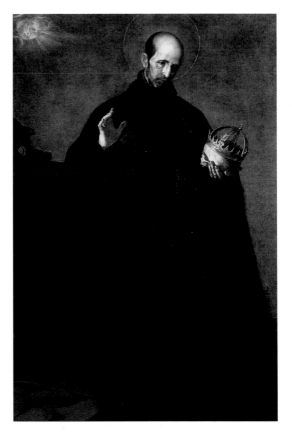

FIGURE 19. Alonso Cano. *Saint Francis Borgia*, 1624. Oil on canvas; 129 x 123 cm (50 3/4 x 48 7/16 in.). Museo de Bellas Artes, Seville.

Among Cano's works we find several portrayals of Saint John, although no single piece is strictly comparable to the Chicago painting. Cano's earliest known representation of John the Baptist is a sculpture identified as the central figure from the high altar in the Church of San Juan de la Palma, Seville (fig. 20).[47] Despite their differences in media, the mood of the figures in the sculpture and the Chicago painting is not dissimilar, and both are conceived in a vein of moderate, classicizing naturalism. Admittedly, the body types are almost contrasting: the three-dimensional portrayal seems thin and angular, while the Chicago *Saint John* has a more robust physique. They are, however, similarly arranged, especially the right hand and the position of the legs, as though the two works may have developed from a single pose studied from different angles. In both the Chicago painting and the sculpture, though, the saint's expression possesses a melancholy introspection that is peculiar to Cano's characters and that is also present in the artist's other important depiction of the Baptist, *Saint John in the Desert* (fig. 21).[48] As in the Chicago picture, the painted composition is based on the

complex but stable geometry of diagonals, and the saint is seated before a dark mass of rock and a tree that gives way to a distant view. Again, the horizon line intersects with the dominant diagonals in the center of the figure; and once more, the saint's sorrowful, intent expression and quiet presence convey the grave significance of his role as precursor of the Messiah. Although the paintings in Chicago and Cincinnati are separated by at least twenty years, there is one technical detail that unites them across the decades and also suggests Cano's authorship: both canvases display nearly the same adjustment of contour in the position of the forefinger, where it rests on the reed cross (see fig. 22). Might this concern for the eloquent, nuanced gesture reveal the same eye at work?

Conclusions

While our greatest challenge has been the absence of fully comparable works by both Velázquez and Cano, our study of the painting has produced a much clearer sense of *Saint John*'s distinguishing technical characteristics: its *mantelillo* linen canvas, its *barro de Sevilla* ground, and the

FIGURE 20. Alonso Cano. *Saint John the Baptist*, 1634. Polychromed wood; h. 119 cm (47 in.). Colección Güell, Barcelona.

FIGURE 21. Alonso Cano. *Saint John in the Desert*, 1645/50. Oil on canvas; 185.1 x 113 cm (72⁷/₈ x 44 ¹/₂ in.). Cincinnati Art Museum.

FIGURE 22a–b. a): At left, *Saint John in the Wilderness*, detail of hand; b): At right, *Saint John in the Desert*, detail showing similar adjustments in the positioning of the fingers.

presence of pigments and techniques that confirm its creation in early-seventeenth-century Seville. We have also, however, uncovered elements of technique and style that are more unique and that have directed us to Velázquez and Cano with greater certainty. As we have seen, the most singular aspect of technique—and the one that, to date, has been observed most frequently in works by Velázquez—is the existence of distinctive brush wipings.[49] Less consistent with Velázquez, on the other hand, but much in keeping with Cano's style, is the approach to composition based on a unified spatial system. In the end, the evidence we have assembled presents us with three possible scenarios. If we look exclusively at the technical consistencies with known works by Velázquez, the most likely conclusion is that the Chicago painting is by Velázquez. If we pay attention only to the affinities in the underlying conception of the image, we must opt for Cano—as have the organizers of an upcoming exhibition of his work, in which *Saint John in the Wilderness* will be included.[50] The apparent incompatibility of technique and composition might be resolved, however, if we were to understand the Art Institute's *Saint John* as the result of a joint effort in which Cano designed the painting and

Velázquez executed it. As we have seen, collaboration was a hallmark of Sevillian artistic enterprise in which large commissions would almost always be shared between regular associates.[51] There is no reason why Cano and Velázquez, early in their careers, could not have taken a similar approach. While we cannot, given the limited information available, confirm which of these possibilities is more likely to be correct, we can look forward, for the time being, to further investigations that will bring this painting and its elusive creator more fully to light.

CONSERVATION/REVELATION: HENRI DE TOULOUSE-LAUTREC'S *BALLET DANCERS* FINDS RENEWED HARMONY

FAYE WRUBEL, CONSERVATOR OF PAINTINGS
FRANCESCA CASADIO, ANDREW W. MELLON CONSERVATION SCIENTIST

History

In 1931 the collector Frederic Clay Bartlett donated Henri de Toulouse-Lautrec's painting *Ballet Dancers* to the Art Institute, where it is now exhibited in the Birch Bartlett Gallery along with other masterpieces such as Georges-Pierre Seurat's *A Sunday on La Grande Jatte— 1884* (1884–86) and Toulouse-Lautrec's *At the Moulin Rouge* (1895). The last of Bartlett's gifts to the museum, *Ballet Dancers* (fig. 1) is no ordinary painting. The artist created it, along with three other murals depicting the ballet at the Paris Opera, to decorate the walls of L'Auberge Ancelin. This country inn was located at Villiers-sur-Morin, a small village east of Paris where Toulouse-Lautrec would travel to visit his friend, the gentleman-painter René Greniers. He executed the works during a stay at the inn in 1885 or 1886, perhaps when he was kept indoors by bad weather.[1]

Toulouse-Lautrec painted three of the murals directly on a plaster wall, locating the fourth on a wooden door. Of these, *Ballet Dancers* is the largest. While images of the series have been published, there is no record of how it appeared in situ and the location of the other three paintings is presently unknown.[2] It is thought that the murals were taken from the wall and transformed into portable paintings sometime between 1913 and 1920.[3]

Technical Examination

The process of removing a painting from a stationary wall is well established in the Italian tradition of fresco and wall painting restoration. However, it is important to note that the Toulouse-Lautrec paintings were not made using fresco, a technique in which color is applied onto wet plaster and is bound into it as it dries. *Ballet Dancers* was created using a method called *secco*, in which an artist applies paint to dry plaster, in this case binding the color through the use of a drying oil. Separating a plaster mural from a wall involves many variations on a basic procedure: protecting the painted surface, prying the plaster layers apart, and attaching a new backing support. First, it is necessary to define the shape of the painting by cutting

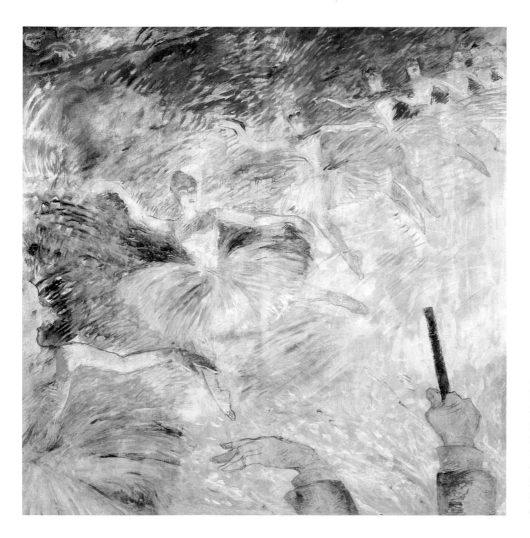

FIGURE 1. Henri de Toulouse-Lautrec (French, 1864–1901). *Ballet Dancers*, 1885/86. Oil on plaster transferred to canvas; 153.5 x 152.5 cm (60 1/8 x 60 in.). Helen Birch Bartlett Memorial Collection, 1931.571. The painting before treatment, disfigured by darkened varnish and discolored restorations.

its perimeter with a sharp knife. Next, the paint surface must be covered with a strong protective facing to hold it together during the removal process. This facing must be attached with a strong yet reversible adhesive—usually a form of animal-hide glue—that will not alter the painting's appearance. The facing is reinforced and stiffened by building up several layers of cardboard, cloth, wood, or similar materials.

Once the painting is securely protected with the facing, removal begins. Separation is accomplished by prying the upper layer of plaster from the lower layers, which can be done by inserting a thin, flat spatula or similar tool between the layers and pulling the outer layer away from the wall. Afterward, the back is sanded, smoothed, and leveled; any plaster pieces lost during the transfer process are filled. Then, a new support backing is attached using a permanent adhesive. (In the case of *Ballet Dancers*, this backing consisted of one layer of thin gauze and two layers of heavy linen canvas.) Once backed, the painting is attached to a wooden stretcher. The final step is removing

the protective facing, uncovering the painting. If executed successfully, the procedure results in a painting on plaster, attached to a stretched canvas.

Unfortunately, the removal of *Ballet Dancers* was not done well, and the plaster support suffered extensive damage. Examination of a composite X-radiograph of the work (fig. 3) showed significant areas of loss and large cracks throughout, especially at the corners. A thin line running from top to bottom center indicated that the painting had been cut in half, most likely to facilitate the transfer process. The two halves were rejoined with the application of the linen backing.

Although it is unlikely that a painting of this kind would have been varnished in situ, a shiny surface varnish had been heavily applied at some point.[4] Over time, the appearance of *Ballet Dancers* was severely compromised by the darkening of this coating and by lightened discoloration from old retouching (see fig. 1). Both of these elements created a pattern over the original image, making it difficult to appreciate the strong diagonal thrust that is

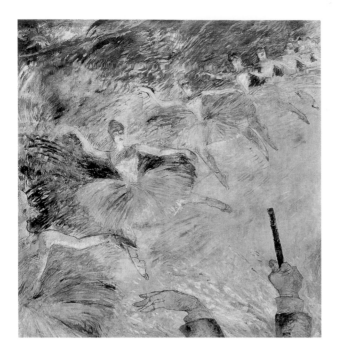

FIGURE 2. This photograph, taken before 1949, illustrates the work's original composition, in which two triangles were divided by a strong diagonal line running from lower left to upper right.

FIGURE 3. *Ballet Dancers*, X-ray showing the extensive amount of loss throughout the painting.

the work's most important formal element. Indeed, conservation records include a black-and-white photograph (fig. 2) dated to before 1949, which clearly depicts a composition in which the dancers' feet form a strong diagonal line running from bottom left to upper right. This creates two inverted triangles, a light one at the bottom and a dark one at the top. The painting had undergone only minor conservation at the Art Institute before the fall of 2003.

To bring the painting closer to its earlier appearance, I recommended cleaning it by removing the old discolored varnish film as well as the heavy overpaint. Examination of the X-ray (fig. 3) revealed the amount of old restoration to be much greater than the size of the losses. This was encouraging, as it meant that more of Toulouse-Lautrec's original paint could be uncovered. As a preliminary step, solubility tests were then conducted near the edges of the work to ensure that removing both the varnish and the earlier restoration would not damage the original paint. Elements that demanded special consideration, however, were the surviving charcoal lines such as those defining the hands of the conductor at the painting's

lower-right corner. By gently cleaning up to the lines and then rolling swabs over them to thin the varnish, I was able to determine that treating these areas would be safe, although challenging. A discussion with curatorial staff led to the decision to proceed with the treatment.

Restoration

I then began the cleaning, easily removing the darkened natural resin varnish with conventional cleaning solvents and taking extra care to work around the charcoal drawing lines (see figs. 4–5). During this stage, I found small pieces of brown craft paper adhered to the surface of the painting, remnants of the first layer of facing. These pieces were removed with dampened cotton swabs. Reversing the earlier restorations, though, proved to be much more difficult than I originally anticipated. The previous restorer had built up many layers of paint and filling material covered by oil paint, and these could not always be lifted using traditional cleaning solvents. While some could be cleaned in this way, others required chipping away with a surgical scalpel, a tedious and lengthy process that did, however, succeed at exposing significant amounts of original paint (see fig. 6).

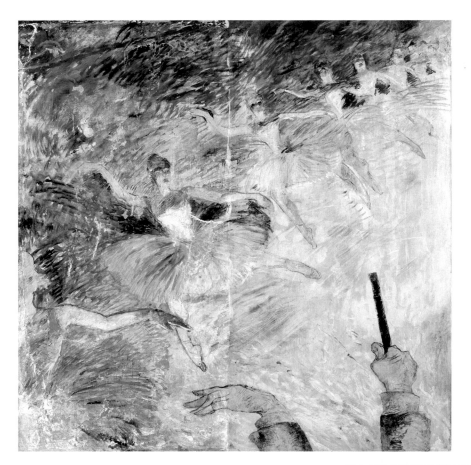

To ensure that the cleaning was done correctly, the X-ray image (fig. 3) was traced onto a clear Mylar overlay, creating a map of the size, shape, and location of the damages. I then placed this map directly over the painting and used it as a guide during the cleaning. Removing the overpaint and overfill led to the surprising discovery that the plaster pieces lost during the original transfer process had been filled with a turquoise material rather than more traditional neutral or white gesso putty. This substance extended to the front of the picture in places where the original plaster was missing, and cross-section analysis confirmed that it was the first layer added to the back of the plaster before the canvas was attached.

Another unusual find was the presence of several heavy layers of filling material and overpaint on the surface. These were apparently added in order to level off the face of the painting, compensating for areas of the plaster support that had become misaligned while the fabric backing was being attached. The overfilling did, however,

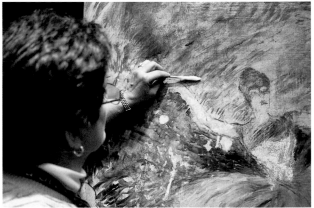

FIGURE 4. *Ballet Dancers* midway through the cleaning process.

FIGURE 5. Conservator Faye Wrubel undertakes the delicate task of cleaning around the charcoal lines that define figures.

SCIENTIFIC ANALYSIS OF MATERIALS

Scientific analysis, like a time machine, can help us recover not only the process with which *Ballet Dancers* was removed from the wall of L'Auberge Ancelin, but also, perhaps more importantly, the exact moment when Toulouse-Lautrec painted it. As Faye Wrubel has mentioned, the workers who converted *Ballet Dancers* from a plaster mural into an easel painting did so by using a combination of conventional and unconventional methods. Cross-sectional and instrumental analysis has disclosed each step of their procedure. As illustrated in fig. 1, the inn's walls were covered with a gypsum plaster and had already received two coats of white and off-white paint before Toulouse Lautrec set his hands on them.[1] The men who removed the mural used a starch-based paste to attach the facing layers, the residues of which were still detectable on the painting's surface. Once the painting was separated from the wall, they smoothed the gypsum layer from the back, reducing it to a very thin, irregular trace layer.[2] Then they sealed the bottom of the gypsum layer with a turquoise layer composed of lead white and Prussian blue pigments bound in oil.

But let's now focus on the painted surface of the work itself. *Ballet Dancers*, even with its apparently limited range of hues, truly reflects the Impressionists' embrace of what they identified as the colors of modernity, particularly yellow and orange. The industrial revolution brought about great advances in artificial lighting, which shocked viewers with its unexpected, blinding brilliance. Artists such as Toulouse-Lautrec and Edgar Degas were highly interested in these innovations and were newly equipped to render them justice, supplementing their traditional pigments, which included a limited range of transparent lakes and dull, brownish yellow ochers, with a new arsenal of brilliant colors made available by late-nineteenth-century advances in chemical science. Lautrec's lavish use of the new yellow pigments in *Ballet Dancers* was quite unique: only two other works are known to contain as many of them, Édouard Manet's *Waitress* (1878; National Gallery, London) and another painting in the Art Institute's collection, Georges-Pierre Seurat's *A Sunday on La Grande Jatte–1884* (1884–86).[3]

Ballet Dancers was created using two shades of chrome yellow, zinc yellow, and cadmium yellow, the names of which recall the recently discovered elements cadmium and chromium. The artist used brushstrokes of chrome yellow[4] on the top of the dress of the dancer in the lower-left corner; he employed zinc yellow[5] in the lemon and green background color visible on top of her shoulder and below the hand of the spectator at the upper left (see fig. 2). On the white bodice of the central ballerina, Toulouse-Lautrec chose chrome yellow to render the reflections of the Paris Opera's artificial lighting, relying upon the same pigment to capture the touches of flickering light on the diaphanous chiffon of her tutu. For the deep yellow-orange tone of her left wrist, however, he adopted the much more costly cadmium yellow.[6] The artist also used chrome yellows extensively on green areas: they are one component of mixed greens, based on Prussian blue, found on the tutu of the central dancer and in the green background close to the spectator's hand.[7] An actual green pigment, the brilliant emerald green,[8] was chosen instead for selected brushstrokes in the background, visible over the shoulder and below the wrist of the dancer in the lower-left corner.

In addition to helping us understand Toulouse-Lautrec's use of pigment, scientific analysis has also revealed additional insights into his intent. We discovered beeswax added to the drying oil, a widespread practice that gave the colored paste a thicker body and slowed the drying of oil colors, improving their consistency and opacity and reducing their tendency to yellow.[9] Moreover, as Toulouse-Lautrec's contemporary Jehan-George Vibert remarked in *The Science of Painting*, "Colour-grinders argue that wax . . . gives to the colors a mattness which all painters seek at present."[10] Indeed, the presence of beeswax suggested that Lautrec was seeking for his *Ballet Dancers* a matte, dry surface, very unlike the glossy, thickly varnished look produced by an earlier restoration. In the end, scientific analysis, by revealing the use of these materials, helps support the conservator's decision to remove the varnish and restore to the work its original appearance.

FRANCESCA CASADIO

ANDREW W. MELLON CONSERVATION SCIENTIST

Toulouse-Lautrec's painting layer

Coats of off-white paint on the inn's wall

Plaster of the inn's wall

Turquoise sealing layer

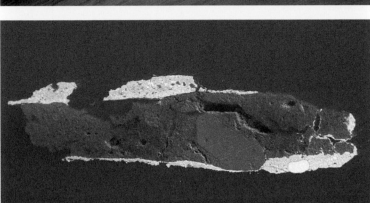

250 um

FIGURE 1a–b. a): At top, reflected invisible light micrograph of a cross section from the top of the dress of the first dancer at the lower-left corner, showing each layer in the structure of *Ballet Dancers*; original magification 100 x; b): At bottom, a scanning electron micrograph, in backscattered electron mode, of the same cross section. Images such as this one show the lighter elements (like calcium in the gypsum plaster layer) in darker shades of gray than the heavier elements (like the lead-based turquoise sealing layer at bottom and three paint layers at top), which appear bright white.

FIGURE 2. Shown here are the locations of the microscopic painting samples that were analyzed to identify the yellow pigments Toulouse-Lautrec employed. Each symbol represents a different pigment, as detailed in the legend below. Zinc yellow was used selectively in the medium green background; chrome yellow appears mainly mixed with blue and in bright, lemon yellow tones; and cadmium yellow was used for deeper, almost yellow-orange hues.

● = chrome yellow

▲ = zinc yellow

★ = cadmium yellow

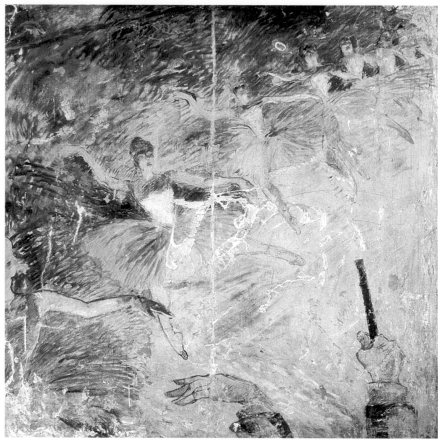

cover a sizeable amount of original paint. While the cleaning process left the painting's planar irregularities revealed, we opted to expose more of the original paint rather than produce a smooth, even surface.

After cleaning (see fig. 7), the next objective was to complete the extensively damaged image, using thinly applied washes of color in an effort to match the painting's dry surface appearance. Reversible materials were chosen for this in-painting because they help prevent damage to the original paint and can be easily removed in the future. In preparation for in-painting, I refilled old losses using a water-soluble putty made of rabbit-skin glue and whiting. I then applied a very thin spray of reversible surface coating that was intended to act as a barrier between the original paint and the current restoration. During this stage, care was taken to avoid giving the surface a shiny appearance.

The first color that I applied was a pale blue-gray, which blocked out the large losses in the background and

FIGURE 6. Wrubel was able to remove old restorations with a surgical scalpel, uncovering the original paint hidden underneath.

FIGURE 7. *Ballet Dancers* after the overpaint and overfill had been removed, revealing the work's actual state before in-painting commenced.

FIGURE 8. Wrubel in-painting *Ballet Dancers*.

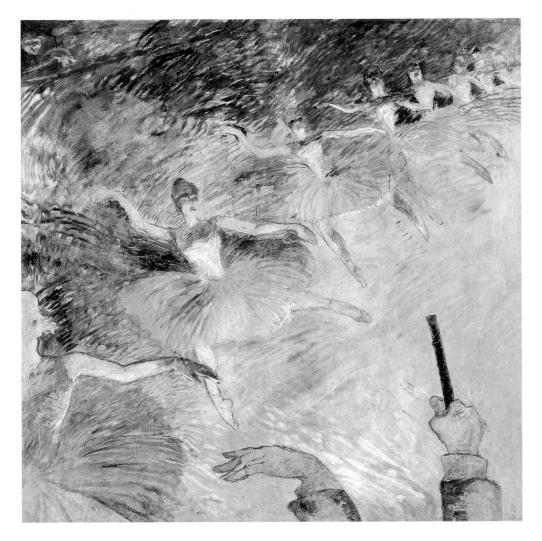

FIGURE 9. *Ballet Dancers* after treatment, which restored the dynamism of its composition.

enabled me to focus on the figures (see fig. 8).[5] The in-painting materials were selected for their different optical properties, working together to achieve the effect of matching Toulouse-Lautrec's painting, with its opaque background and figures applied in thin washes of color. While I used some washlike glazes over the paint in the background, the final result needed to appear chalky and dry as well as opaque. For the figures of the dancers, I chose colors based on their ability to be applied in thin, transparent glazes.[6] All of these materials are designed to hold their color and to remain readily soluble and reversible, a main requirement for products used in the restoration of all paintings. In the end, this treatment has enabled viewers to enjoy the dynamic, movement-filled composition of *Ballet Dancers* without the distraction of the disfiguring restorations and to experience the work as a whole in a way closer to that which Toulouse-Lautrec originally intended (see fig. 9). Even though we could not restore it to the wall of L'Auberge Ancelin, we were able, through the practice of conservation, to reveal the painting's colors, surface, and strong sense of visual harmony to a new generation of viewers.

PIECEWORK: CONSERVING THE FLORENCE ELIZABETH MARVIN QUILT

LORNA A. FILIPPINI, FORMER ASSOCIATE CONSERVATOR OF TEXTILES
CHRISTA C. MAYER THURMAN, CHRISTA C. MAYER THURMAN CURATOR OF TEXTILES

While covers like the Art Institute's Florence Elizabeth Marvin quilt are often described as "crazy quilts," both components of this term are very misleading. The word "crazy" is inappropriate unless it is understood to refer to a rather disjointed combination of various sections; it is generally believed that this usage relates to "crazed" or broken glass, which displays similarly haphazard alignments. Moreover, such pieces were never really "quilted"; instead, they were worked in sections and then joined or pieced and sometimes attached to a backing layer of fabric by intermittent stitches.[1]

Objects such as this one might also be described as "pictorials," a nineteenth-century term that also leaves something to be desired. Nevertheless, it is undoubtedly a better name for such elaborately composed covers, which were intended as showpieces. They were never intended for practical use nor were they composed of textile remnants or leftover scraps of clothing. On the contrary, such covers include expensively made fabrics, silks and velvets that were further embellished with skill-ful needlework, sections of lace and ribbons, and at times beads and semiprecious stones, often resulting in three-dimensional images accomplished through raised work or appliqué. Dates, names, poems, and painted scenes might also appear on a pictorial. Such covers were usually casually presented in a Victorian home, where they would have been draped over a settee in the parlor. While they may have been used on a bed, such placement would only take place on extremely important occasions—never was a cover of this type to be slept under or tucked along a mattress.

Very little is known about Marvin, the maker of this quilt, other than that she lived in Brooklyn Heights, New York; the piece twice bears the date 1886. For many years the property of Dr. and Mrs. Fred Epstein, this spectacular object was purchased by the museum in 2002 through the Margaret Cavigga Trust.

The Marvin cover (fig. 1) is composed of various fabrics made of cotton, silk, and wool in plain, twill, and satin weaves, many velvets or otherwise patterned. Several

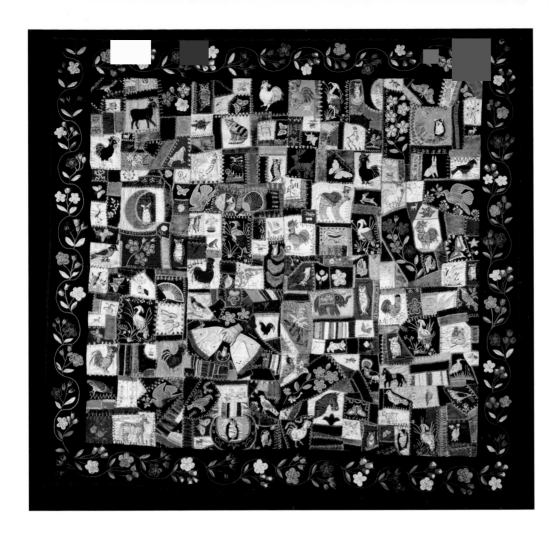

FIGURE 1. *Crazy Quilt with Animals*, 1886. Designed and executed by Florence Elizabeth Marvin (American, b. 1856). Silk, cotton, wool, plain, twill, and satin weaves, some velvet, some with supplementary patterning wefts, some self-patterned, and some printed with gold leaf; pieced and appliquéd; some areas raised; padded with cotton; embroidered with silk, silk chenille, cotton, and a variety of metal threads in back, buttonhole, chain, detached chain, double feather, herringbone, knot, overcast, satin, single satin, sheaf, stem, and straight stitches; couching and French knots; embellished with gilt-metal spangles; metal, jet, and glass beads; backed with silk and cotton, satin weave; machine-quilted with silk thread; 206.7 x 209.2 cm (81 ⅛ x 82 ⅜ in.). Restricted gift of the Margaret Cavigga Trust, 2003.294.

of these textiles were printed with a pattern in gold leaf. The piece was embroidered with threads of cotton, silk, silk chenille, and various types of metal; beads and metal spangles add further embellishment. When constructing a crazy quilt, the maker usually began by preparing small components known as blocks. To create these, she arranged the shaped fragments over a square of plain cotton fabric; she then turned under their edges, joining them together with a decorative, embroidered stitch that is worked along a line straddling the two fragments and into the cotton ground.

Afterward, she decorated the surface with additional needlework and appliqué, and then united the finished squares in the same manner as the smaller fragments, producing a finished quilt top. She then laid the quilt top over a backing fabric, joining the two layers by binding the edges and adding decorative stitches to the interior or placing knots at the intersection of the blocks.

At first sight, the Art Institute's quilt appeared to have been composed of sixteen blocks of colorful fragments that were cut into regular and irregular shapes varying greatly in size and surrounded by an outer border of black silk fabric. Although some fragments were left unembellished, many of the smaller ones were filled with embroidered birds, butterflies, figures, and flowers. While the use of appliqué is not uncommon in crazy quilts, its appearance on this example is its most interesting feature.[2] The larger fragments were appliquéd with animals, birds, and flowers cut from velvet. The animals and birds were embroidered and stuffed in high relief; most of the latter have beaks and claws that were formed of wire wrapped

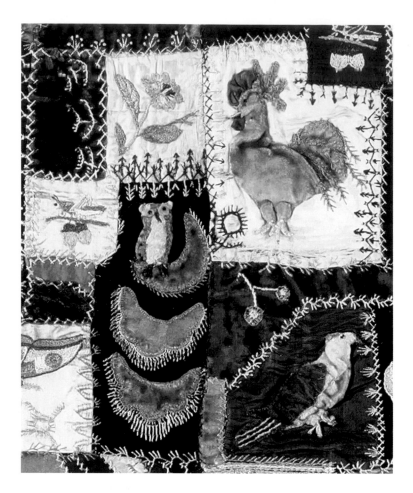

FIGURE 2. Post-treatment detail featuring examples of an embroidered butterfly and flowers, decorative fragment joining stitches, and appliquéd birds. Visible are the yellow rooster and the colorful bird beneath it, both of which underwent considerable conservation.

with silk thread and project outward from the plane of the appliquéd fabrics (see fig. 2). The double-sided flowers, rendered in orange, red, white, and yellow, were pleated to form three-dimensional petals with embroidered leaves, stems, and raised stamens. These same flowers meander lazily around the quilt's outer border. The piece's most unusual appliqué can be seen just below the center, to the left, where a hand, clutching a scarf, reaches out eerily toward the viewer.

The quilt was examined for the first time when it arrived at the museum in October 2003. Since it had always been an object used solely to provide visual pleasure, it exhibited no evidence of damage that could be associated with general wear and tear. In fair to poor con-

dition overall, it included relatively strong and intact areas as well as ones that were very fragile or crumbling. Most immediately noticeable was its uneven surface tension, which resulted mainly from the fact that, at some point since its completion, the outer edges of the top and the backing had been reattached with machine stitching.[3] As a consequence, the outer border was irregular; the left and bottom edging intruded into the flowering meander; and the edge's machine stitching ran carelessly over areas of the original needlework. Most alarming of all was the structural stress caused by the reattachment: the back was shorter than the front, which caused the front to protrude out over the lower seam.

Interior creasing and tensions greatly contributed to the quilt's overall condition, and holes and tears of varying sizes were scattered throughout. While some of these losses resulted directly from the tension problems, others were due to the maker's choice of materials. The weight of the stuffed motifs often damaged the thin, more fragile fabrics on which they were appliquéd. Most of the black-dyed silk fabrics exhibited cracking, shattering, and some degree of disintegration, probably a result of the oxidation of an iron mordant that was used to set the dye. Other losses can be attributed to the late-nineteenth-century practice of weighting silk with a metal salt such as tin during finishing, which helped achieve the crisp, stiff look that was fashionable at the time.

On the raised areas of the appliquéd details, the surface of the velvet had been abraded, exposing the plain ground weave to view. Most of the animal figures with protruding beaks and claws displayed some exposed wire, resulting from the loss of some of their silk thread wrapping. Others had shed almost all of their protective silk, leaving raw, often damaged wire protrusions in place of beaks and claws (see figs. 3–4). These rough wires had, in turn, compromised the silk fabric with which they were in contact. Minor damage included the loss of embroi-

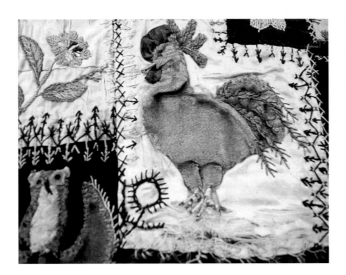

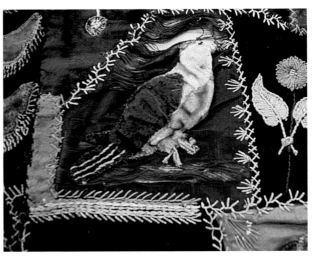

FIGURE 3. Detail showing the quilt's central rooster in its preconserved state. The animal had lost some of the silk thread that had originally wrapped its wire feet; the rough, exposed wire damaged the silk ground fabric just below it. The pile had worn off most of the raised velvet surfaces of the body, and the silk warps were lost from the satin weave fabric of the comb.

FIGURE 4. Detail of the colorful bird immediately below the central rooster (see fig. 3), showing the loss of silk warps from the cotton weft of the satin ground weave. This was due to the stress of the appliquéd bird's weight on the more delicate foundation fabric. Loss is also visible around the claws and was caused by their exposed wires.

dered stitches in areas where the ground weave had been damaged and the absence of several embellishing metal spangles and open seams. The backing fabric exhibited extensive warp abrasion and loss resulting in scattered slits in the satin weave.

Many losses were not immediately visible, as most were underlaid with patches of dyed silk or black wool, many of which were much heavier than the areas they attempted to support. Several of the old "repairs" had been stitched through to the backing. Most of the patches were slipped in through a large area of loss and often twisted in the attempt, placing additional stress on the damaged surface. Some tears and slits were concealed by "pleating" them into a neighboring seam or appliqué, or by enclosing them in small seams. This method of reducing the appearance of damage was used freely throughout the black border, especially along the inner lower edge just to the left of center. The most evident of these stitched repairs were several large, crudely darned areas of exposed wefts. Each of these repairs somehow added to the tension problems in its own way.

At about this time, the quilt was slated for an upcoming exhibition and was to be illustrated in a small accompanying publication.[4] We consequently formulated a

treatment plan to prepare the object for display and photography, with the goals of minimizing the existing stresses by removing all stitched repairs and improving the piece's general appearance by underlaying losses with appropriately dyed patches of thin silk fabric. Once we freed a damaged spot of poorly executed repairs, we slid the new silk underneath, securing the original, top fabric to the underlay with couching or span stitches of "hair silk," so called because its diameter approximates that of a fine human hair.

Photography was scheduled about halfway through the treatment process. By that point, we had removed some of the most obvious earlier repairs and stabilized the various areas of loss. To lend support and minimize stress to the quilt during photography, it was hung on a large, solid support at a 100-degree angle. Once in this position, it became very clear that the tensions between the front and back layers were greater than we had originally estimated. Indeed, the front slid down and overhung the outer edging by several inches. During the short time that the quilt was on the slant support, several spots in the vicinity of newly treated areas experienced some increase in warp loss, forming fine slits in the fabric. It was very clear that our initial course of action did not adequately

FIGURE 5. After conservators removed the machine stitching along the quilt's edges, they were able to separate the front and back faces. The upper layer, folded back, shows the reverse of the quilt front. Some of the disintegrated brown cotton backing remains caught in needlework. The lower layer is the cotton padding reverse of the quilted red backing, which is visible along the folded edge.

address the major cause of loss and may actually have been contributing to the damaging tension problems.

At that juncture, we adopted a new, more radical treatment plan that called for separating the front from the backing layer; once this was accomplished, each of the layers could be treated separately before they were re-joined. While this approach would have been impossible in most quilts, the absence of any real "quilting" on this piece made it feasible. First, we removed the machine stitching from the outer edge seam and rolled away the backing from the quilt. Between the front and back layers we discovered a thin, disintegrating layer of glazed, brown cotton plain weave. This deterioration was most probably caused by the oxidation of the iron mordant of the brown dye. Where not caught to the pieced silk fragments by the decorative needlework, this layer had fallen away and tumbled toward the bottom of the quilt, gathering in scattered pockets between the front and back (see fig. 5). These cotton fragments had an accumulated weight that exerted its own pressures and were inadvertently caught in both the old and new repairs.

All of this loose, detached cotton was removed from the bedcover. Once we cleared it from the reverse side of the front, we realized that the quilt had not, as we had originally thought, been built from sixteen small, pieced blocks worked over cotton supports. Rather, Marvin had inadvertently created it in a way that contributed to its current fragility: she pieced fragments to each other one by one, using neither blocks nor a cotton fabric base. In several sections, a larger silk fragment would extend under several smaller ones that were, in effect, appliquéd to it. In some instances this lent some strength to the area, while in others it created an uneven surface tension. Once Marvin had pieced all of these fragments together and joined them with the border fabrics, she laid this cover over the then solid piece of brown cotton and started to embroider.

We began our treatment of the quilt with the top, humidifying, opening, and laying flat its outer edges. We then removed all earlier repairs—including those we had only just executed. Afterward, we underlaid most of the losses with specially dyed support silks, which were cut to the size of the damaged fragments and stitched to their outer edges with hair silk (see fig. 6). Most damaged areas were aligned and stabilized with hair silk, which we stitched into the underlaid support. Several large areas of loss, especially along the outer edge, were overlaid with dyed silk crepeline.[5] Although we were able to support the losses, restore much of the thread alignment, and correct the surface tensions, a concern remained that the weight of the stuffed elements might continue to weaken the silk fragments that supported them. In order to create an internal support that could help distribute the weight throughout the quilt, we laid a sheet of fine muslin over the reverse face of the quilt top, stitching it to the underside of the stuffed elements. We started our work on the backing just as we had on the top, humidifying and opening the edges. Later, dyed silk crepeline was laid over the backing's outer, satin weave face, stitched into its seams, wrapped around its outer edges, and secured with hair silk.

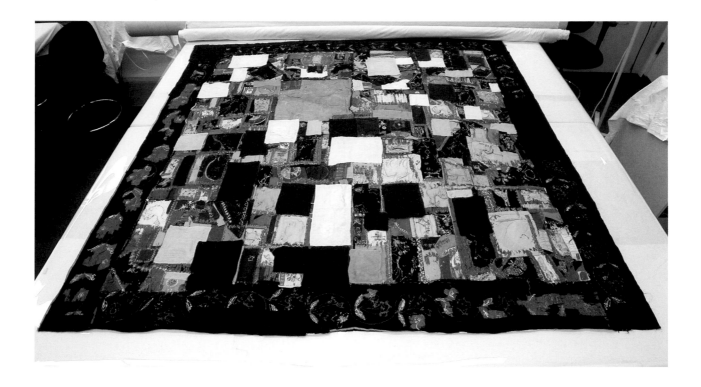

Once we had finished conserving both the front and back, however, it proved impossible to unite the two faces to re-form the original quilt. It appeared that at some point the backing had been stretched out in width and irregularly cut down in length, so that it no longer fitted the top. We solved this problem by dyeing a double face silk, satin weave fabric and using it to both extend the backing and bind the edges. Finally, in order to minimize any future damage that might be caused by the exposed wires of the embroidered beaks and claws, we decided to minimally wrap these elements with new silk floss.

Our last hurdle was devising a storage method that would preserve the treated object and also protect it from itself. In a perfect world, this object would be permanently mounted and forever stored flat. Space constrictions in the Department of Textiles, however, made this option unworkable. Most quilts in the Art Institute's collection are rolled onto muslin-covered, cotton-padded aluminum pipes of three inches in diameter and then suspended in storage cabinets. We opted to store this quilt in a similar manner, with special considerations. We decided to roll the piece on an archival paper tube six inches in diameter, which had been covered and padded like the

FIGURE 6. The reverse of the quilt top after all the dyed repair silks had been underlaid and sewn into place. In any large block that obscures the needlework, a newly applied support fabric is now present.

aluminum pipes. A two-inch-thick, silk-covered, polyester batting interleaving was added to diminish any potential damage caused by the protruding beaks and claws.

Although we were unable to restore the quilt to its original state, our treatment can be considered successful, since the mysteries of its tension problems had been resolved, its losses minimized, and its condition stabilized—all critical to prolonging the object's life for the foreseeable future. Our conservation efforts also brought less material rewards. Quilts are intimate storytellers, introducing today's public to long-forgotten family events and memories. The personal aspect of these objects draws us to them as we relive our own histories. While the Marvin quilt's story remains unknown, we'd had a hand in saving that tale for another day.

HODLER'S *TRUTH*

**KRISTIN HOERMANN LISTER, CONSERVATOR OF PAINTINGS
WITH CONTRIBUTIONS BY SHARON L. HIRSH, FRANCESCA CASADIO,
AND INGE FIEDLER**

In 2003 the Art Institute acquired a painting by the Swiss artist Ferdinand Hodler. The work joined three other Hodler canvases in the museum, which now boasts the largest collection of his paintings in America.[1] The artist began his training in the 1870s, as a Realist painter of everyday scenes. As he developed ties to literary Symbolism during the next decade, his interests shifted toward the expression of spiritual concepts through figural symbols. In the 1890s he began a series of monumental allegorical paintings that would engage him for the rest of his life. The subject of the Art Institute's work is a life-size nude, presented against a backdrop of mountain peaks and rising mist (fig. 1). This figure, for which Hodler's wife, Berthe Jacques, served as model, appears again in the same pose in his large-scale, multifigural composition *Truth I*, painted in two versions (see fig. 2).[2] The Chicago painting remained a very personal object for the artist, as he kept it in his possession during his lifetime and never

exhibited it. When it was first shown publicly, three years after his death, it, too, was entitled *Truth*.[3]

When the picture came to the Art Institute it was in a delicate condition and required lengthy conservation treatment to stabilize and flatten the fragile, lifting paint, and to improve its appearance by removing old varnish and retouching small losses.[4] Our physical examination of *Truth* also spurred us to explore larger questions surrounding the painting's place in Hodler's oeuvre. In this essay, we offer a detailed study of the artist's technique and working method, combined with art-historical evidence, in order to place *Truth* more firmly within his artistic chronology, establishing specific links between the painting, its related studies, and later works that it informed. We also trace the ways in which the artist approached and revised the painting's allegorical subject, reflecting the complex exploration of interrelated symbolic themes that is the hallmark of his work.

FIGURE 1. Ferdinand Hodler (Swiss, 1853–1918). *Truth,* 1896/98, 1902. Oil on canvas; 200.5 x 105 cm (79 x 41 ¹/₂ in.). Joseph Winterbotham Collection, 2003.119.

Painting Technique

> Hodler is a mystic and a realist, a duality which disconcerts and disorients. . . . He excels in rendering the things of the past or of the dream and the realities of life.[5]

In *Truth*, Hodler employed different painting techniques for the imaginary landscape and the realistic nude. He roughed out the tumultuous surroundings in a broad, schematic manner, using a wide brush and vigorous strokes, leaving vagrant drips across the bottom of the picture. The expressive brushwork through the fluid paint directly conveys a sense of nature's elemental forces. Rather than depending on illusionism, Hodler created an impression of different substances through his painting process. In the heavy white cloud that has settled in the bottom-right corner, he introduced optical grays and gentle indentations into the form by simply varying the pressure on the palette knife as he spread the smooth white paint across the unprimed canvas (see fig. 3). For the puffy, buoyant clouds at the top, he applied a much stiffer paint that did not spread easily, dragging it across the surface with his brush, leaving uncovered pockets within each stroke that literally fill the cloud with air (see fig. 4). He went back with a dry brush to stretch out the paint more diaphanously and to pounce and feather the texture into a more nebulous state. In another descriptive technique, the artist used long, smooth, vertical brushstrokes for the slick, glaciated surfaces of the steep mountains that rise up and beyond the top of the picture.

In contrast, Hodler painted the figure with an almost clinical precision, developing Berthe's form in a process that became increasingly elaborate. When he began the painting between 1896 and 1898, he followed a simple technique, building up the body with thin applications of pink, shading toward gray and purple for the shadows; sometimes warming the flesh with a layer of

orange; and adding lively purple contour lines. Although this early state has been almost completely covered by his later reworking, it is still visible in the throat, where the delicate pink modeling, retained as the shadow, contrasts with the paler overlay to the neck (see fig. 5).[6]

Later Hodler became bolder in his technique, covering the earlier pinks with a much brighter sheath of pale yellows and heightening the definition of bones and muscles with thick highlights and deep, saturated shadows. Here and there he employed intense colors to model the flesh but did so with such a light touch that the overall result is still naturalistic, like most of his work of the 1890s.[7] But the brilliant technicolor effects he often favored in the following decades are suggested by the strong contour lines, oscillating between blue, green, purple, and red, that electrify the figure (see fig. 7).[8]

Hodler continued to elaborate the form with layer upon layer of diversely worked paint. Taking a sculptural approach, he alternated between addition and reduction. To pull a taut, smooth skin across Truth's belly, he used his palette knife to spread a thick, opaque highlight of pale yellow paint; he then scraped it back until it became translucent enough to blend with adjacent areas, a process that gave a shimmering, uneven edge to the highlight and left harsh diagonal scratches across the stomach (see fig. 8). In other areas, such as the gray wash under the cheekbone, Hodler wiped the wet color away more gently (see fig. 6). The entire surface of the body has been manipu-

FIGURE 3. *Truth*, detail of lower-right corner, showing optical grays and gentle indentations created with a palette knife.

lated—for example scratched, scraped with a knife, chiseled with oil sticks, gently wiped, caressed with the brush, or pressed with the fingers. Indeed Hodler left clear fingerprints in spots, such as in the pink glaze applied to the nipples.

In the top layers of the painting, he also made extensive use of Raffaëlli solid oil colors, which he used to draw on top of the paint.[9] Similar in form to pastel sticks, Raffaëlli sticks came on the market in mid-1902, which indicates that Hodler was still working on the picture at that time. The oil stick strokes are well melded into the varied amalgam of paint, and their presence was difficult to ascertain until medium analysis identified their distinguishing components (see "Scientific Analysis of Materials," pp. 66–67).[10] They are evident in some spots, where they appear as blunt, chisel-like marks, with thicker deposits of pigment along the edges, as seen in the yellow diagonal strokes that sculpt the face (see fig. 6).

Because most Raffaëlli sticks contain zinc white pigment, the strokes fluoresce bright yellow-green under

FIGURE 2. Ferdinand Hodler. *Truth I*, 1902. Oil on canvas; 196 x 273 cm (77¹/₈ x 107¹/₂ in.). Kunsthaus Zürich.

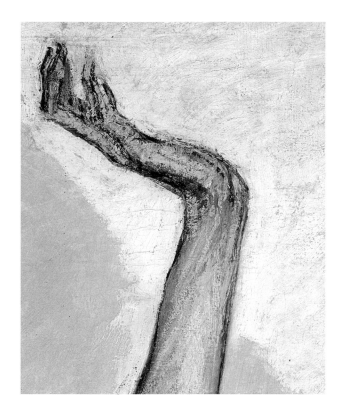

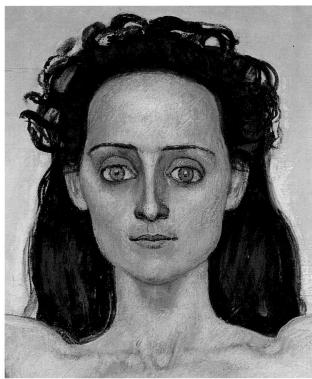

ultraviolet light.[11] In an ultraviolet photograph (fig. 9), we can see how extensively Hodler worked the figure's chest, knitting together separate areas under a smooth, pale skin. He also employed the sticks to cover the pale blue sky with a dull purple haze.[12] As first painted, the lower sky was a more luminous light blue tinged with strokes of pink, as though dawn were just breaking on the horizon. This initial coloring supports Sharon Hirsh's view that this work may have been conceived as an early version of *Day I* (see "A Note on Dating," fig. 5). By later subduing the sky and adding brighter highlights to the body, Hodler gave greater eminence to the figure. The myriad layers of melded color in Truth's skin create a golden iridescence that is further set off by the duller complementary purple of the sky. With this change, Hodler may have shifted the symbolic emphasis from the literal light of Day to the spiritual enlightenment embodied by Truth

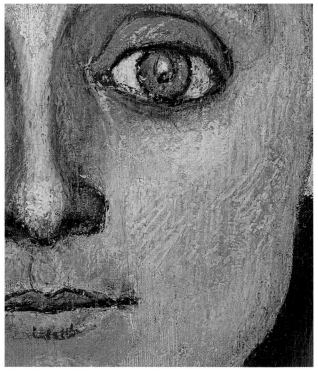

FIGURES 4–6. *Truth.* 4): At top left, detail of upper-right corner, with feathered brushwork; 5): At top right, detail of head and neck, revealing initial pink modeling surrounded by later reworking in pale yellow; 6): At right, detail of face with diagonal oil-stick strokes in cheek and wiped-thin gray layer below cheekbone.

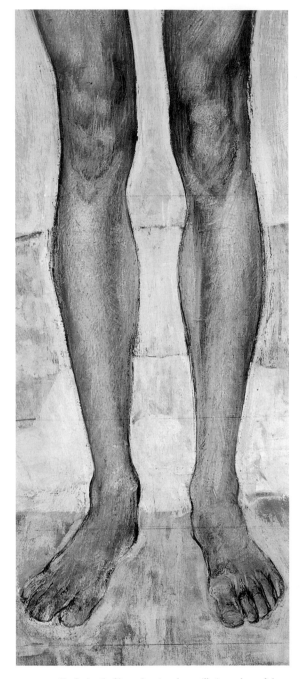

FIGURE 7. *Truth*, detail of legs, showing the oscillating colors of the contour lines and the overlying grid lines in pencil.

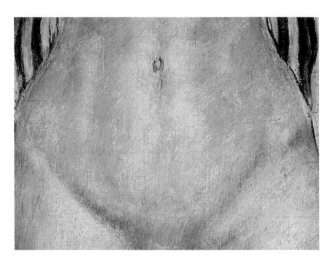

FIGURE 8. *Truth*, detail of stomach, revealing the shimmering highlights achieved with a palette knife and later scraping.

Initial Sketch and Alterations

Even as it displays a remarkably complex painted surface, *Truth* also offers an unusual glimpse of Hodler's artistic process in its earliest stages. An exceptionally clear infrared image of the artist's initial painted sketch can be captured from the reverse because there is no obstructing ground layer (fig. 10).[14] A comparison of this underlying sketch with the finished painting shows that the artist made numerous changes during the painting process to increase the figure's iconic presence. For example, in the initial sketch *Truth* stood turned slightly to the left, but during the painting phase Hodler brought her to a strictly frontal position and overlaid the earlier, more natural hairstyle with a formal coiffure of curls. He made her breasts smaller and higher, and the strands of her hair thinner; he narrowed her legs, simplifying their contours; and widened her waist so its indentation is not so sharp—all changes that emphasize verticality within the picture.

Hodler also extended the mountains, which were much shorter in the initial sketch, so they seem to rise up beyond the top of the canvas, embracing the entire figure as they ascend.[15] This correspondence between landscape and figure is a formal manifestation of Hodler's personal philosophy of Parallelism, which he felt gave a work deeper emotional resonance.[16] Another example of this sympathetic harmony is the cloud at left; a late addition, it runs parallel to Truth's hand, then follows the angle of her bent arm, cupping her elbow as if to help hold her arm aloft.

herself. In a final step, the artist added a light blue aureole around the edge of the figure.[13] This enhances Truth's presence physically, by presenting her contours in a stronger light, and psychically, by suggesting an aura that emanates from her body.

Throughout the painting process, Hodler struggled with the arms and hands. The infrared reflectogram and visible pentimenti reveal that he shifted the left arm back and forth at least four times, repositioning the other one as well.[17] Disconcertingly unnatural, the arms' gesture underscores Truth's iconic pose. Reminiscent of a caryatid, she exemplifies Hodler's belief that his figures "take on an architectonic character: they are monuments of expressive architecture."[18]

Toward the end, Hodler removed the canvas from its stretcher in order to shift the entire composition and reattach it to a slightly smaller one. Examination of the edges shows two sets of old tack holes, one corresponding to the initial stretching, and the other to a second, which was accomplished before the top clouds were added. With this shift Hodler effected a subtle change: he repositioned *Truth* 2 centimeters closer to the top edge, enhancing her monumentality. Her arms, framed more tightly by the marginally narrower format, seem to press out with greater strength, as if holding the clouds at bay.[19]

Preliminary Drawings

The infrared reflectogram of *Truth* shows that Hodler squared the bare canvas in order to transfer a design from another source—a drawing that can now be identified. In this work (fig. 11), Hodler sketched directly from life, capturing the figure with tentative, light pencil lines; squaring the sheet; and then reinforcing both the figure and grid with darker lines in order to transfer them to the canvas more easily.[20] When this preliminary drawing is enlarged on the computer until its grid matches that on the canvas, the superimposed figures from the drawing and the initial sketch correspond almost exactly (fig. 12).[21] Both include the body's slight turn to the left and lower breasts, aspects that were abandoned in the final painting.

We have also pinpointed another drawing (fig. 13) that Hodler used at various stages in the painting's progress. Here he worked out details of Truth's feet, legs, and hands.[22] For the initial sketch on the canvas, he used the feet from the figure at right, reinforcing only the part of the drawing that was needed. He later incorporated various changes from the figure at far left, including the more frontally positioned leg, adding these during the

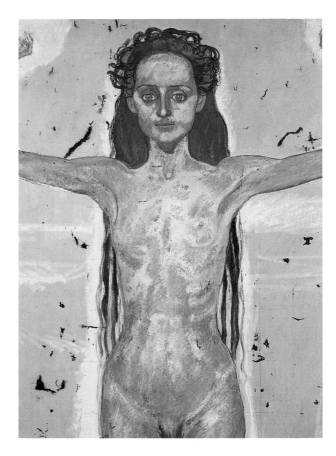

FIGURE 9. *Truth*, detail under ultraviolet light. Raffaëlli oil sticks fluoresce yellow-green due to presence of zinc white; dark purple areas are recent retouchings that do not fluoresce.

painting stage.[23] Hodler also used this sheet to experiment with different hand positions. Comparing these studies with the infrared reflectogram shows that he chose two (the second hand in each of the top two rows), using them for the initial sketch on the canvas.

The artist continued to reconfigure the hands as the painting progressed. He outlined positions for new fingers with red contours but never filled them in; he scraped down fingers he intended to replace but never covered them up. As a result, their different positions are superimposed upon one another like multiple exposures. As Hodler shifted the hands and forearms, he did not adjust the modeling of the form as a whole but instead patched the new and old together with heavy hatching, not bothering to disguise the detours he had made during the compositional process.

SCIENTIFIC ANALYSIS OF MATERIALS

In order to clarify the complex, layered structure of the paint in *Truth*, we took a few microscopic samples and subjected them to thorough scientific analysis. Cross sections fully exposed the sequence of paint layers, which sometimes possess irregular, jagged surfaces; this probably indicates that Hodler scraped or rubbed the surface as he applied successive layers of paint. We found that the very diffused uppermost layer generally contains large amounts of white mixed with fine grains of pigment; when we observed this under ultraviolet light (see fig. 1), it displayed a bright yellow-green autofluorescence characteristic of zinc white, the presence of which we confirmed by SEM/EDX. Having determined by FTIR microspectroscopy and elemental analysis that the overwhelming majority of the underlying painting layers in *Truth* contained oil paint with lead white as the white pigment, we decided to further investigate the anomalous uppermost layer to see if it included Raffaëlli solid colors, which Hodler is known to have used in some of his paintings.

The French patent for Raffaëlli solid colors contains an intricate list of ingredients,[1] but researchers at the Swiss Institute for Art Research, who obtained historic samples of the sticks conserved in the archives of the firm Winsor and Newton, have been able to determine that the hallmark for the sticks is the presence of drying oil, Japan wax (although beeswax paraffins and Carnauba wax have been identified in different specimens), and, frequently, zinc carboxylates (often associated with other metal carboxylates).[2]

Analyzing samples from *Truth* with FTIR microspectroscopy, we were able to identify zinc carboxylates, Japan wax, beeswax, and oil.[3] Our colleagues at the Swiss Institute performed further analysis of the same samples with chromatographic tecniques, comparing the results with their extensive database on Hodler's materials and their reference oil sticks; they corroborated our findings and ultimately confirmed that the artist used Raffaëlli solid colors on selected areas of the painting. Based on the areas sampled, it seems that he employed yellow and violet oil sticks in particular.

We also investigated the possible nature of transparent, yellowish brown exudates that were visible on several areas of *Truth*'s surface. We discovered that these contain zinc stearate, which has been seen coating the surface of some of the reference oil sticks.[4] Swiss researchers have observed similar yellowish brown films on Hodler paintings they have examined; the Raffaëlli colors seem to have slightly deteriorated in these cases, especially in areas where they were applied on top of a layer of oil paint (as in the Art Institute's picture). The varnishing of *Truth* in past restoration treatments may explain the presence of the films, since the mobility of zinc carboxylates can be increased by the use of solvents, which may promote the separation of the phases. In general, however, areas of oil stick on Hodler's paintings have aged well and are neither subject to flaking nor sensitive to solvents.

FRANCESCA CASADIO
ANDREW W. MELLON CONSERVATION SCIENTIST

INGE FIEDLER
CONSERVATION MICROSCOPIST

 Raffaëlli oil stick

Traditional oil paint

FIGURE 1a–c. Cross section of a paint sample close to the elbow of Truth's proper right arm. a): At top, a visible reflected light image showing Hodler's use of Raffaëlli oil sticks over several layers of paint; original magnification 200 x; b): At center, the same cross section photographed under ultraviolet illumination, revealing the peculiar fluorescence of the oil sticks' zinc white pigment; original magnification 200 x; c): At bottom, a scanning electron micrograph in backscattered electron mode; since this technique causes the heaviest element to appear lighter, the bottom layers of lead-based paint look whiter than the top one, which contains zinc.

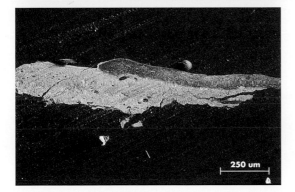

250 um

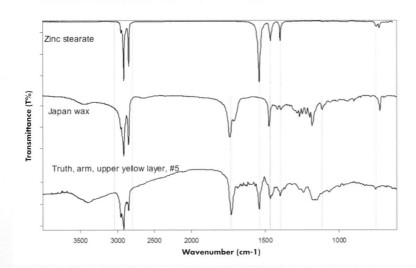

FIGURE 2. At bottom, the FTIR spectrum of the Raffaëlli oil-stick layer shown in fig. 1. To an experienced analyst, a close look at the unique pattern of peaks indicates that this paint layer contains zinc stearate and Japan wax, the spectra of which are provided for comparison above; vertical lines indicate matching peaks.

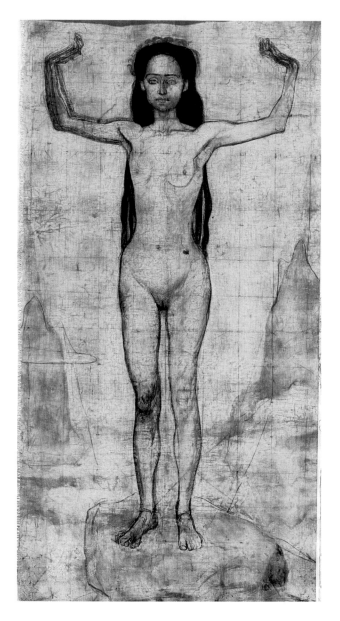

FIGURE 10. *Truth*, infrared reflectogram from reverse showing initial sketch. The image has been flipped so that it corresponds to the orientation of the figure on the front.

Overlying Grid

Hodler frequently laid a set of light pencil lines over the figures in his drawings and paintings to check their alignment, symmetry, and proportions. This was an integral part of his method, both while he was painting and after he had finished. He left these lines exposed, underscoring his interest in the figures' architectonic structure and ac-

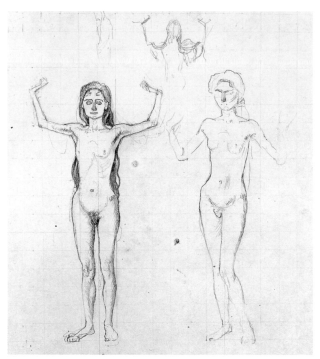

FIGURE 11. Ferdinand Hodler. Study for *Truth*, 1898/1902. Pencil on paper; 40.3 x 36.7 cm (15 7/8 x 14 1/2 in.). Kunsthaus Zürich.

knowledging the significance of the compositional process itself to his particular aesthetic. On *Truth*, he drew a light, intermittent line through the center of the torso, from navel to chin, marking the form's vertical axis.[24] This line confirms that *Truth* is in fact slightly askew: her legs and head tilt slightly toward the left when compared to the torso. These anomalies can be traced to the preliminary drawing and would have appeared natural when the figure was still turned slightly to the left; they were also perhaps a factor in Hodler's decision to rotate the canvas slightly to the right when restretching it.

Additional pencil marks divide Truth's body into roughly equal sections (see fig. 7). These may have served as aids in comparing the proportions and contours of the figure to those of the model, or perhaps to an idealized set of proportions.[25] The artist frequently viewed his models through a frame with a grid of threads stretched across it and was known to pose them again as a painting neared completion. He could have easily judged the painting, with its overlying pencil marks, against the model as seen through his gridded frame.[26]

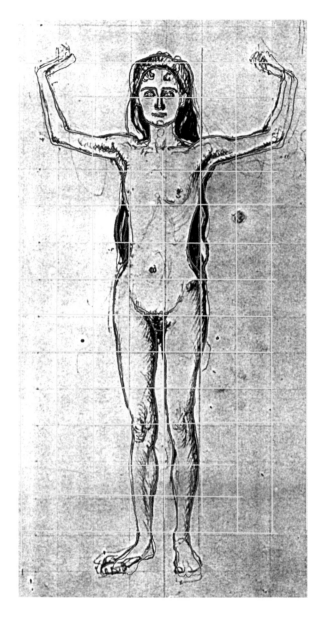

FIGURE 12. Study for *Truth* (fig. 11) with computer overlay of the contour of the initial sketch (fig. 10).

Truth I

The figure in *Truth I* (fig. 2) is very nearly the same size as the one in the Art Institute's painting, and the contours, which correspond very closely when the two images are superimposed, may have been traced from the Chicago picture using a full-size paper cartoon.[27] Infrared reflectography of *Truth I* discloses that the widely spread arms were originally more acutely bent (as can be seen in the pentimento at the figure's right elbow), indicating that the

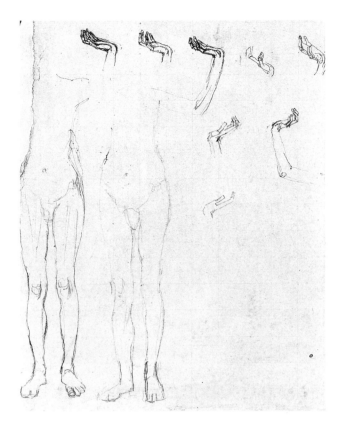

FIGURE 13. Ferdinand Hodler. Hand and figure study for *Truth*, 1898/1902. Pencil on paper, attached to canvas; 31.6 x 24.9 cm (12 $^{7}/_{16}$ x 9 $^{13}/_{16}$ in.). Kunsthaus Zürich.

Chicago *Truth* was its precedent.[28] Similarly, the figure in *Truth I* initially stood on a rock shaped like that in the Art Institute's work. Although Hodler later reworked the figure in *Truth I*, initially he faithfully followed the same rendering of form, using highlights and shading that he had developed in the earlier picture.[29] He modeled the later figure in a more stylized, less naturalistic manner, suggesting that in *Truth I* he was no longer working directly from a model but was instead using the Chicago *Truth* as his primary source. Further evidence points to the fact that Hodler had completed the Art Institute's picture before painting *Truth I*, since he included nuances of modeling from the Chicago painting's top-most layers in the early stages of *Truth I*. That he dated the latter work 1902 thus indicates that he had finished the Chicago *Truth* in that year.

A NOTE ON DATING

**SHARON L. HIRSH, CHARLES A. DANA PROFESSOR
OF ART HISTORY, DICKINSON COLLEGE**

The evolution of the figure in the Art Institute's *Truth* unfolds among the hundreds of preliminary drawings and thousands of notebook sketches in which Hodler recorded his impressions and ideas on an almost daily basis.[1] In the case of *Truth*, two separate but often intertwined developments occur in Hodler's sketchbooks: that of the pose of the nude woman with outstretched arms and hands lifted outward, and that of the symbolic image itself—her title and meaning. Both of these developments, and their intersection in *Truth*, will be traced here.[2]

Throughout the 1890s, Hodler made sketches for compositions that spell out the gradual spiritual awakening of reclining, crouching, or weakly rising figures who are, according to his titles, "sad unto the soul," or "souls in pain." Much of this narrative found its way into major paintings of that time: *Communion with Infinity* (1892; Kunstmuseum Basel), *The Chosen One* (1893–94; Kunstmuseum Bern), *Autumn Evening* (1892–93; Musée des Beaux Arts, Neuchâtel), and *Path of the Chosen Souls* (1893; private collection, Switzerland).[3] A strong underlying theme of all of these compositions was the blooming of the earth and the redemptive power of the sun, or Day[4]; this subject served, as we shall see, as the forerunner to the Chicago *Truth*.

A sketchbook dating to 1895 includes what may be the two earliest examples of the figure later known as Truth.[5] In one sketch, Hodler actually titled the multi-figured image *Day*, writing "the happy ones / the Day / the light and the colors."[6] The other depicts the figure closest to the one in the Art Institute's painting: she stands frontally, her unusually attenuated hands outstretched, on a mountaintop surrounded by clouds (fig. 1).

The following year Hodler produced a large work entitled *Art*, in which a crouching woman appears in the clouds above a mountainscape, holding her arms outstretched in a pose more relaxed than, but still similar to, the figure in the Chicago *Truth*.[7] At this time, the artist seems to have focused primarily on the moment of awakening contained in his early ideas; *Day* is the most common title offered on sketches, although at times a similar figure on a mountaintop is identified as *Spring*.[8] In an undated drawing, probably from 1896 to 1898, Hodler explored Truth itself as a subject, presenting a female figure surrounded by several others called "young people consulting Truth" (fig. 2).[9] At this time he was writing his theories of art, in which he cited Plato as the source for his quote "Beauty is the splendor of Truth," in conjunction with his own comment that "Art is a gesture made by Beauty"; Hodler thus equated Art with Truth.[10] That the artist considered all of these figures, groupings, and stories to be related is clear in the hundreds of drawings and sketches in which they are intermixed.[11]

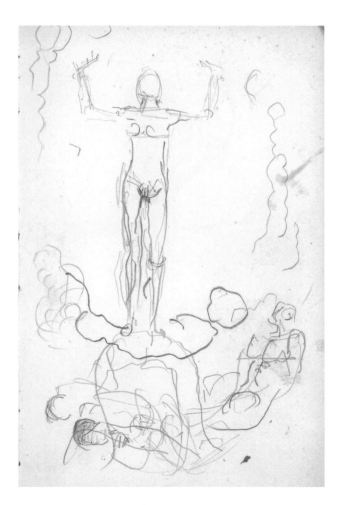

FIGURE 1. Ferdinand Hodler. Sketch for *Day/Truth*, 1895. Pencil on paper. Musée d'Art et d'Histoire, Geneva, 1958–176, notebook 67, n.pag.

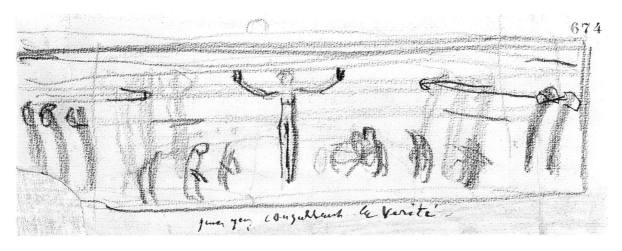

FIGURE 2. Ferdinand Hodler. "Young People Consulting Truth" ("Jeunes gens consultant la verité"), 1896/98. Pencil on paper, mounted on canvas; 9.6 x 24.9 cm (3 ¾ x 9 ¹¹/₁₆ in.). Kunsthaus Zürich.

FIGURE 3. Ferdinand Hodler. Idea sketch for triptych *Day/Truth*, 1895. Pencil on paper, mounted on canvas; 33.1 x 46.3 cm (13 x 18 ¼ in.). Kunsthaus Zürich.

Other notebooks from 1895 reveal that Hodler was beginning to think of his enlightenment story in terms of multipart arrangements.[12] One sketch shows a woman strikingly similar to the Chicago figure at the center of a triptych (fig. 3); as she raises her arms in revelation to the reclining figure below, three dark forms flee to her distant right. The similarities of pose and setting suggest that the Chicago painting is directly related to the central section of the planned *Day* triptych[13] and that the Art Institute's canvas might date from as early as 1895.

Around 1898 or 1899, however, Hodler rearranged somewhat similar figures in a two-part, horizontally divided drawing featuring awakening forms in the lower register and an apparition figure above. In an example from a sketchbook that the artist dated January 1899 (fig. 4), the upper figure has both the outstretched arms of Truth and the folded arms often found in works called *Spring* and *The Source*.[14] This shift from triptych to bilevel composition was decisive, as Hodler seems to have abandoned the triptych format; it is therefore likely that by this year, the Chicago painting was completed, at least in its first state. Sometime after July 1899 (at which time the two-part compositions still occur in his sketchbooks), Hodler developed the lower register of this complex composition into his monumental painting *Day I* (fig. 5).[15] Here, five nude women respond to the dawn with iconic, ecstatic gestures.

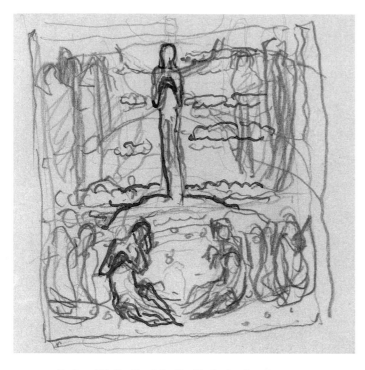

FIGURE 4. Ferdinand Hodler. Sketch for *Day/Truth*, 1899. Pencil on paper. Musée d'Art et d'Histoire, Geneva, 1958–176, notebook 66, p. 13.

In January 1899 Hodler wrote in a letter to a collector friend that he was working on "two paintings, both of them representing Day."[16] This has been interpreted as an indication that he planned two separate versions of *Day*, one of which is *Day I* and one that was "missing" or never completed.[17] It is possible that the Chicago canvas may be this "lost" image, given the picture's close relationship to the earlier sketches of the *Day* triptych. The

artist may have begun it as a painting of Day but changed his mind about the title in 1900 or 1901, after finishing *Day I*. It was after this time that Hodler reworked the painting with oil sticks, as Kristin Lister described earlier; the patented Raffaëlli colors were not on the market until June 1902.[18]

What might have motivated Hodler to change the identity and meaning of the figure at this time? As we have seen, he had already explored the concept of Truth and its connections to Day and Spring in earlier works.[19] The artist claimed, however, that the immediate inspiration for the monumental *Truth I* (which, as Lister has demonstrated, was directly based on the Chicago painting) came from his knowledge of the Dreyfus Affair, in which the officer Alfred Dreyfus, a Jew from Alsace, was wrongly accused of treason and sentenced to life imprisonment by secret court martial in 1894.[20] By the time Hodler painted *Truth I*, Dreyfus had been cleared and the truth acknowledged at last.[21]

He may also have been influenced by the work of Gustav Klimt, whom he met in 1901; in 1898 Klimt executed both a drawing and a painting titled *Nuda Veritas* (Naked Truth; fig. 6) that could have reminded Hodler about the appropriateness of addressing this new theme in his symbolic series.[22] Klimt inscribed his painting with a quote by Friedrich Schiller about truth in art: "You cannot please all by your actions and your art. To please the few is right. To please the many is bad."[23] The inclusion of

FIGURE 5. Ferdinand Hodler. *Day I*, 1900. Oil on canvas; 160 x 340 cm (63 x 133 1/8 in.). Kunstmuseum Bern.

this quote probably referred to a major, public fracas involving Klimt's 1898 murals depicting erotic nudes for the University of Vienna.[24] Hodler had suffered through his own controversy by this time: the 1897 murals commissioned for the new Swiss Museum were rejected by the institution's director.[25] Thus there was empathy on the part of these artists who felt persecuted for painting "the truth." It is noteworthy that by 1902 both had been vindicated, each receiving a gold medal at the Paris Exposition universelle in 1901.[26] Hodler's award was in part for *Day* and underscored the painting's reception as a highly successful allegory.[27] By the end of 1900, Hodler may well have been content with his decision to paint only the lower half of the earlier composition as *Day* and, spurred on by the Dreyfus Affair and his admiration for Klimt's works, reused the upper half as a "new" work called *Truth I* by 1902.

In traditional western imagery, allegorical presentations of Truth traditionally employ two iconographic associations: nature and light. Hodler considered both of these in his original Day compositions, in which figures in nature respond to dawn and repel darkness. By separating the images into Day and Truth, however, Hodler emphasized the definition of Truth as nature, or the "naked truth."[28] This offers insight into the stunningly raw bareness of the Chicago painting. Although, in her first state as Day, this figure was already striking in her almost skeletal thinness and frontal nudity, Berthe Hodler is newly impressive as Truth. The artist's later reworking with Raffaëlli sticks only intensified this; as Lister has noted, these additions darkened the original rosy sky of dawn and imbued the figure itself with illumination, making it glow powerfully from within. By mid-1902, Day had become Truth.

FIGURE 6. Gustav Klimt (Austrian, 1862–1918). *Nuda Veritas* (Naked Truth), 1898. Oil on canvas; 252 x 56.2 cm (99 ¹/₄ x 22 ¹/₈ in.). Theatersammlung der Nationalbibliothek, Vienna.

"TREATED BY STEICHEN": THE PALLADIUM PRINTS OF ALFRED STIEGLITZ

DOUGLAS G. SEVERSON, CONSERVATOR OF PHOTOGRAPHS

Any curator, anticipating the day his museum might go up in flames, should resolve to run for the Stieglitz prints first. Posterity needs them. . . . Stieglitz makes us see the relationship that exists in photography between the image and the surface that carries it—a relationship in which each contends with, yet depends on, the other.[1]

Alfred Stieglitz's portraits of his wife, Georgia O'Keeffe, which he made over a period of nearly twenty years, are perhaps his most celebrated and timeless images (see fig. 1). He executed them in a variety of photographic techniques and styles, rendering a hand on an automobile, for instance, in silver for greater contrast while printing a softly lit neck or torso with platinum salts to emphasize the subtlety of tonal gradations. But it was his use of the palladium process, by itself or in combination with platinum, that helped him achieve the rich interplay of image and surface that is a hallmark of his work. The vast majority of Stieglitz's palladium prints were treated shortly after his death by his fellow photographer Edward Steichen. The exact nature of Steichen's work, however, remains unknown. The most explicit reference to the procedure yet found appears in a letter that O'Keeffe wrote to Daniel Catton Rich, then director of the Art Institute of Chicago, in early 1950. Here, she discussed untreated prints that she wanted her assistant and representative, Doris Bry, to reclaim during an upcoming trip to the museum:

> I hope you will let her take certain prints of Stieglitz that look stained. Steichen does something to them that clears them and to me it seems a good thing to do. I have just finished mounting a number from the key set that are very much improved. I trust Steichen to do this and I would not feel that way about anyone else. He thinks it will give the prints a much longer life.[2]

It appears that, contrary to O'Keeffe's hopes, this mysterious treatment may have had an adverse impact on

FIGURE 1. Alfred Stieglitz (American, 1864–1946). *Georgia O'Keeffe,* 1918. Platinum print; 25.4 x 20 cm (10 x 8 in.). Alfred Stieglitz Collection, 1949.755. In this, one of Stieglitz's earlier portraits, O'Keeffe poses before *Special No. 15* (1916), one of her charcoal sketches of the Palo Duro Canyon.

these photographs decades later. Indeed, it is by researching the changes that have occurred in these palladium prints that we have been able to better assess their stability and, over the last twenty years, make more informed decisions about how to store and exhibit them.

The platinum/palladium process itself was patented and introduced to the marketplace in 1873 by the English photographer William Willis.[3] In comparison to the silver process, which preceded and succeeded it in popularity, the primary advantage of the technique is that it can reproduce a much longer tonal scale. A fuller-sized platinum or palladium print from a properly rendered negative has an unmatched tonal beauty. While Stieglitz (see fig. 2) published many notes and articles in the photographic journals of his day in which he described a variety of processes and procedures, it was the platinum and palladium process that attracted him the most, holding his loyalty for nearly forty years. He wrote, for instance:

Of all the modern printing processes at the command of the photographer, whether amateur or professional, none deserves to be more popular than the platinum. The simplicity of manipulation, combined with the beauty of the results obtained with it, is enough to recommend it to every photographer. And above all, the prints produced by this method are as permanent as the paper which supports the image.[4]

From 1917, the year that he closed his 291 Gallery and began to photograph Georgia O'Keeffe, until the mid-1920s, Stieglitz explored the capabilities and limitations of this process without regard to common practice. He wrote to fellow photographer Paul Strand of making "all sorts of experiments" to evaluate the "elasticity" of palladium (see fig. 3).[5] He sometimes created close to a hundred prints of a given image in order to get one he considered "A1." Unlike a silver print, which is made on a coated paper, the palladium image is embedded in the fibers of

the paper and thus takes on the texture of that support. Stieglitz experimented endlessly with different papers and with various post-processing waxes and varnishes in pursuit of the exact relationship between image and surface that he felt a given photograph required. For Stieglitz, any alteration of that surface would hold great significance.

Stieglitz, who produced these images, and Steichen, who later treated them, had a long and sometimes difficult friendship. While Stieglitz is widely credited with exposing the American public to the work of Paul Cézanne, Henri Matisse, Pablo Picasso, Georges Braque and many other avant-garde European artists through his gallery at 291 Fifth Avenue in New York, it was in fact Steichen who first met many of these artists and introduced Stieglitz to them. But with the advent of World War I and the subsequent demise of the 291 Gallery, the historic collaboration between these two great photographers and strong-willed individuals ended bitterly.[6]

FIGURE 2. Edward Steichen (American, 1879–1973). *Portrait of Alfred Stieglitz*, 1915. Gum/platinum print; 29.4 x 24 cm (11 ¹/₂ x 9 ¹/₂ in.). Alfred Stieglitz Collection, 1949.827.

Steichen does not mince words in his autobiography: "Stieglitz only tolerated people close to him when they completely agreed with him and were of service. . . . Stieglitz and I differed as to what the future of 291 could be, and we also differed in our feelings about the war."[7] They would never again collaborate, as their careers followed widely divergent paths. Steichen's commercial portraiture, projects for publishers such as Condé Nast, war photography, and eventual museum work were all anathema to Stieglitz, whose photographic and philosophical pursuits were much more personal.[8]

Nine years before his death in 1946, the elderly Stieglitz (see fig. 4) named O'Keeffe the executor of his estate, which included roughly 850 drawings, paintings, and sculptures; at least 2,000 photographs; and some 50,000 letters and papers, all of which he intended to donate to nonprofit institutions. To help her sort and distribute these works, O'Keeffe engaged Doris Bry, who remained indispensable for the next thirty years. According to Bry, Stieglitz's collection was housed and sorted at his last gallery, New York's An American Place, over a period of three years. During that time, she and O'Keeffe worked with Rich to select works for a 1948 exhibition at the Art Institute and also culled through the holdings to create the Alfred Stieglitz Collection, comprising 160 of Stieglitz's own works, along with vintage prints by many of his peers.[9] Steichen (see fig. 5), by then the new director of the Department of Photography at the Museum of Modern Art, New York, soon became involved as well. As Bry remembered it, O'Keeffe felt that Steichen was "about the only photographer around who knew the old palladium and platinum printing processes as Stieglitz knew them, and who also had enough regard for Stieglitz that he would take on such a chore."[10]

Bry's recollection was that Steichen came to the gallery sometime during the sorting and distribution process, probably during the winter of 1949. They focused their attention on the palladium prints, which, according to Bry, were "very, very yellow and gave you a feeling of disturbance."[11] Arrangements were made for Steichen to treat them, and "they came back looking clear and fresh . . . newly made again.[12] Bry generally transported the prints to and from Steichen herself and remem-

bered asking him a number of times to specify the procedure, but he always remained secretive. She was not at all surprised that no written account of his method seems to exist. Fortunately she herself was a rigorous record-keeper, placing the notation "Treated by Steichen" on the original mats of all these pictures, along with dates ranging from May 1949 to June 1950. More than 230 such pieces have been located in collections around the world, including fifteen at the Art Institute.[13] While conservators have made a concerted effort to discern patterns of treatment among these works, many factors have made this exceedingly difficult. The tone and color of any given print are significantly influenced by factors such as the type or size of the paper used, processing temperatures, toners or other additives, surface coatings, and so on. If we add to these elements Stieglitz's known history as a great experimenter and technical pioneer, and the absence of specific records of printing procedures, the challenge in trying to isolate the effects of Steichen's treatments becomes obvious.

The issue of Steichen's treatment and its possible long-term effects first arose in 1984, when one of the Art Institute's treated palladium portraits of O'Keeffe (fig. 6) changed noticeably while on loan to an exhibit at the National Museum of Art in Osaka, Japan.[14] Densitometer readings made upon the print's return to Chicago showed significant yellowing at all levels.[15] Possible explanations for these changes include elevated levels of light or humidity during the exhibition and exposure to high or fluctuating levels of temperature and humidity during shipment.

Given the historic importance and value of Stieglitz's photographs and the many unanswered questions surrounding Steichen's treatment of them, the National Gallery of Art in Washington, D.C., hosted a colloquium

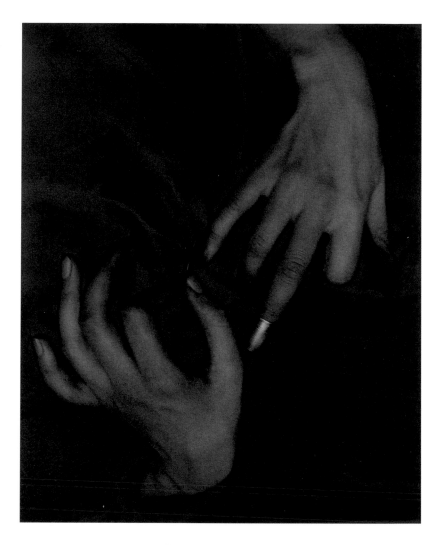

FIGURE 3. Alfred Stieglitz. *Georgia O'Keeffe,* 1919. Solarized palladium print; 25 x 20.3 cm (10 x 8 in.). Alfred Stieglitz Collection, 1949.745. Solarization, a difficult and rarely successful procedure, involves briefly re-exposing a print to light during development.

on the subject in May 1993. Steichen-treated palladium prints were brought from the Art Institute and the J. Paul Getty Museum, Los Angeles, and untreated versions of the same images were brought from the Museum of Fine Arts, Boston, and the Metropolitan Museum of Art, New York. The photographs were analyzed with X-ray fluorescence spectroscopy to verify the predominant metallic elements present in each print and then visually examined, compared, and discussed by the assembled curators, conservators, and art historians.[16] We noticed that many of the treated prints, and nearly all of the untreated ones, have surface coatings, probably a wax or varnish. While

FIGURE 4. Arnold Newman (American, b. 1918). *Alfred Stieglitz and Georgia O'Keeffe,* 1944. Silver gelatin print; 23.3 x 19.8 cm (9 x 8 in.). Gift of Harold Kaye, 1956.1117.

Bry recalled that O'Keeffe and Steichen chose not to recoat prints after treating them, it seems as though Steichen may have done so anyway—perhaps without informing Bry or O'Keeffe—when he found a print's surface to have been altered noticeably by his treatment. It is also possible that his procedure did not remove the surface coatings in the first place. But this cannot be determined without knowing more about the treatment chemistry and identifying the coating material, which could only be done with destructive sampling techniques.

During our conversations, we also recognized that retouching is more prevalent and noticeable—and somewhat less skillfully done—on many of the treated photographs. This may be Steichen's work, as opposed to that done by Stieglitz or O'Keeffe when the images were made. Perhaps our most basic collaborative observation was to recognize that while the treated prints had lighter tonalities, the untreated examples tended to be darker and deeper, sometimes more yellow and occasionally almost orange in tone. It also became apparent that the treated

prints tended to have rougher, raw surfaces, while the untreated ones were smoother and less disturbed. It appears that Steichen's treatment attacked the cellulose in the paper to a degree, disturbing the print's surface and sometimes weakening the paper support. This suggests that Steichen may have used bleach to reduce yellowing, since this is known to degrade cellulose more than simply immersing a print in water.[17]

How, then, did Steichen come to undertake all of this work, and what, basically, did he do? It's likely that O'Keeffe, when examining the prints before their distribution in the late 1940s, determined that many of them seemed to have darkened and yellowed over time. This led her to contact Steichen, who treated them chemically, perhaps with calcium hypochlorite bleach or another equivalent chemical, which would have removed some of the original surface coatings and retouching, which Steichen then reapplied. If this was the scenario, as seems likely,

FIGURE 5. Edward Steichen. *Self-Portrait with Brush and Palette,* 1902. Gum bichromate print; 26.8 x 20 cm (10 x 8 in.). Alfred Stieglitz Collection, 1949.823.

then Steichen's treatment of the prints would indeed have made them more susceptible to physical deteriorations such as surface cracking or weakening of the paper support, and demands that we take the utmost care in handling, housing, and exhibiting them.

Here at the Art Institute, we have responded to the 1984 deterioration and the findings of the 1993 colloquium by loaning and exhibiting Stieglitz's palladium portraits on a very restricted basis. Since 1984, in fact, we have kept all of these prints in our refrigerated storage vault, which ensures that whatever type of deterioration may occur, it will do so at a much slower rate; we have also monitored the works periodically to ensure their continued safety. In 1988, four years into this plan, we found no further changes in *Georgia O'Keeffe* (fig. 6) or any other treated palladium print. So in that year, nineteen of the O'Keeffe portraits (including twelve treated palladium prints) were shown under very carefully controlled conditions in the Art Institute's photography galleries, with no ill effect.[18] Since that time, we have released treated palladium prints for exhibition in similar controlled environments at the J. Paul Getty Museum; in a traveling show organized by the Phillips Collection, Washington, D.C.; and, and most recently, in 2004–2005 at the Musée d'Orsay in Paris and the Museo de Arte Reina Sofia in Madrid.[19] Extensive monitoring has indicated that no further significant tonal changes have occurred.

Edward Steichen's undocumented treatment of Alfred Stieglitz's platinum/palladium prints has presented an intriguing puzzle to conservators, curators, and historians for many years. Georgia O'Keeffe seemed convinced that Steichen's process would "give the prints a much longer life"; whether her statement proves prophetic or ironic remains to be seen. At the very least, if these photographs have indeed continued to change over the past

FIGURE 6. Alfred Stieglitz. *Georgia O'Keeffe,* 1918. Palladium print; 25 x 20.2 cm (10 x 8 in.). Alfred Stieglitz Collection, 1949.759.

forty years, it may likely be because of Steichen's treatments, not in spite of them. But it is hoped that our ongoing investigations, both at the Art Institute and beyond, contribute in some manner to our knowledge and appreciation of these works and to their safekeeping for generations to come.

TIME AND TIDE: RESTORING LORADO TAFT'S *FOUNTAIN OF TIME*— AN OVERVIEW

BARBARA HALL, SENIOR CONSERVATOR OF OBJECTS
ROBERT AARON JONES, AIA, VICE PRESIDENT, PATRICK ENGINEERING

Past: In the Beginning

Rising like an apparition from the west end of the Midway Plaisance on Chicago's South Side, Lorado Taft's colossal 1922 sculpture *The Fountain of Time* (see fig. 1) remains a mysterious presence.[1] Atop a single high base on the edge of a large reflecting pool, a group of one hundred massed figures moves toward an unseen destination. Facing them across the pool, with his back to the viewer, a robed figure, twenty feet tall, leans upon a staff, his impassive face hidden by a hood. The subject matter is elusive. Taft was inspired by the first two lines from Henry Austin Dobson's 1877 poem "The Paradox of Time" "Time goes, you say? Ah no! Alas, Time stays, we go." Taft is quoted as saying, "The words brought before me a picture, which was speedily transformed by fancy into a colossal work of sculpture. I saw the mighty craglike figure of Time . . . watching with cynical, inscrutable gaze, the endless march of humanity . . . the shapes of hurrying men and women and children in end-

less procession, ever impelled by the winds of destiny in the inexorable lock-step of the ages."[2]

Beginning with birth of humankind at the north end of the sculpture, swirls of water gradually rise to form the crest of a low wave; a woman emerges half-formed from the swell, and behind her, a crouching man grasps its crest. The water/wave motif, symbolic of the origin of life and eternal repetition, is integral to the sculpture: the wave carries the figures forward, accenting their drapery and posture to create a dramatic sense of movement. At the apex of the group, a mounted warrior looks rigidly ahead, surrounded by solders, camp followers, and refugees. Other figures range from parents and children to embracing lovers, clerics to dancers; the sculptor is said to have modeled one group of maidens on his daughters and even portrayed himself followed by one of his workmen. At the south end, as death approaches, a man and a woman merge back into the water. Meanwhile, a young woman clasps a gaunt, aged parent whose out-

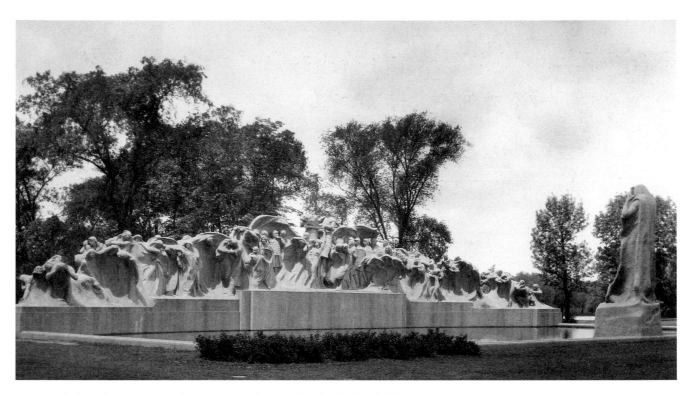

FIGURE 1. *The Fountain of Time* shortly after its completion in 1922. University of Illinois Archives.

stretched arms welcome death, and a young man holds his head in despair as if his end has come too soon.

The Fountain of Time was the only completed element of Taft's ambitious plan to embellish with a canal, bridges, and sculptures Fredrick Law Olmstead's original 1871 design of the Midway Plaisance and nearby Washington Park.[3] Expected to take ten years to complete and cost $1,200,000, it was the subject of enthusiastic discussion when revealed to the press in 1910.[4] The sculptor envisioned much of the financial support coming from the newly created B. F. Ferguson Monument Fund at the Art Institute established by Benjamin Franklin Ferguson, a wealthy Chicago lumberman. Inspired by the example of European public sculpture, at his death in 1905 he bequeathed in trust an endowment of $1,000,000, the "income of which is to be expended for the erection and maintenance of enduring statuary and monuments, in the whole or in part of stone, granite, or bronze, in . . . public places within the City of Chicago, Illinois, commemorat-

ing worthy men or women of America, or important events in American History."[5]

The selection and location of these statues were to be determined by the Art Institute's board of trustees, which in 1913 authorized $50,000 for the erection of a full-size working model of *The Fountain of Time* in plaster.[6] While World War I interrupted Taft's schedule, in 1920 the plaster (see fig. 2) was finally installed on the Midway, where it was exhibited for two years and then approved by the trustees for permanent construction.

However, this model measured over 120 feet long, 18 feet high, and 14 feet wide, and was so complex that Taft could not get a bid on carving it in stone. After many discussions, he was referred to John J. Earley, a Washington sculptor and stone carver who had invented and patented in 1922 a revolutionary process of using cast concrete and aggregate to create artworks and architectural elements. In the "Earley method," aggregate (small quartz pebbles or river gravel) of stepped sizes and shades was mixed

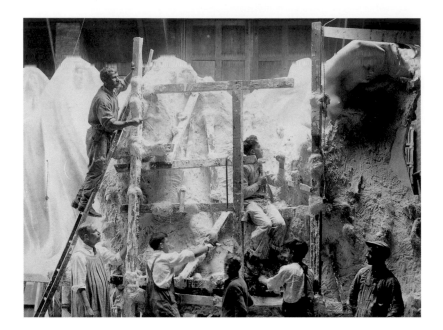

FIGURE 2. Lorado Taft (at bottom left) and his assistants unmolding one section of the full-size plaster cast, 1915/20. University of Illinois Archives.

with cement and sand to produce architectural features of fine detail with carefully controlled color and texture. The aggregate covered the surface of the concrete so densely that little of the cement paste could be seen. Taft was delighted with the effect Earley's technique produced: appearing uniform when viewed from a distance, the surface looked like a pointillist painting up close. Although it had been used architecturally, Earley's method was untried on a complex outdoor sculpture such as *The Fountain of Time*, which was the largest single group of statuary yet made on a single base. Taft and Earley's collaboration, in which they employed a new material and pushed it in a new direction, made the monument's fabrication financially possible and was the key to its creation and ultimate survival.

The work began in 1922, with Taft's studio repairing the plaster model, which had been exposed to the elements during its two years on the Midway. Earley's team then made a plaster mold of Taft's model. The complexity of the figures required the use of 4,500 mold pieces ranging in size from small ones at twelve inches across to the largest, which measured about two by four feet and weighed 1000 pounds.[7] Taft compared the monument's structure (see fig. 5) to that of a house, since it had a con-

crete foundation, a first floor (in this case, the sculptural elements), and a roof (a walkway over the top). Earley and Taft decided from the beginning to make the work hollow to save on concrete and reduce the weight on the foundation. The interior could be accessed by a knee-high opening in the foundation.

After the foundation was poured, Earley's assistant made a contoured drawing of the plaster model, which was translated into a contoured, horizontal, wooden formwork atop the foundation. This was then covered with metal lathe, over which a lean mortar mix was loosely applied to provide a strong, porous inner core on which to cast the outer concrete shell, which contains the sculptural elements. The core was specifically designed to slowly absorb water from the outer shell, preventing excess shrinkage as it set. The plaster molds were then carefully set around the wooden formwork and core; openings were left in the wood for the placement of bulkhead walls to support the sculptural elements and roof. Finally the cement and aggregate mix was poured into the mold, with twenty-six sections, one poured each day. Pieces of the mold were placed carefully to disguise the joins between sections, and steel reinforcing rods were inserted within the shell for additional support where necessary.

Both Earley and Taft considered the finished sculpture a technical and artistic triumph, imagining that the relatively low cost of its technique would put public art within reach of many small towns. At the time, the project received a great deal of attention from the cement industry, for which it still remains a focus of great interest.[8]

Present: Mother Nature vs. Father Time

The condition of buildings and outdoor sculptures is never static for long: their surfaces are subjected to an endless barrage of environmental forces: acid rain corrodes and wind and water erode; freeze-thaw expansion and contraction cracks and fractures surfaces; biological growth, soot and dirt, and the formation of gypsum

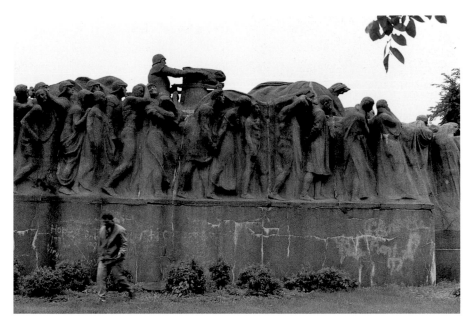

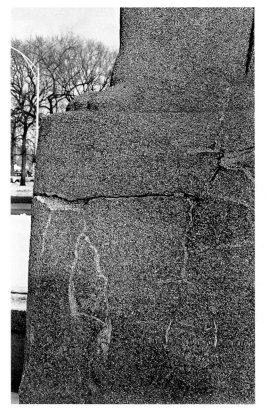

FIGURE 3a–c). a): At top, the back of the monument, showing an all-over darkened, dirty surface with graffiti and white lime leaching from vertical cracks; b): At bottom left, detail of a soldier's head showing the loss of cement paste from between the pieces of aggregate, giving the sculpture a pebbly appearance; c): At bottom right, detail of the base of the figure of Time, showing a network of large and small cracks with light patches of old repairs.

crusts cause discoloration and staining. If left unattended, such damage quickly compromises a work's appearance and structure. Vandalism, neglect, and well-meaning but poor restoration are also harmful factors.

Such changes had already begun on *The Fountain of Time* by 1926, when an inspection indicated that "The entire group, while showing erosion, is still of good character and has only slight hair line cracks where the cast finishes were joined, and there is practically nothing that may be done to the monument to advantage at the present time."[9] The next sixty years took their toll, as further cracks developed in the surface and concrete sculptural elements failed and broke off. Documentation of the monument's condition and many of the subsequent

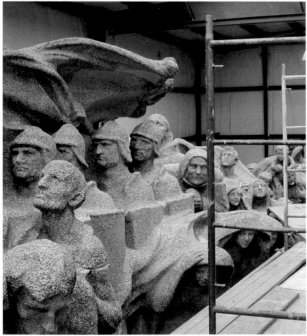

FIGURE 4a–b. a): At top, the massive enclosure and extensive scaffolding enabled conservators to work year round; b): At bottom, the upper level of scaffolding affords a close-up view of the central figural group, cleaned but compromised by years of exposure to Chicago's harsh climate.

repairs for the early years are lacking, but there is mention of surface cleaning using sandblasting and later steam, and several applications of different waterproof coatings to halt surface erosion of the cement and sand; the various colors and mixtures used to repair cracks and missing elements attest to several campaigns of repair. The most substantial was initiated through the Chicago Park District by Emily Taft Douglas, Lorado Taft's daughter. The work was done by Trygve Rovelstad, a sculptor from Taft's original construction team who worked during the summers of 1963 through 1965 repairing cracks and replacing missing limbs and faces. In 1973 the Art Institute agreed to the Park District's request to clean, caulk, and waterproof the sculpture using guidelines that the district had developed in a 1966 restoration. A letter from the Park District at this time notes, "We were told that the cleaning, waterproofing, and repair work should be done at least every five years to prevent further deterioration. . . . This monument . . . is disintegrating rapidly."[10] From this time forward, the Art Institute assumed responsibility for the monument' maintenance.

During the 1970s, the treatment of outdoor sculpture emerged as a distinct discipline in the field of conservation. This meant that the principles and ethics that had been developed for the restoration of fine art began to be applied to outdoor sculpture, with new treatments replacing methods that were often harsh and permanently damaging. Conservators adopted a comprehensive approach that began with investigation into original fabrication techniques; archival searches for historic documents and construction plans; scientific analysis and materials testing; and concluded with a detailed, photo-documented condition report and treatment proposal.

In 1978, at the museum's request, Washington University Technology Associates of St. Louis, one of the very few groups specializing in outdoor sculpture, presented the first of a series of comprehensive studies on the deteriorating condition of *The Fountain of Time*. Working with consultants in concrete and materials analysis, the group identified a number of problems that seemed to be of rapidly increasing severity; the underlying causes of many of these became evident as the original fabrication method was researched. Analysis of the concrete revealed

that it was not "air-entrained"—that is, it did not incorporate air bubbles into the mix to cushion the effects of expansion and contraction; without these, concrete is prone to spalling, or flaking. Of foremost concern was the presence of cracks: long, vertical examples relating to the twenty-six cast sections; horizontal and vertical ones resulting from the continued shrinkage of the concrete over time; cracks caused by thermal expansion and contraction; those related to the layered pouring of the concrete into the molds; and those produced by thermal changes and rusting in the reinforcing steel bars that had been placed too close to the surface. The cracks had weakened the concrete and led to the loss of details such as corner edges, limbs, and noses. Water had entered the sculpture's interior through these areas, resulting in high levels of humidity in both the upper and lower levels. The humidity condensed as droplets during the summer, initiating corrosion in steel materials; in the winter, it froze, forming icicles. Water expands in volume as it freezes, so as ice crystals formed in the concrete pores, they caused the concrete to spall over time. The group also identified problems with the structural stability of the beams and buttresses that supported the sculptural elements and roof; these were caused by cracks and disintegrating concrete.

The associates were also greatly concerned with the continued erosion of the cement paste and sand, particularly on the top of the monument, where it was exposed to wind and rain; this condition compromised the adhesion of the aggregate which, as it was lost, resulted in a lessening of visual detail and sharpness, giving the sculpture a pebbly texture (see fig. 3b). Contributing to this poor appearance was a patchwork of discolored and failed repairs (see fig. 3c) and a surface darkened with biological growth, soot, dirt, black sulfide incrustations, and ghosts of old graffiti; white lime deposits were leaching out of cracks on the back (see fig. 3a).

The group made a number of recommendations for repair, which included, first, eliminating the moisture in the interior by sealing cracks and holes, removing the

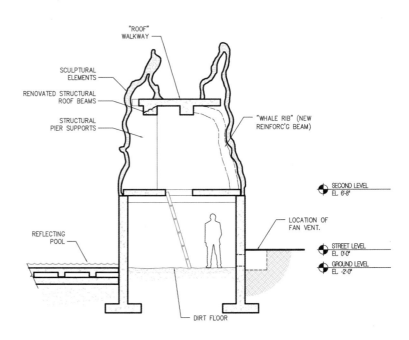

FIGURE 5 A cross section of the monument shows the interior cavities with the second level reached by a ladder, the restored roof beams, and the placement of the new "whale ribs" to further support the sculptural outer shell.

FIGURE 6. Shoring one of the concrete beams on the second-level ceiling helped support the localized, "surgical" removal of deteriorated concrete. In good condition, the original iron reinforcing bar was left in place and augmented by additional rebar supports. Also visible are sections of brick fill and the original wire mesh over which the inner layer of porous concrete was applied.

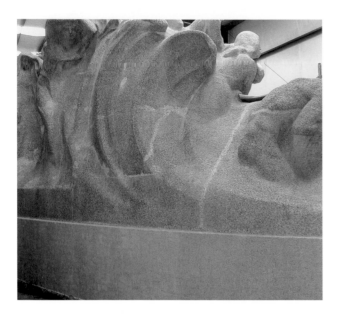

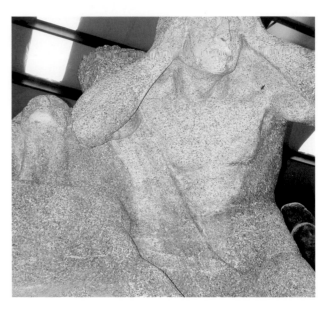

FIGURE 7. The back of the monument, showing, at center, one of the vertical cracks between sections that was reconfigured as a moving join; to both sides are repaired casting cracks.

FIGURE 8. Along with historical documentation, the examination of well-preserved areas such as this figure's neck and torso enabled conservators to determine the color of the original paste.

wooden debris from the original formwork, repiping into the sewer system roof drains that were emptying rainwater into the cavity, and installing a ventilation system. Second, they advised rebuilding the spalled and deteriorated areas of the interior and reinforcing the upper beams. Third, they suggested cleaning the exterior; removing past repairs; fixing cracks and replacing missing elements based on photographic documentation; and applying a moisture barrier to the surface. Last, they recommended further analysis of the concrete and testing of mixes to find a compatible mixture for crack repair.

Beginning in 1993, a Chicago team was formed to implement these recommendations. Bauer Latoza Studio, an architectural firm specializing in historic preservation, had the roof drains rerouted and, to circulate air, added two ventilation fans inside the sculpture (discreetly invisible on the exterior). They designed a heated, temporary steel building (see fig. 4) to cover the monument so that restoration work—estimated to take at least two years and which now included resurfacing the sculpture—could continue uninterrupted through the winter months.

In 1998 the project's manager, Robert Jones, reviewed the task and began to assemble a schedule and team, working on interior structural problems with Wiss,

Janney, Elstner Associates, an engineering firm specializing in concrete, structural stabilization, and materials testing. Andrzej Dajnowski, a sculpture conservator formerly with the Chicago Park District and the Art Institute and then director of his own firm, Conservation of Sculpture and Objects Studio, had spent a number of years on the project and was chosen to oversee its conservation-related aspects, advising on both exterior and interior issues. In many instances, the work ahead was unique; aside from concrete repairs done in the building industry, there was little precedent to draw upon in the field of sculptural conservation. The monument's size and condition were daunting, and the treatment proposed was complex and experimental. As well as using traditional concrete repair methods, it was anticipated that new, untried techniques would have to be developed. At the same time, it was important to us to use recognized conservation, restoration, and historic preservation standards in our work. The selection of a project team was a critical component of a complex undertaking such as this; technical expertise in complementary areas was essential. Decisions were made as a group, after evaluating the merits and drawbacks of proposed repair methods.

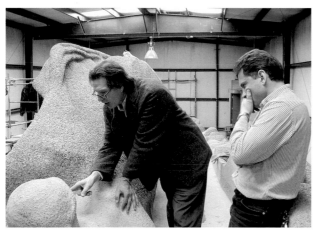

FIGURE 9. Early experiments in resurfacing resulted in snowmanlike features such as this soldier's head, which lacked sufficient definition. The height of the original aggregate can be seen—the level of the resurfacing mixture was intended to be applied just below the top edge.

FIGURE 10. Standing on the sculpture's top level, Herbert George and Andrzej Dajnowski discuss the resurfaced area depicted in fig. 9.

The earlier reports on the monument's structure identified severe decay and proposed new support systems using steel, concrete, or exotic composite technologies. However, our concern about introducing any system that might react differently from the original structure led to a decision to retain and strengthen as much of the old steel and concrete as possible, which is consistent with preservation principles. Wiss, Janney, Elstner, working collaboratively with Takao Nagai Associates, specialists in concrete restoration, set about reinforcing and replacing sections of the deteriorated concrete beams and piers in the upper level (see figs. 5–6). Together, they designed a system that essentially repaired, reinforced, or recast the original beams using gunnite, or sprayed concrete.

In a few locations, it appeared that the original beams and columns were placed too far apart to carry the load of the roof. To help compensate for this, we developed a series of structures called "whale ribs," since they were formed at the horizontal footing and ran vertically up the walls, bending overhead until they intersected a main longitudinal beam (see fig. 5). Made of gunnite and rebar, they used a separator between the gunnite and the concrete shell so that the new beam would not restrict the sculpture's thermal movements.

While work was progressing on the inside of the sculpture, Dajnowski and his staff of conservators and technicians were addressing the exterior. Their first job was to remove the patchwork of previous repairs, which had been made with a variety of materials, including caulk, cements, and epoxylike resins.[11] This painstaking task was done by hand using scalpels and small hammers and chisels, taking care not to damage original surfaces. At the same time, a number of cleaning techniques were being tested on selected areas in an attempt to find a gentle, effective method that did not affect the paste or adhesion of the aggregate or leave a potentially harmful residue. It was found that a combination of approaches worked best. Steam cleaning washed away much of the atmospheric dirt and grafitti, and two commercial products were employed to remove biological growth and an insoluble black incrustation. The heavy lime deposits had to be chipped away by hand using small chisels.

Next, the critical issue of cracking was addressed. Because there were no expansion and contraction joins in the original sculpture, many vertical cracks had appeared in response to thermal pressures. Dajnowski's staff produced a detailed map of all cracks in order to determine, as far as possible, which were non-moving (in other words, produced by concrete shrinkage and curing) and which were actively responding to seasonal changes in temperature. Six of the latter sort were reconstructed as

moving joins; Jones, Dajnowski, and his conservators devised a repair technique using concrete reinforced with titanium rods and pins (see fig. 7). Titanium was chosen for its strength, its resistance to corrosion, and its status as the only metal with similar expansion properties as concrete. Losses such as faces, limbs, and other elements were replaced based on past photographs of the monument.

The team then focused its attention on the enormous job of resurfacing the sculpture. Although not included in the original conservation proposal, it became evident that the aggregate layer needed to be secured to prevent further loss. In the early planning stages, we had tested various resurfacing, or parging, mixes in hidden areas of the work in order to evaluate their color and adhesion capabilities. Wiss, Janney, Elstner conducted accelerated weathering tests to assess the strengths of different cement mixtures, bonding agents, surface consolidants, and protective coatings, in various combinations. We intentionally chose a soft concrete parging mix so that over time and with thermal changes, the new surface would not spall away, taking the old, underlying one with it; this "sacrificial" approach was borrowed from the field of historic preservation. We were able to reproduce the original color of the stone and paste with the help of historical documents and by looking closely at areas of the

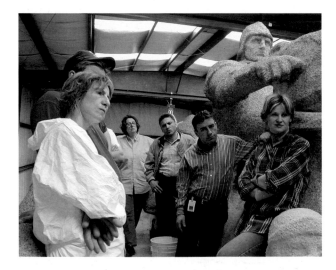

FIGURE 11. Part of the conservation team discusses the resurfacing issue. Members include, from left to right, Rossana Ioppolo, Barbara Hall, Andrzej Dajnowski, Michael Fus, and Beata Ivnska Polek.

sculpture that had been sheltered from the elements (see fig. 8). Appropriate sand was located on site; a substitute for the original Potomac River aggregate, no longer available, was accidentally discovered in a Chicago gift shop, where it was being sold as part of a bonsai kit.

The paste was applied to the surface with a gloved hand, using the high points of the remaining aggregate as a guide. The first tests were disappointing: the faces had an amorphous, "snowman" look that we felt was far from the artist's original intent (see fig. 9). Herbert George, a sculptor and associate professor at the University of Chicago who was a passionate proponent of the restoration, was asked to evaluate the work (see fig. 10). This led to a debate among team members as to what level of restoration was most desirable (see fig. 11). Some of the staff from the Conservation of Sculpture and Objects Studio argued that once we had stabilized the structure, the original surface—which bore the mark of the artist's hand—should be left alone. However, Art Institute staff contended that the sculpture had been cast and recast several times by many people, and was far from Taft's own hand, even when new. In addition, and of critical importance, was that the erosion of paste and loss of aggregate had proceeded to such an extent that, unless new paste was applied, most of the aggregate would disappear over the next few years, taking the remaining surface details with it.

In our discussions, Professor George made the point that certain key elements—the edges on the crest of the wave that carry the movement forward, the sharpness of a soldier's helmet, the details of faces expressing joy or anguish—needed to be redefined if the sculpture were to produce the powerful impression Taft had intended it to. Professor George spent several days working with the conservators to identify these crucial areas and develop a restoration standard; it was then decided that Dajnowski and a few of his skilled staff would work on these key areas to restore the original life and emotion to the work, while the rest of the team would concentrate on the remainder of the sculpture. After the resurfacing was completed, a water repellent was used to seal the surface.

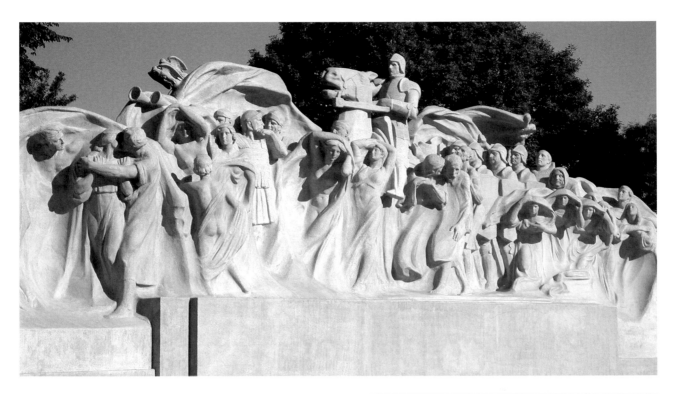

FIGURE 12. With the temporary building removed, the resurfaced, restored *Fountain of Time* was returned to view with a renewed sense of sculptural clarity and movement.

The Future: A Renewed Moment in Time

When the temporary enclosure was removed and we could finally stand back and look at the sculpture, its haunting beauty was again revealed (see figs. 12–13). Dajnowski and his devoted team of workers and conservators are to be praised for the two years of painstaking work they devoted to its restoration, and for the outstanding results they achieved.

What will the future hold for *The Fountain of Time*? Today, the Chicago Park District is restoring the reflecting pool, which will be operational in the spring of 2006. New landscaping and better, more dramatic nighttime illumination is planned as well. The long-term effects of the city's harsh climate and the intrinsic flaws of the monument's concrete construction will make restoration a continuing process, and we wonder if one day it might benefit from being protected by an elegant canopy. We have learned a great deal about the sculpture and hope that our repair methods will extend the life of one of Taft's masterpieces. We know that the figure of Time is watching over our work as well as that of the procession of conservators who will be his companions into the future.

FIGURE 13. The figure of Time, surrounded by a protective fence, awaits the restoration of the reflecting pool.

UNDER A WATCHFUL EYE: THE CONSERVATION OF SOVIET TASS-WINDOW POSTERS

HARRIET K. STRATIS, PAPER CONSERVATOR
PETER ZEGERS, ROTHMAN FAMILY RESEARCH CURATOR

At some point during the late 1940s, well-meaning Art Institute staff carefully collected groups of posters into dozens of neat, brown paper packages, sealed them, and tucked them away for safekeeping with little understanding of their historical significance or the importance of archival storage methods. In the early 1970s, prior to the construction of an enhanced print and drawing study room and art storage area, these same packages were moved en masse several times before finding a permanent home behind a false wall in one of the new facility's storage closets.[1] There they remained until 1994, when a paper conservator and conservation technician decided to find out what was behind that wall. To their surprise, a peek into the bundles and rolls revealed several thousand bold, brightly colored images of aesthetic and historic significance—a major collection of American and European posters from the 1890s to the 1940s.[2] As these objects were unwrapped, unrolled, unfolded, and flattened over the intervening months, this inadvertent time capsule revealed words and images recording some of the major sociopo-litical issues and events of the twentieth century, including the two world wars. While art historians took advantage of an opportunity to look anew at these works from a twenty-first-century perspective, paper conservators tackled the challenging task of opening and flattening the posters in order to determine their condition and the materials with which they were made. Then they assessed the extent of damage and determined an appropriate course of action to conserve them, rehouse them, and assure their preservation for decades to come.

Among this large collection, one group in particular stood out for its forthright images and text, for the extraordinary manner in which it was produced, and for its extremely poor condition. Known as the *TASS-OKHO*, or TASS-Window, posters, these works (see fig. 1) were produced as a daily propaganda effort by the TASS news agency during World War II, known in Russia as the Great Patriotic War (June 22, 1941–May 9, 1945). Publicly displayed from the onset of the German invasion, the posters were meant to boost the morale of Soviet troops

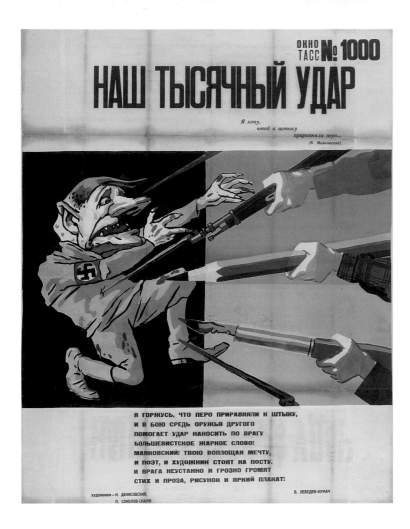

ОКНО ТАСС № 1000

НАШ ТЫСЯЧНЫЙ УДАР

Я хочу,
чтоб к штыку
приравняли перо...
(В. Маяковский)

Я ГОРЖУСЬ, ЧТО ПЕРО ПРИРАВНЯЛИ К ШТЫКУ,
И В БОЮ СРЕДЬ ОРУЖЬЯ ДРУГОГО
ПОМОГАЕТ УДАР НАНОСИТЬ ПО ВРАГУ
БОЛЬШЕВИСТСКОЕ ЖАРКОЕ СЛОВО!
МАЯКОВСКИЙ! ТВОЮ ВОПЛОЩАЯ МЕЧТУ,
И ПОЭТ, И ХУДОЖНИК СТОЯТ НА ПОСТУ.
И ВРАГА НЕУСТАННО И ГРОЗНО ГРОМЯТ
СТИХ И ПРОЗА, РИСУНОК И ЯРКИЙ ПЛАКАТ!

Художники—Н. ДЕНИСОВСКИЙ,
П. СОКОЛОВ-СКАЛЯ

В. ЛЕБЕДЕВ-КУМАЧ

FIGURE 1. N. F. Denisovskii (Russian, dates unknown) and Pavel Petrovich Sokolov-Skalya (Russian, 1899–1961). *Our One Thousandth Blow,* June 5, 1944, no. 1000. Multicolor stencil on paper; 160 x 123 cm (63 x 48 ⅛ in.). The inscription reads: "I'm proud that the pen has been equated with the bayonet. . . . Both poster and artist are at their post. Verse and prose, drawings and bright posters tirelessly and menacingly inveigh against the enemy!"

and citizens, and to function as a psychological weapon against the enemy. They existed, in effect, as an illustrated war diary from the Soviet perspective. By the conflict's end they numbered some 1289 works, and the Art Institute is fortunate to have a representative sampling of 156 posters made between 1942 and 1945.[3]

Correspondence, newspaper clippings, and exhibition records in the museum's archives have enabled us to firmly trace the provenance of the seven earliest posters to the USSR Society for Cultural Relations with Foreign Countries, Moscow, commonly referred to by its Russian acronym, VOKS. The paper trail ends there, and provenance information for the majority of the works remains elusive, although research is ongoing. It can, however, be firmly established that the Art Institute exhibited TASS-Window posters on several occasions during World War II. In a July 1942 letter to Daniel Catton Rich, then director of the museum, Ryessa D. Liberson, head of the American branch of VOKS, alluded to a poster exchange program to benefit "people in our country, especially artists, [who] are eager to learn something about the works of American artists, [and] their part in the fight for civilization and democracy, against the dark forces of Nazism."[4] To be sure, initiatives such as these were common during this period and were meant to further artistic and intellectual dialogue. The fact that the Art Institute was both a museum and a school made it a logical recipient of the Soviet posters; it was most likely placed on a VOKS mailing list and received regular shipments of posters from then on.

It became clear during our 1994 examination that each of the TASS-Window posters arrived at the museum individually folded, wrapped with a band of the same paper used to print it. Some had been removed from their wrapping; several were mounted onto linen backings for display; the majority remained untouched. Why they were not opened and accessioned along with other posters in the collection is puzzling. One possible explanation could be the low stature given to posters by generations of curators and art historians. Another might be the hostile

FIGURE 2. Margaret Bourke-White (American, 1904–1971). *Posters in the Window of Dietetics Shop on Gorky Street*, 1941. Published in Margaret Bourke-White, *Shooting the Russian War* (Simon and Schuster, 1942), p. 175.

After the German invasion of 1941, the editorial board of the TASS news agency, the successor to ROSTA, turned to the technique once again, composing the posters' messages in response to incoming news from various fronts and to directives from the Kremlin and Politburo (see fig. 2). The agency's aim was to promote the Soviet war effort, urging defeat of an ally-turned-enemy now well within the nation's own borders.

In conceiving the posters, designers relied upon two pictorial traditions as they worked to influence the hearts and minds of the Russian people. In one, a socialist-realist aesthetic was used to create exalted, heroic representations that conjured a sense of national pride and patriotism in viewers. In the other, caricatures akin to those in political cartoons provided biting visual satire that readily inflamed anti-German sentiments. Among this second group, it was not uncommon for an image to appear as a political cartoon in the black-and-white pages of the daily newspapers *Pravda* or *Krasniai Svesda*, or the satirical weekly *Krokodil*, before being transformed into a color poster on a much larger scale. In the true spirit of Soviet socialism, a collective of artists, poets, and writers collaborated with the TASS editorial board to arrive at "appropriate" captions, images, and text for each daily poster.

Then a regiment of artisans would translate the images into multiple stencils and, with brushes, paints, and papers in hand, make numerous copies (see fig. 3).[6] The team worked around the clock seven days a week, cutting stencils, mixing a surprising array of colors, and preparing sheets of paper that they would piece and paste together to form the finished products. They used materials that were cheap and easily accessible in wartime. The papers were of the poorest quality: mass-produced with acidic wood pulp and little else, they discolored immediately upon exposure to light and became so dramatically embrittled over time that they could not be folded or unfolded without breaking into pieces. The posters' longevity, however, mattered little to those who produced them—their significance rested solely on their images and text, and on the daily messages they delivered to a war-weary public. Most often the posters were constructed from between four and six sections of stenciled paper that the makers overlapped and adhered to form contiguous

relations that quickly developed between the former allies after the war. In a political climate suspicious of those with Soviet sympathies—a time during which Rich was himself under FBI surveillance for "un-American" activities—to accession the recently acquired Soviet posters may have been an institutional liability rather than a priority.[5] In fact, it was only upon completion of the 2004 conservation campaign that the works became an accessible part of the museum's collection.

The *TASS-OKHO* posters take their name from the post-revolutionary Russian practice of installing posters on or behind the windows (*okha*) of empty storefronts to disseminate the news of the day to a broad audience. A few years later, during the Russian Civil War (1919–22), the Bolshevik government revived this tactic through the central news agency ROSTA (*POCTA*), which issued a series of propaganda posters with the designations *OKHO* and *POCTA* prominently featured at the top.

images. At the top they added strips of paper bearing each poster's title and series number; along the bottom they applied larger sections holding stenciled text (see fig. 4). The names of each artist and author were prominently featured. This assembly process was daunting, given that makers churned out editions of five hundred to fifteen hundred posters each day, working through the night so that by daybreak copies were already mounted on walls and in store windows throughout Moscow and beyond.

Our own close inspection of individual posters revealed several important characteristics of their creation. First, it became evident that large quantities of paint were used daily, mixed in batches by several workers at a time. The paints themselves were of low quality and made with a water rather than oil base, much like present-day poster paints. Ranging from matte to semigloss in appearance, they were most likely thinned down with turpentine, judging from the pronounced smell of that solvent within the folds of the posters. This was likely done to extend the amount of paint needed to produce a given run; it also made the paint spread readily and dry rapidly, allowing workers to stencil numerous posters in rapid succession.

As a result of mixing and diluting multiple vats of paint at a time, colors in one section of a poster often vary to some degree from those in the adjoining sections that overlap it. This too can be said of the images themselves—because they were assembled so quickly, the alignment is often askew. To contemporary viewers, however, these irregularities reveal the individual, handmade character of the works and suggest the backbreaking efforts of their makers. For these artisans, getting the posters out onto the streets was perceived as a matter of life or death, since the works were intended to incite Russians to combat the German war machine at a moment when it was unclear whether or not they would all perish.

Inspired by these tireless efforts, a team of paper conservators, technicians, and student fellows undertook the task of treating the Art Institute's 156 TASS-Window posters in a collective campaign of our own. The works are all extremely large, some as long as nine feet and as wide as four, and all were in extremely fragile condition. They had numerous tears and losses throughout, and any mishandling whatsoever would only have multiplied them. The posters were most severely embrittled along

FIGURE 3. Margaret Bourke-White. *Poster Factory Run by Moscow Artists*, 1941. Published in *Shooting the Russian War*, p. 170. Obviously staged, this photograph features TASS's artist director, Pavel Petrovich Sokolov-Skalya, who gestures with a brush toward the images on the wall. Sokolov-Skalya was an accomplished, well-known realist painter and the author of a considerable number of the TASS-Window posters represented in the Art Institute's collection.

FIGURE 4. Margaret Bourke-White. *Poster Artist with Stencil*, 1941. Published in *Shooting the Russian War*, p. 172.

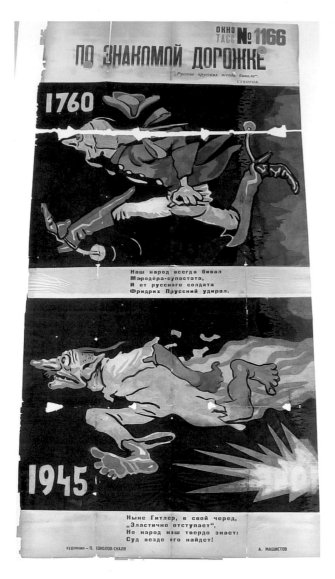

FIGURE 5a–b. Pavel Petrovich Sokolov-Skalya. *Along a Familiar Path*, April 14, 1944, no. 1166. Multicolor stencil on paper; 193 x 99 cm (7 x 39 in.). a): At left, the poster before treatment; b): At right, the work after conservation.

the multiple fold lines, which were also discolored by the adhesive used to join them in the first place and darkened further by exposure to air. From the outset, we decided to leave the discoloration, which has not diminished the works' visual impact in any way, as evidence of their history. Instead, we focused our efforts on stabilizing the paper structure and re-creating missing passages of image and text (see fig. 5).

Starting in the summer of 2004, our team began its conservation campaign by experimenting to see how much manipulation the posters could sustain. We discovered

rather quickly that their large dimensions and inherent weakness dictated that any handling had to be kept to a bare minimum. This meant that we needed to work to stabilize their structure while moving them as little as possible. First, we placed each poster face down on a nonstick fabric and lightly sprayed it with water, which immediately hydrated the paper fibers and made the paper easier to manipulate. Tears were realigned and mended; painted areas that had folded onto themselves were unfolded and put back in place; and the object as a whole was relaxed and slowly smoothed out to remove any pronounced undulations. We then immediately "lined" the poster, backing it with a strong Korean paper that had been made

and colored to our specifications.[7] We adhered this paper to the reverse of the original poster with a mixture of wheat-starch paste and methylcellulose, which provided just the right working properties: the paste spread easily and evenly, its tack creating an ideal bond (see fig. 6). Using a traditional Japanese lining method, we pounded a broad stiff-bristled brush over the entire surface of the lining to further ensure adhesion. Immediately following this, we placed the poster face down in a drying stack, laying it between nonstick fabric and blotting paper, with weights on top; it remained this way for several weeks so that even drying and overall flattening could be achieved.

Once the lining was in place, we could handle the poster with ease and were able to begin the task of image compensation, or in-painting. Each work was set on an easel, and, using a combination of colored pencils, watercolors, and acrylic paint, we re-created missing passages using the same bold palette as the original (see fig. 7). The colored pencils were especially effective, since we could use them, dipped in turpentine and softened, to reproduce the same uneven, semigloss appearance of the original stenciled paint layers. When letters in the text were missing, we would consult published illustrations of a given poster to determine how to accurately restore them. We were able to fill in missing letters by simply tracing adjacent ones and then recreating them by hand. Finally, we developed a long-term storage solution, encapsulating each poster in an individual mylar enclosure that was secured with an ultrasonic welder (see fig. 8). This approach assured that the painted surface of each work would be protected when handled and could be moved easily in the future, in preparation for publication and exhibition.

Today, a year after the conservation team began its efforts to stabilize the works' structure and improve their appearance, this important collection of TASS-Window posters has emerged from obscurity and taken its rightful place as a major visual document of the Nazi invasion of Russia. Now accessible, these holdings are a treasure for artists, historians, and all those interested in understanding the power of the visual image and emblazoned word to influence a population and record for all time the events of a turbulent moment in twentieth-century history.[8]

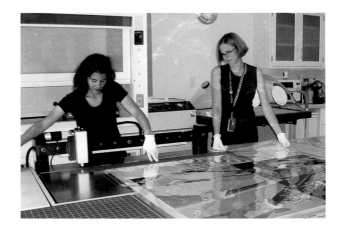

FIGURE 6. After lining, Paper Conservators Harriet Stratis and Kristi Dahm inspect the back of *Victory*, May 12, 1945, nos. 1243–44.

FIGURE 7. Conservation Technician Caesar Citraro in-paints *Victory* (see fig. 6) with an assortment of materials.

FIGURE 8. Conservation Technician Christine Conniff O'Shea and Conservation Fellow Rebecca Pollak encapsulate *Our One Thousandth Blow* (fig. 1) after treatment was complete.

ON TIME: APPROACHES TO THE CONSERVATION OF FILM, VIDEOTAPE, AND DIGITAL MEDIA

SUZANNE R. SCHNEPP, ASSOCIATE CONSERVATOR OF OBJECTS

Objects conservators, trained in handling conventional materials such as metal, stone, and wood, face quite a different set of challenges in dealing with time-based media—works on film, videotape, laserdisc, CD, and DVD. This is a relatively new area of conservation, and there are still many unknowns, especially considering the rapid pace at which technology continues to advance. These media are subject to deterioration just as more traditional ones are; their situation is more complex, however, because they can only be viewed by means of machinery that is itself subject to the vicissitudes of time. In this essay, I will explore briefly the characteristics, possibilities, and limitations of time-based media in its various forms, particularly as they have revealed themselves in some recent projects at the Art Institute of Chicago in which we've collaborated with the artists themselves to ensure the preservation of their works.

Time-based media are distinguished by the way in which the information that they carry has been saved. Analog information is recorded with almost infinite gra-dations; film, for example, records the impression of light waves on extremely tiny light-sensitive particles. Digital information, on the other hand, involves the translation of light into small, discrete packets. While different levels of detail can be achieved, the fineness of digital records has not been able to match that of analog until quite recently. For example, an image captured on film can be enlarged many times and still appear to be composed of smooth gradations of tone; if taken digitally, they will resolve into pixels at the same level of magnification.

Digital information can be saved in "raw" or "com-pressed" forms—the latter sort is created by formulas that remove what is judged (by the compression system being used) to be redundant. This removal is absolute: when the tape is uncompressed for viewing, the information is filled in by the formulas but may differ slightly from the original. Since greater degrees of compression lead to greater information loss, conservators prefer digital infor-mation in a raw or relatively uncompressed state.

FIGURE 1. Bruce Nauman (American, b. 1941). *Art Makeup, Nos. 1–4*, 1967–68. 16 mm color film, silent. Twentieth-Century Purchase Fund, 1974.229a–d. This detail shows the artist beginning to apply a pink layer of makeup over a white one. Note the overall golden tone, first thought to be discoloration.

The Media

Film, an analog medium, is the oldest time-based medium and perhaps the most stable, consisting of light-sensitive materials (and possibly dyes) bound into a gelatin layer or layers and backed by a plastic strip (see fig. 1). While the gelatin is relatively stable, it can expand or contract with changes in humidity and is also vulnerable to attack by bacteria and mold. The plastic backing strips, however, can cause film to self-destruct. Early-twentieth-century film was made on celluloid (cellulose nitrate) stock that readily deteriorates to form nitric acid, which itself accelerates the process of degradation, reducing the film to powder. Celluloid is also flammable and, if stored in poor conditions, can even spontaneously combust. In the 1940s cellulose triacetate was developed, and this much safer, less flammable material is still in use today. However it, too, can deteriorate, especially in conditions of high humidity, and forms acetic acid, which gives the film a distinct vinegary smell. The most stable film stock today is polyester, which is very resistant to chemical attack.

While videotape also has a layered structure and uses a polyester base, this backing is much thinner than film's and more likely to stretch and break. In this medium, information can be either analog or digital and is contained in magnetic metallic oxide particles bound in a polyurethane layer. This layer deteriorates and then flakes off easily; this, combined with dirt deposits, creates tiny, white "dropouts" that give the appearance of snow on the projected image. Videotape, which lasts only about ten years, comes in many different formats with corresponding playback machines, most of which are now obsolete.

The only way to extend an analog tape's life is to copy it, but each attempt substantially degrades the quality of the images. A good analogy is making a photocopy of a photograph and then copying the photocopy: each step away from the original will be of worse quality than the one before. While video analog information can be transformed into digital information, this process is controversial in the field of video preservation, since the original, continuous image can only be sampled at discrete

FIGURE 2a–c. These magnified images of a laserdisc, a CD, and a DVD show the "pits" and "lands"—the tiny gaps and flat intervals—in which digital information is recorded.

intervals, so only portions of the analog signal can be retained. Transferring analog tapes, or, for that matter, film, into a digital format will thus materially change the work.[1]

The laserdisc can be either single- or double-sided and contains its video portion in analog form, although the sound can be recorded either in analog or digital. The range of saturation and luminance is very narrow on a laserdisc, and very intense color or light effects can cause a herringbone pattern to be produced.[2] The information is stored by casting or stamping the plastic disc with miniscule "pits" and flat intervals, or "lands," that receive a metallic coating and are then read by a beam of laser light that is scattered by the pits and reflected off the lands (see fig. 2). Nothing but light touches the disc during playback, so there is no wear; however, the pits are closely spaced and it was difficult to mold them with precision, so flawed discs were often produced. More stable than videotapes, laserdiscs enjoy a lifetime of between ten and one hundred years,[3] depending on their quality of manufacture and conditions of storage; nevertheless, they were superseded in popularity by the CD and DVD and are now considered obsolete.

The structure of CDs and DVDs is not unlike that of laserdiscs. They, too, carry information as a series of pits and lands, although the information is in digital coding (see fig. 2). A CD made of the most durable archival materials may survive for perhaps one hundred years, while most commonly available CDs are made of much less stable materials. Since DVDs can store a much greater quantity of information than CDs by virtue of their double-sided design and closer pit spacing, they are usually the media of choice for works of art involving moving images.[4] While the lifetime of a DVD disc is still in question, its points of weakness seem to be the strength of the adhesive that binds its two sides together and the susceptibility of its metallic layers to corrosion. It is probable, however, that the format itself will become outmoded before the discs deteriorate.

The Machinery

Since artworks in all of these media require machines in order to be experienced, the availability of these playback and viewing devices, and replacement parts for them, are central problems for conservators. For example, the moving image component of the Art Institute's *The Truck* (fig. 3), by George Segal, exists as both a 16 mm master film and many copies of Super 8 film in Magi Cart cartridges, which were designed for small home projectors that are totally unsuitable for continuous public use. Since the demise of the original projector, we are faced with the choice of using a copy of the 16 mm film or transferring the piece to another format altogether. If we moved the work to, say, DVD, we would have to consider, among other things, the curious question of whether we should try to reproduce the characteristic clicking sound of the

little home projector, as that was part of the original experience of the artwork.

A similar, important judgment that we must make is whether the appearance of a player or monitor is an essential part of a piece. Nam June Paik's *Family of Robot: Baby* (fig. 4), for example, consists of a laserdisc played on fifteen five-inch Samsung color televisions set within a metal framework. Clearly the shape and size of these televisions, and, one might argue, their design, are quite important to the work's presentation. These televisions are no longer made, however, so we must maintain them and stockpile parts; in the future, we may even have to replace the picture tubes with monitors of another technology to preserve the illusion that they are in original working order.[5] On the other hand, a piece such as Bruce Nauman's *Good Boy Bad Boy* (fig. 5), in which two simple black monitors display different laserdiscs, might be shown on two similar but not identical monitors without compromising its integrity.

Such issues also are pertinent with respect to pieces produced in the most widely used technology presently available: even DVD will eventually be supplanted by something new. With digital information, however, it will be possible to let the work live in a computer hard drive until we are able to translate it into a new language or ensure that the older one in which it was written can be read by newer systems. Even now there are computer

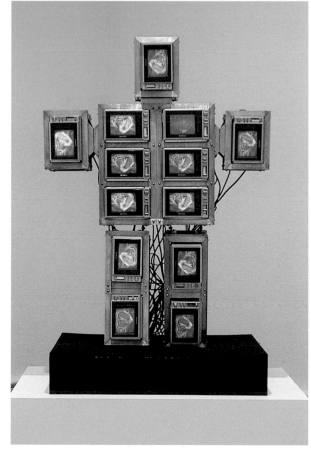

FIGURE 3. George Segal (American, b. 1924). *The Truck*, 1966. Plaster, metal, glass, wood, plastic, and Super 8 mm color film (16 mm master film); 167.6 x 554.8 x 152.4 cm (66 x 220 x 60 in.). Mr. and Mrs. Frank G. Logan Purchase Prize Fund, 1966.336.

FIGURE 4. Nam June Paik (Korean, b. 1932). *Family of Robot: Baby*, 1986. Television monitors, laserdisc player, laserdisc, and metal (from an edition of 9). 96.2 x 133.4 x 20.3 cm (37 7/8 x 52 1/2 x 8 in.). Gift of Society for Contemporary Art, 1992.283.

FIGURE 5. Bruce Nauman. *Good Boy Bad Boy*, 1985. Videotapes/laserdiscs, players, and monitors (edition 29 of 40). Dimensions variable. Gift of Lannan Foundation, 1997.150.

programs that simulate the working of older systems, enabling us to run works written with old programs on new computers.

Treatment Examples

The two examples just mentioned only hint at the unique challenges that each attempt to conserve a work in a time-based medium inevitably produces. One of our recent efforts involved Bruce Nauman's film *Art Makeup, Nos. 1–4* (fig. 1), in which the artist is shown applying four layers of paint to his face and torso. When I began the project, the piece had not been shown within recent memory, chiefly because there was as yet no gallery space dedicated to presenting works on film. While surveying the film and video collection, I examined *Art Makeup* and found that its four segments were actually out of order on the reel and that there was quite a bit of "leader," or blank film, between them. The film's overall yellowish tone was a concern, since it was difficult to tell if this was intentional or whether it represented discoloration. My most critical discovery, though, was the telltale odor of vinegar as I opened the film can, which indicated that it was deteriorating and needed to be reproduced in more stable materials.

The exciting thing about working with contemporary works is that the artists themselves are often available for consultation. In this case, Nauman, although not interested in taking a direct part in the reconstruction, did have a number of suggestions. Initially, he pointed us to several copies of the piece at Electronic Arts Intermix (EAI) in New York, a nonprofit firm devoted to archiving and distributing artists' films. He also recommended that EAI's former director, Stephen Vitiello, act as consultant, since he had extensive experience working with Nauman and *Art Makeup* in particular. We also needed someone to undertake the very sensitive task of physically editing the Art Institute's copy; we chose Bill Brand, an experimental and documentary filmmaker who had done similar work for such institutions as the Museum of Modern Art and the Whitney Museum of American Art, New York.

First, Vitiello went through the EAI's copies of *Art Makeup* to choose the best for comparison with the Art Institute's version; it may well have been necessary for him to select different sections of more than one film in order to obtain the best reproductions possible. Next, I hand carried the museum's copy to Brand's New York studio, where I met with him and Vitiello to do an initial examination (see fig. 6). By carefully inspecting the film, Brand was able to determine that Nauman apparently shot his original version on color reversal film, which is developed in such a way that the camera copy becomes the print used for exhibition, thus leaving no negative for further reproduction. The Art Institute's copy, which appears to be of the same generation as those in the EAI collection, is a print produced from a lost internegative that was itself made from earlier prints that had been spliced together.[6] The leaders had somehow been spliced in a way that misidentified the different segments, and this presumably led to their being assembled in the wrong order. At some point, titles with a 1971 copyright date had

been inserted into the leaders, which were, at 29 to 32 seconds each, too long. Nauman preferred an interval of three seconds between segments, but did like the flickering quality of the scribbled notations on the blank leader. He also wished to have the 1971 date removed, since he actually created the work about four years earlier.

We were happy to learn that the Art Institute's copy was in excellent condition, with no splices, few scratches, and stable color—Brand informed us that the yellow cast was, after all, intentional. However, he still had to reorder the segments, cut down the leaders, and make the other adjustments that Nauman had requested. In order to produce copies of the film once it had been edited, it was necessary to create another internegative that could be used to print exhibition copies. This work was done at Colorlab, a company in Rockville, Maryland, that specializes in high quality processing of film for such institutions as the National Archives. The reproduction was done with what is called "wet-gate" printing, in which the film to be copied is immersed in a liquid that acts to fill in and minimize scratches. Making exhibition prints from a negative can be a somewhat risky step, since it involves running it through machinery that can unexpectedly misbehave; for this reason, we decided to have two internegatives made, one to keep in cold storage as a back-up copy and another from which to make exhibition prints. Each internegative is made with a "check print" that acts as a standard for correct color and is kept with the internegative. Both Brand and Vitiello approved check prints before the exhibition copies were produced. Afterward, we had the work reproduced onto a low-compression videotape so that students and scholars can view it easily. As a last step all of the film, including the bits of leader that had been removed, were wound on archival cores and stored in archival cans. The new version of *Art Makeup* that resulted from this rather complex process has been extremely successful—Bruce Nauman, in fact, requested a copy that will be kept at EAI as the new "best" version. Clearly, though, the scope and complexity of the project required me and my Art Institute colleagues to entrust a number of other professionals with the necessary work—a rather unsettling situation for us conservators, who are used to doing the job ourselves.

FIGURE 6. Bill Brand and Stephen Vitiello in Brand's New York studio. The successful conservation of *Art Makeup, Nos. 1–4* depended upon Brand's sensitive editing and Vitiello's extensive knowledge of Nauman's work.

Another fruitful collaboration with an artist involved *Inasmuch As It Is Always Already Taking Place* (fig. 7), a work by Gary Hill. When the museum acquired it, the piece consisted of sixteen 8 millimeter videocassettes played on sixteen players and displayed on sixteen specially modified monitors ranging from a 1/2 inch video camera viewfinder to a 23 inch diagonal TV picture tube. These tubes are displayed in a horizontal recess in a wall with the snaky wiring to each monitor quite evident. Each screen displays a different body part, and there are only very subtle movements and sounds.

Since videotape has a relatively short life span, our objective from the outset was to transfer the work to another format while sacrificing the least information possible. In this case, the 8 millimeter videocassette is an analog medium, so we at first considered moving the piece to laserdisc, which also accommodates analog. After deciding that laserdisc was, for all practical purposes, obsolete, we explored our other option, DVD, which involves digitization and compression, which we worried might fail to capture the nuances of Hill's work. Ideally, we imagined, we could make one uncompressed digital record for storage purposes and produce another in some very popular format, such as DVD, for exhibition. We then turned to the artist, who, fortunately, was willing to oblige us by making digital reproductions of the work

FIGURE 7. Gary Hill (American, b. 1951). *Inasmuch As It Is Always Already Taking Place*, 1990. 16-channel video and sound installation with 16 modified monitors, received as 8 mm videotape and now also on DVD, recessed into wall (edition 1 of 2); niche: 40.6 x 137.2 x 167.6 cm (16 x 54 x 66 in.). Gift of Lannan Foundation, 1997.144.

from his master copies. Hill himself would have direct control over the aesthetic aspects of the work's translation to a compressed digital medium, and this helped obviate the apprehension that we would otherwise have felt about the change.

Another of our concerns centered on the longevity of the work's original cathode ray tubes, which are still popular but will probably gradually be overtaken by other technologies such as liquid-crystal display (LCD) or plasma screens. We believed it would be prudent to obtain backup tubes while they are still available, a course of action that the artist himself was investigating, since another museum had requested his assistance in obtaining them. He now scavenges the tiny viewfinders he used for the piece from second-hand equipment available on such Web sites as eBay. Some of the cathode ray tubes are readily available, while others can only be obtained by custom order and are quite costly. Unfortunately, just any tube of the same size won't do: they differ in the filament that provides the electron beam that excites the phosphor screen; the focus of the electron beam; the phosphor type used for the screen; and even the type of glass used. The properties of the picture also change as the tubes age, making it likely that when a tube fails in a piece such as Hill's, the new one, even if nominally the same, will no longer match the others: all of the tubes may have to be replaced at the same time.

As we have seen, there are many new considerations that spring from the conservation of time-based works, from issues of information science to the role of artists in helping their creations survive the transition from one format to another. Although we as conservators have honed our knowledge of the technical aspects of these media, in many ways we have had to learn to relinquish control, since our traditional areas of expertise—cleaning, filling, and in-painting—certainly are of little help. But just as artists will continue to use technology in constantly changing ways, so strategies for preservation—and the role of conservators in inventing and implementing those strategies—are certain to remain fluid.

GUIDE TO TECHNICAL TERMS

CROSS SECTION

In this technique, fragments of paint, including all the painting, preparation, and ground layers, are mounted in a transparent resin. The resin block, once hardened, is ground and polished, exposing a cross section that shows all constituent layers in one plane. Cross sections can be observed and documented with a microscope in reflected light and ultraviolet fluorescence; they can also be subjected to analysis with SEM/EDX, FTIR, and Raman instrumentation.

FOURIER TRANSFORM INFRARED SPECTROSCOPY (FTIR)

Extremely versatile, this technique allows researchers to characterize a vast array of materials. Scientists compress a few microscopic particles of sample into a thin film, place it under a microscope, and record a graph, called a spectrum, that shows peaks at the discrete frequencies at which the sample absorbs the incoming infrared radiation. By comparing this spectrum with a reference database, they can identify an unknown material in the same way that a detective matches fingerprints to an individual.

POLARIZED LIGHT MICROSCOPY (PLM)

This powerful preliminary observation technique uses a microscope with two rotating, polarizing filters to characterize the optical properties of particles. A sample powder is mounted on a glass slide, dispersed in a transparent medium, and examined in transmitted light. The microscopist looks at the color, refractive index, shape, and size of each particle and also observes how it interacts with white and ultraviolet light. These observations, when compared to a database of reference materials, allow an experienced analyst to determine the pigments present in a mixture.

RAMAN SPECTROSCOPY

With this technique, scientists can easily identify a wide range of materials nondestructively and in minutes. A sample is excited with visible and invisible laser light, and the majority of the radiation reflects off it, unchanged. However, a small portion of light interacts with the material under study (a phenomenon known as the Raman effect) and is scattered back to the microscope. This scattered radiation is recorded as a function of wavelength and displayed as a spectrum, a graph in which each particular compound has a characteristic fingerprint. When using a microscope, spectra can be recorded from samples as small as 1 micron (one thousandth of a millimeter) across; with a special attachment, analysis can be easily carried out in situ, with the laser beam focused on the surface of the artifact without taking any sample.

SCANNING ELECTRON MICROSCOPY WITH ENERGY DISPERSIVE X-RAY SPECTROMETRY (SEM/EDX)

This technique utilizes electrons, rather than light, to create an image of a sample. It allows analysis of very small quantities of materials, which are normally coated with a thin film of carbon or gold. A small beam of electrons is focused onto the material's surface. When this happens, three phenomena take place: secondary electrons allow scientists to obtain a three-dimensional image at very high magnification and resolution (up to 100,000 x); backscattered electrons highlight the distribution of the elements, recording them in brighter shades of gray according to their atomic weight; and X-ray fluorescence emission allows analysts to determine which elements are present. The EDX spectrum consists of a graph containing a series of peaks, each one occurring at a precise energy characteristic of a particular element. It is important to note that this technique gives information about what atoms are present in a sample but not their relationship; it also does not indicate the organic compounds present. For these reasons, it is best complemented with a molecular fingerprinting technique such as FTIR or Raman spectroscopy.

SAMPLING

Samples are usually limited to a minimal amount (.1 milligram) and normally consist of a few particles of powder sample removed with a scalpel blade or tungsten needle. Accurate documentation is made of each sample's position and condition.

SCIENTIFIC ANALYSIS

While nondestructive techniques of analysis are preferred, instrumental techniques have reached such a high level of sensitivity that they enable scientists to glean an immense amount of information from microscopic samples. In such cases, destructive methods of analysis are tolerated, as the benefits greatly exceed the costs. There are some limitations when analyzing samples from works of art: they might be contaminated by modern conservation materials; contain complex mixtures of very different materials and/or many superposed layers; or be of a very small size, which may produce results unrepresentative of the object as a whole. To overcome such limitations, close visual examination of the object; preliminary testing with nondestructive techniques; and careful, collaborative planning by analysts, conservators, and curators are crucial.

NOTES

CASADIO, HEYE, AND MANCHESTER, *FROM THE MOLECULAR TO THE SPECTACULAR: A STATUE OF OSIRIS THROUGH THE EYES OF A SCIENTIST, A CONSERVATOR, AND A CURATOR,* **PP. 8–15.**

1. For more on this object, see Elizabeth Feery, "Statue of Osiris," *Art Institute of Chicago Museum Studies* 29, 2 (2002), pp. 52–53; see also New York, Christie's, *Antiquities,* sale cat. (June 5, 1998), lot 61, in which it was erroneously identified as a statue of Ptah-Soker-Osiris. According to Lucas Livingston (unpublished report, Sept. 4, 2002, files, Ancient Art collection) the statue is most closely related to Type IV-C of the typology of Ptah-Soker-Osiris figures as classified by Maarten J. Raven, "Papyrus-Sheaths and Ptah-Soker-Osiris Statues," *Oudheidkundige Mededeelingen* 49–50 (1978/79), p. 267. However, the translations of the hieroglyphic inscriptions by Emily Teeter of the Oriental Institute, Chicago (with Mary Greuel, Apr. 23, 2003, files, Ancient Art collection), identify the figure as Osiris.

2. In recent years, several statues identified as depictions of Ptah-Soker-Osiris and dated to the Ptolemaic period have also appeared for sale, including Antiquarium, Ltd., *Ancient Treasures 2,* sale cat. (2005); New York, Sotheby's, *Antiquities,* sale cat. (June 12, 2003), lot 107; New York, Christie's, *Antiquities,* sale cat. (Dec. 5–6, 2001), lot 331; London, Christie's, *Antiquities,* sale. cat. (Nov. 7, 2001), lot 416; and New York, Sotheby's, *Antiquities,* sale cat. (June 12, 2001), lots 215–16.

3. The front reads: "Words said by Osiris, Foremost of the Westerners, the Great God, Lord of Abydos, that he may give offerings to the Hathor, Osiris-ir-des, daughter of Wsim-nechen (?), true of voice." On the back is inscribed: "[A gift that the king gives] to Osiris, Foremost of the Westerners, the Great God, Lord of Abydos, that he may give invocation offerings consisting of bread, beer, and every good and pure thing upon which the god lives, [to] the Hathor, Osiris-ir-des, daughter of Wsim-nechen (?), true of voice." The scribe inadvertently left us his smudged fingerprint at the base of the front inscription, where he must have grasped the figurine while the black paint was still fresh.

4. The consolidant was BEVA, a registered trademark for a thermoplastic, elastomeric polymer mixture. It has been used for relining paintings and as a consolidant for paintings, leather, and textiles. For more on BEVA, consult CAMEO: Conservation and Art Material Encyclopedia Online, http://www.mfa.org/cameo.

5. Although we have not attempted to characterize this adhesive, its dark brown color suggests that it may be an animal glue, commonly employed in antiquity but also often used in the modern era; see Richard Newman and Susana M. Halpine, "The Binding Media of Ancient Egyptian Painting," in *Colour and Paintings in Ancient Egypt,* ed. W. V. Davies (British Museum Press, 2001), p. 22. Because we know that the figure has been separated from its base in the recent past, we cannot eliminate the possibility that this adhesive is of modern date. The linen has not yet been fully characterized.

6. As this new plaster was being removed, we realized that there is no obvious connection of original paint and preparation layer between the feet and the base. It is possible that these pieces were finished separately and then adhered together. The yellow paint on the base does form a slight mound where it would presumably connect with an attached figure. We can only surmise that there is much original material missing.

7. There is a break just above the ram's horns, but the feathers, adhered into place, appear to be made from the same piece of wood as the horns. The wood of the body was identified as *Ficus sycamorus,* with the caveat that the small sample size taken from the tenon makes the species identification somewhat tentative. Dr. Alex Weidenhoeft, Forest Products Laboratory, University of Wisconsin, Madison (Mar. 29, 2005, sample and letter, files, Department of Conservation). For a description of the wood and recorded examples of its use, see Paul T. Nicholson and Ian Shaw, eds., *Ancient Egyptian Materials and Technology* (Cambridge University Press, 2000), pp. 340–41. For more on the ancient Egyptians' use of *Ficus sycamorus* wood, see A. Middleton and S. Humphrey, "Pigments in Some Middle Kingdom Coffins," in Davies (note 5), pp. 10–11; and Euphrosyne Doxiadis, *Portraits du Fayoum: visages de L'Égypte ancienne,* trans. Dennis Collins (Gallimard, 1995), p. 94.

8. A description of common copper woodworking tools such as saws and chisels can be found in Nicholson and Shaw (note 7), pp. 355–56.

9. Although we made attempts at unambiguously identifying the organic binder for the ground layer using FTIR microspectroscopy, these were impaired by the presence of significant amounts of modern conservation materials. The elevated water solubility of the ground layer, however, suggests that the same binder was used both for the ground and paint layers (namely acacia gum).

10. The black pigment has been identified by Raman spectroscopy as carbon black (either charcoal or black soot that would collect under cooking vessels), a common material in the traditional Egyptian workshop. The greenish blue hues were obtained with a mixture of atacamite and paratacamite, two copper chlorides. Evidence of the presence of an organic colorant has also been found in selected areas: the possibility of such material being a copper proteinate or copper carbohydrate pigment or a modern colorant is currently under study; see David Scott et al., "An Ancient Egyptian Cartonnage Broad Collar: Technical Examination of Pigments and Binding Media," *Studies in Conservation* 49 (2004), pp. 177–92.

11. It is important to note that huntite was discovered and characterized as a mineral specimen only in 1953; see George T. Faust, "Huntite, $Mg_3Ca(CO_3)_4$, a New Mineral," *American Mineralogist* 38, 1/2 (1953), pp. 4–23. The first published record of its use as a pigment in ancient Egypt for the decoration of ceramic artifacts is Joseph Riederer, "Recently Identified Egyptian Pigments," *Archaeometry* 16, 1 (1974), pp. 102–109. For more on the history and research surrounding huntite, see Luciano Colombo, *I colori degli antichi* (Florence: Nardini, 1995), pp. 29–66; and A. Lucas, *Ancient Egyptian Materials and Industries* (London: E. Arnold, 1962), p. 349.

12. For more on this, see Ann Heywood, "The Use of Huntite as a White Pigment in Ancient Egypt," in Davies (note 5), p. 7; and Lorna Lee and Stephen Quirke, "Painting Materials," in Nicholson and Shaw (note 7), p. 115. Heywood noted that use of huntite seems to have been restricted to highly colorful decoration schemes, often on small-scale objects, and often alongside the more costly pigments realgar and orpiment, exactly as found on the Art Institute's Osiris.

13. Heywood (note 12), pp. 7–8. In an extension of the Metropolitan Museum survey, huntite was found on two small painted terracotta figures from the Roman period in the Brooklyn Museum. Heywood called for wider study of other collections to help answer the questions this survey raised about huntite's chronological and geographical spread.

14. *Vitruvius: The Ten Books on Architecture,* trans. M. H. Morgan (Harvard University Press, 1926), pp. 218–19.

15. Egyptian blue is a surprising invention for the ingenuity and quality of its production process, in addition to its availability and affordability; its makers were responding to a great demand for this particular color blue, which is not available in great quantity in nature. For more on the history and research surrounding Egyptian blue, see Joseph Riederer, "Egyptian Blue," in *Artists' Pigments: A Handbook of Their History and Characteristics,* vol. 3, ed. Elizabeth West FitzHugh (Washington, D.C.: National Gallery of Art/Oxford University Press, 1997), pp. 23–46.

16. For further information on cinnabar, see Daniel Le Fur, *La Conservation des peintures murales des temples de Karnak,* Éditions Recherches sur les Civilisations (Paris: ADPF, 1994); and Rutherford J. Gettens, Robert Feller, and W. Thomas Chase, "Vermillion and Cinnabar," in *Artists' Pigments: A Handbook of their History and Characteristics,* vol. 2, ed. Ashok Roy (Washington, D.C.: National Gallery of Art/Oxford University Press, 1993), p. 159. Cinnabar has been identified in several Egyptian artifacts dating from the last three centuries B.C. For more on these, see Howell G. M. Edwards, Susana E. Jorge Villar, and Katherine Eremin, "Raman Spectroscopic Analysis of Pigments from Dynastic Egyptian Funerary Artifacts," *Journal of Raman Spectroscopy* 35 (2004), pp. 786–95; Lorna Green, "Recent Analysis of Pigments from Ancient Egyptian Artefacts," in *Conservation in Ancient Egyptian Collections* (London: Archetype, 1995), p. 85; Lee and Quirke (note 12), p. 114; and Scott et al. (note 10), p. 177.

17. There are tantalizing clues to pararealgar's use in the broad collar as well, where it has been employed to outline triangular shapes of reserved ground color. The fading of this color has rendered the contrast with the reserved areas very faint.

18. Orpiment, an arsenic sulfide, was more sparingly used, detected only in the inscription and on the tall plumes.

19. The light-fading of arsenic sulfides is a well-known phenomenon that has been recently clarified in several papers and has also been shown to occur in the dark; see Vincent Daniels and Bridget Leach, "The Occurrence and Alteration of Realgar on Ancient Egyptian Papyri," *Studies in Conservation* 49 (2004), pp. 73–84; D. L. Douglass, Chichang Shing, and Ge Wang, "The Light-Induced Alteration of Realgar to Pararealgar," *American Mineralogist* 77 (1992), pp. 1266–74; and Karen Trentelman, Leon Stodulski, and Mark Pavlosky, "Characterization of Pararealgar and Other Light-Induced Transformation Products from Realgar by Raman Microspectroscopy," *Analytical Chemistry* 68, 10 (1996), pp. 1755–61. In the past, pararealgar has been misidentified in many instances as orpiment due to the fact that the two pigments share a very similar visual appearance and the same characterizing element, (As), when investigated with elemental analytical techniques. Thanks to the advances in analytical instrumentation, in recent years numerous examples of findings of pararealgar in polychrome Egyptian artifacts have been published: see A. Rosalie David et al., "Raman Spectroscopic Analysis of Ancient Egyptian Pigments" *Archaeometry* 45, 4 (2001), pp. 461–73; Edwards et al. (note 16); and Peter Vandenabeele et al., "Spectroscopic Examination of Two Egyptian Masks: A Combined Method Approach," *Analytical Letters* 33, 15 (2000), pp. 3315–32. Pararealgar was also found on a number of papyrus objects; for more on these, see Green (note 16), pp. 88–89; Daniels and Leach (above); and Lucia Burgio and Robin J. Clark, "Comparative Pigment Analysis of Six Modern Egyptian Papiry and an Authentic One of the 13th Century B.C. by Raman Microscopy and Other Techniques," *Journal of Raman Spectroscopy* 31 (2000), pp. 395–401.

20. Modern consolidants have been applied over some areas of the painted surface. Two common modern consolidants—polyvinylacetate (PVA) and polyethylmethacrylate/methylacrylate (B-72)—were detected in various areas.

21. For a description of binding media in Egyptian paintings with a list of scientific findings, see Richard Newman and Susana M. Halpine, "The Binding Media of Ancient Egyptian Painting," in Davies (note 5), pp. 22–32.

22. For more on this, see the proceedings of two international symposia, *The Oxalate Films: Origin and Significance in the Conservation of Works of Art* (Milan: Vega, 1989); and *The Oxalate Films in the Conservation of Works of Art* (Bologna: Editeam, 1996).

KORBEL AND KATZ, *BINDING BEAUTY: CONSERVING A COLLECTION OF JAPANESE PRINTED BOOKS,* PP. 16–23.

1. Records indicate that literacy levels were at 40 to 50 percent for men and about 15 percent for women by the 1860s, which included all samurai and a good number of peasants and merchants. Even if the cost of a book was too high for a large segment of the population, an abundance of public lending libraries existed. See Matthi Forrer, *Eirakuya Tōshirō, Publisher at Nagoya: A Contribution to the History of Publishing in 19th-Century Japan* (Amsterdam: J. C. Gieben, 1985), p. 77. See also R. P. Dore, *Education in Tokugawa Japan* (London: Athalone Press, 1984), pp. 254, 317–22.

2. *Kōzo* is the fiber from the inner bark of the Asiatic tree *Broussonetia papyriferia*, also known as paper mulberry. See Matt T. Roberts and Don Etherington, *Bookbinding and the Conservation of Books: A Dictionary of Descriptive Terminology* (Library of Congress, 1982).

3. Colophons became required in 1722, when they had to contain the date of the publication, the author's real name, and the publisher's information. This was a way for the shogunal authorities to regulate the publishing industry, and some scholars believe it also identified potential enemies of the shogunate. See Forrer (note 1), p. 73.

4. Ibid., p. 68.

5. The art of bookbinding, as well as those of papermaking and printing, evolved in Japan from inventions originating in China. Kojiro Ikegami, *Japanese Bookbinding: Instructions from a Master Craftsman* (New York: Weatherhill, 1998).

6. During the Heian period, more commonly known as Classical Japan, the Japanese imperial court was at its height. The era was also marked by the rise of the samurai and by great cultural evolutions in literature and the arts. For more, see ibid.

7. Although Toda's is the earliest, most complete catalogue of Ryerson's collection, it is in no way a complete account of the museum's illustrated book collection as a whole. See also the related articles by Toda and Helen Gunsaulus in *Bulletin of the Art Institute of Chicago* 21, 4 (Apr. 1927): pp. 52–53; 21, 9 (Dec. 1927): pp. 110–112; 22, 1 (Jan. 1928): pp. 8–9; and 25, 8 (Nov. 1931): p. 109.

8. Lignin is a complex molecular system found in the structure of wood. In the manufacture of wood-pulp paper products, its presence greatly hastens deterioration by producing acids that break down the paper fibers.

9. Methylcellulose is a plant-based emulsion used as a weak adhesive or thickening agent in a variety of applications including poultices. In this case, water is held in suspension long enough to reverse the water-soluble adhesives originally used on the books.

10. The purpose of any enclosure is to protect its contents from mechanical damage and, in varying degrees, to mitigate the effects of dirt, pollution, and light.

11. Several modifications, based solely on a need to shelve the books vertically in a limited amount of space, were made to the conventional *maru chitsu* design. Most notable are the absence of the ridge strip on the front flap of the wraparound case and the repositioning of bone clasps on very thin volumes.

12. Starch pastes are made from rice or wheat grains from which the protein component has been removed, leaving the starch behind. They are used as an adhesive in conservation practice because of their purity, reversibility, and strength.

DAHM, *TARNISHED BY TIME: THE TECHNICAL STUDY AND TREATMENT OF A REDISCOVERED OLD MASTER DRAWING,* PP. 24–29.

1. The dates are estimated from various historical sources. See Astrid Tümpel, "The Life of Pieter Lastman," in *Pieter Lastman: Leermeester van Rembrandt*, ed. Astrid Tümpel and Peter Schatborn (Amsterdam: Rembrandt House, 1991), p. 11.

2. *Judah and Thamar* and *Sophonisba Receiving the Poisoned Cup* are published in F. W. H. Hollstein, *Dutch and Flemish Etchings, Engravings, and Woodcuts, ca. 1450–1700*, vol. 10 (Amsterdam: M. Hertzberger, 1949), p. 35, no. 1 and p. 37, no. 23, respectively. *The Preaching of Saint John the Baptist*, which has been on loan to the Art Institute from the diocese of Springfield, Illinois, since 1998, is reproduced in Kurt Friese, *Pieter Lastman, sein Leben und seine Kunst: Ein Beitrag zur Geschichte der Holländ. Malerei im XVII. Jahrh.* (Leipzig: Klinkhardt and Biermann, 1911), pl. 27.

3. All in-painting was carried out with watercolor. A water-soluble layer of methylcellulose was applied first in order to isolate the paper from the in-painting media and to facilitate their future removal if necessary.

4. For more information on this process, see Margo R. McFarland, "The Whitening Effects of Peroxide Gels on Darkened Lead White Paint," *Book and Paper Group Annual* 16 (1997), pp. 55–66.

5. A watermark is a trademark imparted to paper by wires on the papermaker's screen, or mould. Watermarks, visible only in transmitted light, are often fanciful designs particular to a paper manufacturer.

6. For the earliest known use of this version of the Strasbourg Bend watermark, see Edward Haewood, *Watermarks* (Amsterdam: Paper Publications Society, 1970), p. 67. For examples of this watermark found in prints by Rembrandt and his followers, see Nancy Ash and Shelley Fletcher, *Watermarks in Rembrandt's Prints* (Washington, D.C.: National Gallery of Art, 1998), pp. 181–87.

7. Titian's monumental woodcut is better known than Andreani's copy, but the orientation and size of the drawing indicate it was Andreani's version and not Titian's that was the model for the Art Institute's work. For an illustration of *Pharaoh's Army Drowned in the Red Sea*, see David Rosand and Michelangelo Muraro, *Titian and the Venetian Woodcut*, exh. cat. (Washington, D.C.: International Exhibitions Foundation, 1976), p. 70.

8. This connection was kindly suggested by Peter Black of the Hunterian Museum and Art Gallery, University of Glasgow. The Rubens drawing is undated but presumably would have been executed between 1600 and 1608, when the artist was in Italy. The Louvre catalogue suggests that the original design source could have been a fresco by Giulio Romano or, more generally, the School of Raphael. See Fritz Lugt, *Musée du Louvre: Inventaire général des dessins des écoles du Nord* (Musées nationaux, 1949), vol. 2, p. 22, cat. 1038.

9. For more on Lastman's collecting, see Tümpel (note 1), p. 12, n. 39.

ZUCCARI, VÉLIZ, AND FIEDLER, SAINT JOHN IN THE WILDERNESS: *OBSERVATIONS ON TECHNIQUE, STYLE, AND AUTHORSHIP,* PP. 30–45.

The authors would like to thank the following colleagues for their generous efforts to provide access to paintings and research materials: Bruno Mottin, Centre de recherche et de restauration des musées de France; Stephen Bonadies, Cincinnati Art Museum; Claire Barry, Kimbell Art Museum, Fort Worth; Rafael Romero Asenjo and Adelina Illán Gutiérrez, Madrid; Charlotte Hale, Metropolitan Museum of Art, New York; Carmen Garrido, Museo del Prado; Rhona MacBeth, Jean Woodward, and Irene Konefael, Museum of Fine Arts, Boston; Steven Kornhauser, Wadsworth Atheneum, Hartford; Jo Hedley, Wallace Collection, London; Rita Albertson and Philip Klausemeyer, Worcester Art Museum; and Patricia Garland, Yale University Art Museum. Special thanks go to Richard Newman of the Museum of Fine Arts, Boston, for ongoing assistance, which included analyzing samples from *Saint John in the Wilderness*. We gratefully acknowledge Gridley McKim-Smith's inspirational work on Velázquez and her enthusiastic interest in this project.

We are also greatly indebted to Rachel Billinge, David Bomford, Ashok Roy, and Martin Wyld at the National Gallery, London, for providing advice; access to paintings and research files; copies of X-rays and technical photographs; analysis of samples; and for producing the X-ray of Alonso Cano's *The Vision of Saint John the Evangelist*.

At the Art Institute of Chicago, we wish to especially acknowledge John Gedo for his invaluable bibliographic research and Lorna A. Filippini for her extraordinary, painstaking analysis of the canvas of *Saint John in the Wilderness*. We also wish to thank Martha Wolff and Larry Feinberg for their support and comments on the manuscript and Bonnie Rimer for her infrared imaging work.

1. The provenance of *Saint John* can be securely established to R. P. Nichols, who owned it until at least 1865; see A. Lavice, *Revue des musées D'Angleterre* (Paris: Renouard, 1867), p. 245. It appeared in *Art Treasures of the United Kingdom* (1857) and the *British Institute Exhibition* (1860) as cat. 58, "School of Murillo"; see Algernon Graves, *A Century of Loan Exhibitions, 1813–1912* (1913; repr., New York: Burt Franklin), vol. 2, p. 843. Two versions exist of the catalogue of the former exhibition. The first, printed with "[PROVISIONAL]" after the title, is dated May 5, 1857; in this, *Saint John* is cat. 1080, attributed to Velázquez, "From the Standish Collection," and lent by R. P. Nichols. In the definitive version, published after May 20, 1857, it appears as cat. 795, with the same information. Exhibition organizer George Scharf made an annotated copy of this catalogue, now in the Heinz Archive, National Portrait Gallery, London, along with his manuscript notebooks. In this, he recorded cat. 795 as being "5' 6 ¹/₂" x 4' 9 ¹/₂." In an earlier notebook, he entered different measurements, "6' 10" x 6' 1," which exceed the former by precisely 15 ¹/₂" in each dimension. It is possible that this difference, divided in half, might be the width of a frame molding, and that the measurements in Scharf's catalogue represent the frame's view size.

Before Nichols, *Saint John* is thought to have been owned by Julian Williams; see *Guía de forasteros de la ciudad de Sevilla* (Seville, 1832), pp. 84–85, which lists a painting in Williams's Seville home as "Velasquez, San Juan en el desierto." While Frank Hall Standish acquired the work from Williams after 1832, its identification as "from the Standish Collection" in *Art Treasures of the United Kingdom* is confusing, since Standish's only painting of corresponding subject and dimensions is listed in 1842 as by Juan de Castillo. Standish bequeathed his collection to Louis Philippe of France in 1842; see *Catalogue des tableaux, dessins et gravures de la Collection Standish* (Paris: Crapelet, 1842), in which *Saint John* is probably cat. 95, attributed to Juan de Castillo. See also Christie's, London, *Catalogue of the Pictures forming the Celebrated Standish Collection*, sale cat. (May 27–28, 1853), lot 152, as "Saint Jean dans le desert, by Juan de Castillo"; and Richard Ford, "Sale of the Standish Spanish and Other Pictures," *Athenaeum* 1336 (June 4, 1853), pp. 680–811, cat. 93, as "(School of) Murillo." Most scholars have identified the Art Institute painting as cat. 93, the dimensions of which do not match *Saint John*.

After the 1860 exhibition, the work re-emerged in the possession of Hugh Blaker, who perhaps acquired it at a Christie's sale of Dec. 22, 1919; lot 161, measuring 67 x 60 in. and consigned by the estate of Mr. R. Fleming, is listed as "Velasquez, Saint John." According to W. R. Valentiner, Agnew's purchased it in 1922; see Valentiner to Robert B. Harshe, Jan. 11, 1923, and Aug. 1, 1923, files, Department of Medieval through Modern Painting and Modern European Sculpture. Agnew's sold the painting to Charles Deering, whose daughter Barbara Deering Danielson gave it to the Art Institute.

2. August L. Mayer, "Two Unknown Early Works by Velázquez," *Burlington Magazine* 40, 226 (Jan. 1922), pp. 3–9. For an illustration of *The Virgin of the Immaculate Conception* (1618/19) see Michael Clarke, ed., *Velázquez in Seville*, exh. cat. (National Galleries of Scotland, 1996), pp. 156–57, cat. no. 33.

3. August L. Mayer to Hugh Blaker, Sept. 9, 1921, files, Department of Conservation.

4. It seems probable that Williams sold the painting to Standish with the understanding that it was an autograph work by Velázquez. For a general reference to early works by Velázquez in the Williams collection, see Sir Edmund Head, "Noticia de los quadros que se hallan colocados en la Galeria de Rey N. S.," *Foreign Quarterly Review* 13 (Feb./May, 1834), pp. 237–71. This attribution was subsequently changed, first in the 1842 catalogue of Standish's pictures (see *Catalogue des Tableaux*, note 1) and again in a review of *The Art Treasures of Britain*; see W. Burger, *Trésors d'art esposés `a Manchester en 1857* (Paris: Renouard, 1857), p. 119. Ford (note 1) supported the Velázquez attribution, however, as did Sir William Stirling-Maxwell in *Annals of the Artists of Spain* (London: John C. Nimmo, 1891), p. 818. Other advocates include August L. Mayer, *Velázquez: A Catalogue Raisonné of the Pictures and Drawings* (Faber and Faber, 1936), p. 9; Enrique Lafuente Ferrari, *Velázquez: Complete Edition* (Phaidon/Oxford University Press, 1943), p. 18; Martin S. Soria, "Velázquez and Tristán," in *Varia Velazqueña: Homenaje a Velázquez en el III centenario de su muerte, 1660–1960*, ed. Antonio Gallego y Burin (Madrid: Ministerio de Educacion Nacional, 1960), vol. 1, pp. 456–62; José Gudiol, *Velázquez, 1599–1660* (Barcelona: Ediciones Poligrafa, 1972), pp. 28, 62–63, 325; and idem, *The Complete Paintings of Velázquez* (New York: Greenwich House, 1983), pp. 62–63, 73, 325.

5. Other scholars, while admiring the painting's beauty and unquestionable quality, have either doubted its attribution to Velázquez or rejected it outright. See, for example, Elizabeth Du Gué Trapier, *Velázquez* (New York: Hispanic Society of America, 1948), pp. 126–35; Bernardino de Pantorba, *La vida y la obra de Velázquez: Estudio biografico y critico* (Madrid: Compañía Bibliográfica Española,

1955), pp. 214–15; and Harold Wethey, "Velazquez and Alonso Cano," in Gallego y Burin, ed. (note 4), pp. 452–55. Wethey noted that "some scholars no longer regard this figure as a work by the Sevillian painter himself, even though the high quality of the painting is worthy of as great a master as he," and went on to compare it to to a work by Alonso Cano, indicating that "Cano's authentically signed picture of the same subject is admittedly weaker than the Chicago canvas." See also José López Rey and Angelica Mayer, *Velázquez: A Catalogue Raisonné of His Oeuvre* (Faber and Faber, 1963), pp. 134–35, esp. p. 105, pl. 157; José Camón Aznar, *Velázquez* (Madrid: Espasa-Calpe, 1964), vol. 1, pp. 82–83, 246; vol. 2, p. 1003; Eric Young, "Two Spanish Baroque Pictures," *Art Institute of Chicago Museum Studies* 8 (1976), pp. 73–86; and Gridley McKim-Smith, "La técnica sevillana de Velázquez," in Alfredo J. Morales et al., *Velázquez y Sevilla*, exh. cat. (Seville: Junta de Andalucia, 1999), vol. 2, pp. 109–23.

6. Mary Kuzniar, Depatment of Medieval through Modern European Painting and Modern European Sculpture, memo regarding change in attribution, Dec. 7, 1990.

7. These studies include Gridley McKim-Smith, Greta Andersen-Bergdoll, and Richard Newman, *Examining Velázquez* (Yale University Press, 1988); Carmen Garrido Pérez, *Velázquez: técnica y evolución* (Museo del Prado, 1992); Gridley McKim-Smith and Richard Newman, *Velázquez en el Prado: ciencia e historia del arte* (Museo del Prado, 1993); and Zahira Véliz, "Velázquez's Early Technique," in Clarke (note 2), pp. 79–84.

8. For more on the possibilities and limitations of technical art history, particularly in the case of the Rembrandt Research Project, see Ernst van de Wetering, "Rembrandt's Manner: Technique in the Service of Illusion" and "The Invisible Rembrandt: The Results of Technical and Scientific Research," both in Christopher Brown, Jan Kelch, and Pieter van Thiel, *Rembrandt: The Master and His Workshop; Paintings*, exh. cat. (Yale University Press/National Gallery Publications, 1991), pp. 12–39 and 90–105, respectively.

9. The painting has a somber tonality that suggests that it may have undergone changes in overall color harmony and tonal balance. The sky is gray (in part because of the unstable blue pigment, smalt; see note 27); the landscape is dark; and the foliage is mostly brown with only traces of green. Details of the landscape, which at first appears poorly defined, emerge only when the painting is viewed in strong light. These changes have had an impact on the overall appearance of the work, shrouding the landscape and all of its nuances in darkness; creating a heightened contrast between the figure and its surroundings; and closing off the visual space. Nevertheless, apart from these general changes the painting is in a good state and has neither suffered major paint losses nor been significantly over-cleaned.

10. We inspected Pacheco's *Christ Attended by Angels* (1616; Musée Goya, Castres). In addition to those mentioned in this article, the Cano paintings include *Saint John the Evangelist* and *Saint John the Apostle* (both 1635/37; Musée du Louvre, Paris); *Christ Bearing the Cross* (1635/37; Worcester Art Museum); *The Immaculate Conception* (1620/21; private collection, Paris); and *Vision of the Crucified Christ to Saint Theresa* and *Vision of the Resurrected Christ to Saint Theresa* (1629; Colección Forum Filatélico, Madrid).

11. For more on this, see Francisco Pacheco, *Arte de la Pintura* (1649; repr., Madrid: Catedra, 1990); Zahira Véliz, "Francisco Pacheco's Comments on Painting in Oil," *Studies in Conservation* 27 (1982), pp. 49–57; and idem, ed. and trans., *Artists' Techniques in Golden Age Spain: Six Treatises in Translation* (Cambridge University Press, 1986), pp. 31–106.

12. For more on the *bodegones*, see David Davies, "Velázquez's Bodegones," in Clarke (note 2), pp. 51–65. *The Waterseller of Seville* is illustrated in ibid., p. 152, cat. no. 31.

13. For illustrations of these two paintings, see ibid., pp. 132, 134, cats. 21–22.

14. *Luis de Góngora y Argote* is reproduced in Morales et al. (note 5), vol. 1, p. 214, cat. 100.

15. See McKim-Smith, Andersen-Bergdoll, and Newman (note 7), pp. 8–10; Garrido Pérez (note 7); and McKim-Smith and Newman (note 7).

16. Garrido Pérez (note 7), pp. 53–63; McKim-Smith and Newman (note 7), pp. 113–15.

17. Three of the works are *The Adoration of the Magi*, *Mother Jerónima de la Fuente* (1620; Museo del Prado), and *Saint Ildefonso Receiving the Chasuble from the Virgin* (1622/23; Ayuntamiento de Sevilla). For more, see Garrido Pérez (note 7).

18. See Charlotte Hale, "Dating Velázquez's *The Supper at Emmaus*," *Metropolitan Museum Journal* 40 (2005), forthcoming.

19. Véliz (note 7).

20. However, even when the generally more coarsely woven plain-weave canvases were used, it seems evident that Velázquez, in agreement with the recommendations of Pacheco, applied the ground in a way that would cover the natural texture of the canvas to provide a smooth, even surface suited to painting with the precision of his early style. See Richard Newman, "Observaciones acerca de los materiales pictóricos de Velázquez," in McKim-Smith and Newman (note 7), pp. 111–44.

21. Because the verso is obscured by the lining, Filippini examined an X-ray of the painting to produce a thread-by-thread diagram of the canvas weave. Based on her survey of the X-ray of *The Supper at Emmaus*, its fabric support appears to be of the same family of weaves yet does not match that of the Chicago canvas.

Filippini's full report is on file in the Department of Conservation.

22. See Adelina Illán Gutiérrez and Rafael Romero Asenjo, "Características de las preparaciones sevillanas en pintura de caballete entre 1600 y 1700: Implicaciones en el campo de la restauración y de la historia del arte," in *Proceedings of Congreso de IIC (Grupo Español)* (2005), forthcoming; McKim-Smith, Andersen-Bergdoll, and Newman (note 7); Garrido Pérez (note 7); McKim-Smith and Newman (note 7); and Véliz (note 7). For a detailed analysis of the grounds from several works of this period, see Newman (note 20) and Illán Gutiérrez and Romero Asenjo (note 22).

23. Similar grounds have been found in all of the Seville paintings. Analysis of the ground from *Saint John the Evangelist on Patmos* shows it to consist mainly of calcium carbonate, silica, and some natural iron oxide pigment with very little lead white; some iron pyrite was also confirmed by EDS analysis; see Ashok Roy, personal communication, Apr. 10, 2001, files, Department of Conservation. Recent analysis by SEM/EDS of the ground from an earlier sample of *Kitchen Scene with Christ in the House of Martha and Mary* showed it to be a mixture of silica, calcium carbonate, and some iron oxide pigment; dolomite was also present; see Ashok Roy, personal communication, May 23, 2005, files, Department of Conservation. For more on *Luis de Góngora y Argote* and *The Kitchen Scene,* see Gridley McKim-Smith, Inge Fiedler, Rhona MacBeth, Richard Newman, and Frank Zuccari, "Velázquez: Painting From Life," *Metropolitan Museum Journal* 40 (2005), forthcoming. A similar brown ground has been identified in *The Supper at Emmaus*; Charlotte Hale, personal communication, May 9, 2005.

24. Richard Newman's SEM/EDS analysis of two ground samples indicated that the ground is composed of a heterogeneous mixture that includes large amounts of silica and calcium carbonate along with some clays and iron oxides, charcoal black, and a small amount of lead white. Small clusters of iron sulfide (pyrite) and a trace of zircon have also been found. See Richard Newman, personal communication, May 2, 2005, files, Department of Conservation. See also Véliz (note 11).

25. For more on *barro de Sevilla* and its unique chemical makeup, see an unpublished paper by Rafael Romero Asenjo, "Aproximaciones a la técnica pictórica de Pedro de Camprobín y Passano: La Escuela Sevillana del Siglo XVII," 1999.

26. Analysis by SEM/EDS of the ground from *The Vision of Saint John the Evangelist* showed it to be a single brown layer containing a high amount of silica, calcium carbonate, and iron oxide pigment, plus small quantities of aluminum-magnesium-silicates and lead white. Although the elements detected are similar to those identified in Velázquez's brown grounds, there appears to be a higher percentage of iron oxide present in the painting by Cano, suggesting a different composition. The ground from Cano's *Saint John in the Desert* (1645/50) is completely different and consists mainly of lead white with some charcoal black and red lead. More detailed analysis of the ground samples from these and other related works is being conducted.

27. For more on Velázquez's use of pigments, see McKim-Smith, Andersen-Bergdoll, and Newman (note 7); Garrido Pérez (note 7); McKim-Smith and Newman (note 7); and Carmen Garrido, "Genius at Work: Velázquez's Materials and Technique," in Jonathan Brown and Carmen Garrido, *Velázquez: The Technique of Genius* (Yale University Press, 1998), p. 17. For more on smalt and its propensity for discoloration, see Bruno Mühlethaler and Jean Thissen, "Smalt," in *Artists' Pigments: A Handbook of Their History and Characteristics*, vol. 2, ed. Ashok Roy (Washington, D.C.: National Gallery of Art, 1993), pp. 113–30; Joyce Plesters, "A Preliminary Note on the Incidence of Discoloration of Smalt in Oil Media," *Studies in Conservation* 14 (1969), pp. 62–74; and Rudolf Giovanoli and Bruno Mühlethaler, "Investigation of Discolored Smalt," *Studies in Conservation* 15 (1970), pp. 37–44.

28. Polarized light microscopy was used to identify microscopic-size pigment mixtures taken from approximately sixty areas of the painting that are representative of the various colors used in the work. In some cases, electron microprobe and SEM/EDS analysis was used to confirm the microscopic identification.

29. For an illustration of *Las Meninas*, see Brown and Garrido (note 27), p. 181, fig. 28a–o.

30. Garrido (note 27).

31. Frank Zuccari, "Radiography Applied to the Study of a Portrait of Philip IV in the Museum of Fine Arts, Boston," in *Application of Science in Examination of Works of Art: Proceedings of Seminar, September 7–9, 1983*, ed. Pamela A. England and Lambertus van Zelst (Boston: Museum of Fine Arts, 1985), pp. 251–61.

32. For more on the characterization of these graphic lines, see Véliz (note 7). For excellent comparative illustrations of X-radiographs, see McKim-Smith, Andersen-Bergdoll, and Newman (note 7); Garrido Pérez (note 7); and McKim-Smith and Newman (note 7).

33. Though the practice is mostly associated with Velázquez, one other painter in Spain, El Greco, is known to have used the unpainted edges of his canvases to wipe his brushes. Sixteenth-century Spanish paintings were often executed on prepared panels larger than the dimensions of the image, and artists used the margins to wipe brushes because they knew these areas would never be seen when the painting was installed in an altarpiece, which would mask all but the painted image.

34. See, for example, his *Portrait of El don Bufón Diego de Acedo, El Primo* (1644; Museo del Prado).

35. Cano's use of graphic lines has been documented principally in works from the 1630s; these appear to be less opaque than those in *Saint John in the Wilderness*. We are grateful to the Museo de Bellas Artes, Seville, and specifically to Maria del Valme Muñoz Rubio and Fuensanta de la Paz, for informing us that "graphic lines" are visible in the radiographic image of Cano's *Saint Francis Borgia*. They were unable to provide a radiographic image for comparison with other X-rays of Cano's works.

36. Complicating this, however, is that these passages of paint are not dissimilar from the treatment of foliage in Alonso Cano's *Via Dolorosa* (c. 1636; Worcester Art Museum); for an illustration of this work, see *Alonso Cano: La modernidad del siglo de oro español,* exh. cat. (Madrid: Fundación Santander Central Hispano, 2002), p. 44.

37. Influences on such representations range from Northern prints to paintings and prints by Jusepe de Ribera and even contemporary Spanish works such as the *Saint John the Baptist in the Desert* by the court painter Bartolomé González (1621; Museum of Fine Arts, Budapest), which clearly references Caravaggio's treatment of Saint John the Baptist. For an illustration of González's painting, see *Obras maestras del arte español: Museo de Bellas Artes de Budapest*, exh. cat. (Madrid: Banco Bilbao Vizcaya, 1996), cat. 16.

38. For more on this, see McKim-Smith (note 5), pp. 109–23. This article includes an intriguing discourse on lines, social limits, and authority in Sevillian culture.

39. Examples of this borrowing include Pacheco's drawing *Saint John on Patmos* (1632; British Museum, London), a very close variant of Velázquez's *Saint John the Evangelist on Patmos* that employs what is essentially the mirror image of the painted figure; for an illustration of this work, see Clarke (note 2), pp. 160–61, fig. 35.

40. For an illustration of this painting, see Morales et al. (note 5), vol. 1, pp. 64–65, fig. 25.

41. His name has been mentioned in past discussions about the painting, especially in comparison with the Cincinnati *Saint John*; see, for instance, Wethey (note 5).

42. For more on these connections, consult Angel Aterido Fernández, ed., *Corpus Velazqueño: Documentos y textos* (Madrid: Ministerio de Educación, Cultura y Deporte, Dirección de Bellas Artes, 2000); and idem, ed., *Corpus Alonso Cano: Documentos y textos* (Madrid: Ministerio de Educación, Cultura y Deporte, Dirección de Bellas Artes, 2002).

43. Indeed, there are but a dozen or so secure works by Velázquez dated to between 1620 and 1630, and only two or three by Cano, providing all too limited a basis of comparison.

44. See Alfonso Pérez Sánchez, "La pintura de Alonso Cano," in *Figuras e imagines del barroco: estudios sobre el barroco español y sobre la obra de Alonso Cano*, Colección Debates sobre arte 9 (Madrid: Fundación Argentaria/Visor, 1999), pp. 213–36, esp. 216–18. *The Immaculate Conception* is reproduced on p. 217 .

45. Quoted in Francisco Calvo Serraller, *Teoría de la pintura del siglo de oro* (Madrid: Cátedra, 1981), p. 477.

46. Cano also displayed his knowledge of perspectival depth in his drawing *Saint Matthew and the Angel* (c. 1620; Apelles Collection, London). For an illustration of this work, see José Miguel Medrano, *Alonso Cano: Dibujos*, exh. cat. (Museo del Prado, 2001), p. 153, fig. 41.

47. For more on this work, see Manuel Gómez-Moreno Martínez, "Alonso Cano, escultor," *Archivo español de arte y arqueología* 2 (1926), pp. 177–214; and Enrique Valdivieso and Juan Miguel Serrera, *Pintura sevillana del primer tercio del siglo XVII* (Madrid: Instituto Diego Velázquez, Consejo Superior de Investigaciones Científicas, 1985), pp. 323–24.

48. Like the Chicago painting, this work also relates compositionally to a sculpture by Cano, *Youthful Saint John the Baptist* (c. 1630?; Granada Cathedral, on loan to the Fundación Rodríguez Acosta, Granada). For an illustration of this work, see Zahira Véliz, "Quotation in the Drawing Practice of Alonso Cano," *Master Drawings* 37, 4 (Winter 1999), p. 379, fig. 11. The Cincinnati painting may also have been inspired by an etching of the same subject by Simone Cantarini (1640s?; Biblioteca Nacional, Madrid), illustrated in ibid., p. 378, fig. 8.

49. Although observed in many of Velázquez's works, some marks of this kind are evident in the right background of *The Immaculate Conception* (private collection, Paris), attributed to Cano by Alfonso Pérez Sánchez (see note 44). In light of cur-

rent research, we believe that attribution remains an open question.

50. *De Herrera a Velázquez: La pintura sevillana en la encrucijada de 1600* will be shown at Fundacion Focus-Abengoa, Seville, and the Museo de Bellas Artes, Bilbao, beginning in Nov. 2005.

51. For a discussion of artistic practice in Seville in the first quarter of the seventeenth century, see Peter Cherry, "Artistic Training and the Painters' Guild in Seville," in Clarke (note 2), pp. 67–75; and Zahira Véliz, "Becoming an Artist in Seventeenth-Century Spain," in *The Cambridge Companion to Velázquez*, ed. Suzanne Stratton-Pruitt (Cambridge University Press, 2002), pp. 11–29.

WRUBEL, CONSERVATION/REVELATION: HENRI DE TOULOUSE-LAUTREC'S BALLET DANCERS FINDS RENEWED HARMONY, PP. 46–49, 52–53.

The author would like to thank Mary Weaver Chapin for sharing her art-historical knowledge of Toulouse-Lautrec's work and acknowledge the valuable assistance of her colleagues Francesca Casadio, Douglas Druick, Inge Fiedler, Gloria Groom, Jennifer Paoletti, and Frank Zuccari.

1. For more on the genesis of the murals, see Gale B. Murray, *Toulouse-Lautrec: The Formative Years, 1878–1892* (Clarendon Press, 1991), p. 96.
2. For illustrations of the other four works in the series, see M. J. Dortu, *Toulouse-Lautrec et son oeuvre* (New York: Collector's Editions, 1971), vol. 1, pl. 239–42.
3. The works are referred to as wall murals in Gustave Coquiot, *H. de Toulouse-Lautrec* (Paris: A. Blaisot, 1913), pp. 60–61. They are described as having been removed from the inn in Théodore Duret, *Lautrec par Théodore Duret* (Paris: Bernheim-Jeune, 1920), pp. 119–20.
4. The thick varnish layer was analyzed with FTIR microspectroscopy, with the aid of a diamond cell accessory, and was identified as dammar (a natural resin) diluted with Venice turpentine.
5. This was a Magna Color, manufactured by Bocour Artist Colors.
6. These were Gamblin Restoration Colors, manufactured by Gamblin Artists Colors.

CASADIO, SCIENTIFIC ANALYSIS OF MATERIALS, PP. 50–51.

The author would like to thank the Barker Welfare Foundation for a grant in support of the purchase of the FTIR microspectrophotometer and the Andrew W. Mellon Foundation for its generous support of conservation science research at the Art Institute of Chicago. The precious assistance of Inge Fiedler for the preparation, documentation, and SEM/EDX analysis of the cross sections, as well as for PLM analysis of loose paint samples, is gratefully acknowledged.

1. The composition of these paints was uniform in all samples taken and consisted of lead white (sometimes containing impurities of cerussite) and barite, bound in oil; it was particularly rich in transparent grains of quartz and other silicates in the uppermost layer.
2. This layer measures as little as 30 microns in some areas and as much as 350 microns in others; 1 micron is 1/1000 of a millimeter.
3. *Waitress* was painted with cadmium yellow, Naples yellow, and chrome yellow; *A Sunday on La Grande Jatte–1884* contains zinc yellow, cadmium yellow, and chrome yellow. All the other paintings examined contain a maximum of two of the new yellows and often still show widespread use of yellow ocher; see Roy S. Berns, "Rejuvenating Seurat's Palette using Color and Imaging Science: A Simulation," in Robert L. Herbert, *Seurat and the Making of "La Grande Jatte,"* exh. cat. (Art Institute of Chicago/University of California Press, 2004), pp. 214–29; and Anthea Callen, *The Art of Impressionism: Painting Technique and the Making of Modernity* (Yale University Press, 2000), p. 147.
4. Chrome yellow (lead chromate) is a brilliant yellow which could be produced in hues varying from lemon to orange, with lighter shades usually containing lead sulfate. The first description of this pigment dates back to 1809, but it was not introduced onto the market before 1818. The chrome yellows were well known for their predisposition to darken, and one sees a trend in their substitution with more stable yellows staring in the late 1870s. For more on the pigments discussed here, see Rutherford J. Gettens and George L. Stout, *Painting Materials: A Short Encyclopedia* (Dover, 1966).
5. Zinc yellow (a zinc potassium chromate), was first commercially available in 1847 but was never hugely popular due to its inherent instability. Used by Seurat on his monumental *A Sunday on La Grande Jatte–1884*, it has darkened considerably to a dull yellow-ocher tone; see Berns (note 3).
6. Cadmium yellow (cadmium sulfide) possesses a brilliance comparable to that of the chrome yellows but is more stable. Introduced in 1817, it was quite rare and not commercially available before the 1840s; in 1883 cadmium yellows cost ten times as much as the chrome and Naples yellows, and by 1896 they were still nearly four times as expensive; see Callen (note 3).
7. Sold as "chrome greens" or "cinnabar greens," these products of industrial manu-

facture were ground into such fine particles that the individual grains of Prussian blue and chrome yellow are virtually undistinguishable under the optical microscope; only instrumental techniques of molecular or elemental analysis can separate the components of the mixture. See David Bomford et al., *Art in the Making: Impressionism* (London: National Gallery/Yale University Press, 1990), p. 63.
8. He chose the brilliant, popular pigment emerald green (copper acetoarsenite) for some of the brushstrokes of the background over the shoulder and below the wrist of the dancer in the foreground. Prussian blue, not typically employed by the Impressionists, who preferred artificial ultramarine and cobalt blue instead, is the main blue pigment found in this painting. Other pigments identified include calcium carbonate white, lead white, red lake, red lead, red ocher, Van Dyke brown, quartz, and other silicates. Charcoal black was used sparingly in some of the color mixes and mainly employed for the line drawings of the contours of some of the figures. Barite is also widespread: it was commonly added at the time to commercial paints as an extender or filler.
9. A drying oil is the medium that ensures the adhesion of the painting layers to the wall and the cohesion of the pigment particles within the painting layer itself.
10. Jehan-George Vibert, *La Science de la peinture*, 10th ed. (Paris: P. Ollendorff, 1893), as quoted in Callen (note 3).

FILIPPINI AND THURMAN, PIECEWORK: CONSERVING THE FLORENCE ELIZABETH MARVIN QUILT, PP. 54–59.

Treating the Florence Elizabeth Marvin quilt was a highly collaborative effort on the part of the conservation staff of the Department of Textiles: former Associate Conservator Lorna A. Filippini was assisted by talented department specialists Isaac Facio and Sophie Lin as well as Ai Kijima, a student intern from the School of the Art Institute of Chicago.

1. Quilting is a fine needlework technique in which a raised pattern is formed by stitching together two pieces of cloth over an internal padding or batting layer.
2. Appliqué involves the forming of a design or pattern by attaching a shaped piece of cloth to a ground or foundation fabric.
3. The interaction between two joined layers can enhance the overall strength of an object. When this interaction is compromised by poor fit or alignment, the resulting tension can cause one or both layers to bubble, crease, and stretch. In this pieced quilt, the loss of alignment accelerated loss in the fibers weakened by iron mordanting and tinning; multiplied the gravitational forces exerted by the weighty appliquéd motifs; and compromised the strength of the object when hung.
4. This exhibition, *Exploring Quilts: Art, History, and Craftsmanship*, was on view from March 17 to September 12, 2004; it was accompanied by a gallery guide of the same title.
5. Crepeline is a loosely woven silk organdy fabric, commonly used as a backing support in the conservation of fragile textiles.

LISTER, HODLER'S TRUTH, PP. 60–65, 68–69.

The authors would like to thank Hans-Jörg Heusser, director of the Swiss Institute for Art Research, Zürich, for generously making available all of his institution's Hodler resources. We are also grateful to all of the institute's Hodler Project staff, especially Paul Müller and Matthias Fischer. Special acknowledgment is due to Karoline Beltinger for generously sharing her knowledge of Hodler's materials and technique, and for analyzing paint samples from the Art Institute's *Truth*. Conservators at the Swiss Institute have studied Hodler's painting technique for a number of years in conjunction with their research for the Hodler Project and catalogue raisonné; the results of the first part of their ongoing efforts will be published in late 2005. We also extend our gratitude to Bernhard von Waldkirch and and Hanspeter Marty of the Kunsthaus Zürich for sharing their expertise, answering numerous technical questions, and making the works in their care available for study. Many thanks also to Klaas Jan van den Berg at the Netherlands Institute for Cultural Heritage for sharing the unpublished report of his analysis of Raffaëlli solid oil colors. A grant from the Barker Welfare Foundation supported the purchase of a FTIR microspectrophotometer, and the Old Masters Society funded the acquisition of a Zeiss binocular microscope, both of which were indispensable to this project.

1. For the other Hodler paintings in the Art Institute's collection, see Reinhold Heller, "Ferdinand Hodler: A Unique Note in the Birch Bartlett Collection," *Art Institute of Chicago Museum Studies* 12, 2 (1986), pp. 167–87.
2. The second version of the composition, *Truth II* (1903), is also in the Kunsthaus Zürich, and is reproduced in Nationalgalerie Berlin, *Ferdinand Hodler*, exh. cat. (Nationalgalerie Berlin, 1983), p. 305, cat. 82.
3. Thanks to Matthias Fischer for providing the exhibition history. Upon Hodler's death, *Truth* passed to his son, Hector, who died soon thereafter, and then to Hector's wife, by whom it was first exhibited, with the title *Truth*, in the large 1921 Hodler retrospective in Bern.
4. Small scrapings of the top clear varnish were analyzed with the aid of a diamond

cell and identified as an acrylic copolymer varnish. After this was removed, residues of a yellowed varnish were also evident in some areas; analysis by FTIR microspectroscopy indicated that this was a natural resin varnish (with a spectrum very close to aged amber varnish) diluted with turpentine. As Hodler did not varnish his paintings after his early period, we can hypothesize that this amber coating was added after his death, probably during a restoration. The acrylic layer must have been added much later, as acrylics appeared on the market only after the 1940s.

5. Louis Duchosal, "Le Salon Suisse," *Revue de Genève*, Oct. 20, 1885, pp. 38–39, quoted in Sharon Hirsh, *Hodler's Symbolist Themes* (UMI Research Press, 1983), pp. 13, 160. Duchosal, a Symbolist poet and friend of Hodler, wrote this in a review of an earlier painting, *A Glimpse into Eternity* (1885; Kunstmuseum Bern).

6. This early state is also visible as the shadows around the collarbone; in places in the face that have not been covered with additional highlights, such as the eye sockets and around the lips; and in the feet.

7. The following pigments have been identified by PLM, FTIR, and SEM/EDX analysis on the samples examined: whites: mainly zinc white and lead white, with kaolin, quartz, barite and gypsum identified in traces in isolated occurrences; blues: mainly ultramarine blue with occurrences of cerulean blue and cobalt blue; yellows: mainly Naples yellow and yellow ochers; reds: red and pink lakes, red ocher; purples: manganese violet and traces of cobalt phosphate violet. Lead white rather than zinc white was used in the early state.

8. Hodler frequently mentioned the importance of contours in his few preserved texts; see, for instance, "The Mission of the Artist: A Lecture Given to the Société des Amis des Beaux-Artes in Fribourg, on March 12th 1897," in Jura Brüschweiler, "Ferdinand Hodler, Writer: Introducing a Few Texts by the Artist," in Peter Selz, *Ferdinand Hodler*, exh. cat. (Berkeley: University Art Museum, 1972), p. 122.

9. These oil sticks, formulated by the French artist Jean-François Raffaëlli, incorporated wax in addition to oil and pigment; they were soft enough to be easily deposited by drawing directly on the paint surface yet dried as hard and permanent as other oil paints. For more on Raffaëlli oil sticks, see Danièle Gros and Christoph Herm, "Die Ölfarbenstifte des J.-F. Rafaëlli," *Zeitschrift für Kunsttechnologie und Konservierung* 18 (2004), part 1, pp. 5–28. Thanks to Eva-Maria Schuchardt for her translation. See also Karoline Beltinger et al., "A Technical Study of Ferdinand Hodler's Painting Technique—Work in Progress," *Preprints of the ICOM-CC 13th Triennial Meeting in Rio de Janeiro* (London: James and James, 2002), pp. 388–93; and Ernst Linck, "Die Maltechnik Ferdinand Hodlers," *Technische Mitteilungen für Malerei* 50, 7 (1934), pp. 49–50; quoted in Beltinger et al. (above), p. 391.

10. The oil-stick passages were often wiped smooth, scraped thin, or covered with additional highlights of brushed-on paint. Under very high magnification, there are often translucent discolored areas of a bumpy texture within the stroke. These may be zinc carboxylates produced by degradation; see "Scientific Analysis of Materials."

11. The fluorescence also highlights the linear character of the oil-stick strokes. Not all areas that fluoresce this color were necessarily worked with oil sticks, although visual examination suggests that their use was pervasive. Hodler also employed some zinc white from the tube when painting with the brush.

12. Although analysis has led us to conclude that this layer is Raffaëlli oil color, it does not fluoresce in ultraviolet light because it does not contain zinc white. In agreement with our findings, a reference sample of original oil stick, "tint 164" permanent violet, was shown not to contain zinc white but rather manganese violet, very little cobalt phosphate violet, and little barite. For more information, see "Scientific Analysis of Materials."

13. It was added late in the process because the pencil lines, the very last step, were introduced when only the pale aureole was still wet.

14. Infrared photographs are normally shot from the front, because the white ground layer between canvas and paint is usually impenetrable. Because *Truth* has no ground layer, infrared reflectography done from the reverse easily penetrated the thin canvas; the infrared image photographed from the front, by contrast, reveals little additional information, since it only penetrated to an intermediate paint level, obstructed by the layers of paint on top of the sketch. In order to obtain high resolution, *Truth* was photographed in 84 small sections that were computer montaged. Thanks to Allison Langley and Julie Simek for supervising the infrared photography and to Julie Simek for montaging the assembly.

15. Hodler cut a horizontal back edge across the earlier shape of the rock pedestal and further emphasized the horizontal by later adding a ridge of distant mountains.

16. Parallelism was an all-encompassing philosophy stressing unity and harmony over individual differences; it manifested itself visually in symmetry and the repetition of similar forms. For more, see Charles Harrison, Paul Wood, and Jason Gaiger, *Art in Theory, 1815–1900: Anthology of Changing Ideas* (Blackwell, 1998), pp. 1060–64.

17. In the infrared photograph, the multiple lines for the arm on the left indicate two separate positions, first closer to the head, then farther out by half the arm's

width. Other, later changes are only visible as pentimenti on the front of the painting.

18. Ferdinand Hodler, "My Present Tendencies—Night (1891)," Bibliothèque Publique et Universitaire, Geneva, Ms. Fr. 2984/361–366, in Brüschweiler (note 8), pp. 115–16

19. The bottom edge remained more or less the same. He also rotated the canvas slightly to the right. Hodler frequently restretched paintings to make such minor adjustments; see Beltinger et al. (note 9), pp. 390–91. When acquired by the Art Institute, the picture had been restretched by a restorer onto a new stretcher that was too large, without attention to the artist's edges. As part of the recent treatment, we ascertained the artist's edges in order to restretch the painting as originally intended.

20. I am indebted to Bernhard von Waldkirch for describing Hodler's technique in figs. 12–13. In reaching my conclusions I was working from reproductions and Von Waldkirch's descriptions. That this drawing was done from the model seems apparent from its greater naturalism. Pubic hair was eliminated in the initial sketch on canvas but included in the final painting; Hodler did not include it in *Truth 1* or *Truth 11*. At this time, pubic hair was rarely included in works to be exhibited publicly; thanks to Gloria Groom and Jill Shaw for this information. It is also interesting to note the light pencil arabesques around Berthe's arms. Although not strengthened or used, they explore the possibility of draping her long hair across her arms, as shown in the small rough sketch at the top of the sheet. This idea again demonstrates that the Chicago *Truth*, in its earliest phases, was more strongly connected to *Day*, where, particularly in the preparatory gouaches, the women seem to be emerging from thick curtains of hair as if from the darkness before dawn.

21. In this process the artist transferred a drawing square-by-square, reproducing each section of a line as it intersects each square. In this method, slight distortions between squares can result. This may account for the less fluid contours in the initial sketch on canvas. It appears that in the final painting process, Hodler once again consulted the preliminary drawing or the model to reestablish the correct relationships and the fluidity of the lines. Already in the preliminary drawing, he had decided to pull Truth's arms farther apart. The wider position for the arm on the right is faintly marked on the drawing.

22. See Bernhard von Waldkirch, *Ferdinand Hodler vom Frühwerk bis zur Jahrhundertwende: Zeichnungenaus der graphischen Sammlung des Kunsthauses Zürich*, exh. cat. (Kunsthaus Zürich, 1990), pp. 147–65.

23. The left figure was certainly drawn before the painting was completed, because the high arch of the foot from the drawing was followed in a lower paint layer but later changed in the finished work.

24. Both *Truth I* and *Truth II* have central axis lines as well.

25. As a student, Hodler copied Albrecht Dürer's drawings of idealized proportional systems for depicting the human body. The placement of lines on the Chicago painting also suggests that he may have used them to check the degree to which the figure was off-center on the canvas.

26. See Beltinger et al. (note 9), p. 391.

27. Swiss Institute conservators have found evidence that Hodler used cartoons to transfer figures in his paintings, such as that of Spring, closely related to Truth. A photograph of the artist's studio shows life-size paper figures—perhaps cartoons for a painting—cut out and pinned to a wall; Caroline Beltinger, personal communication, Feb. 2004. Comparison of the figures of *Truth* and *Truth I* shows that the upper arms and thighs have been lengthened in the latter work and the slight tilt of the legs straightened; these changes could have been made by shifting the cartoon slightly as it was transferred. In *Truth I* the head and thighs have also been broadened; other contours correspond exactly between the two paintings. Infrared reflectography has revealed that there is no preliminary grid under *Truth I*. (There is a grid, however, between the initial and final paint layers; Hodler presumably used this to check proportions and alignment as he worked.) Thanks to Hanspeter Marty for providing measurements of *Truth I* and allowing us to examine it with infrared reflectography. For Hodler's use of tracing, see Beltinger et al. (note 9), pp. 389–90. 28. The more acutely bent arms of the Chicago *Truth* were also used in the gouache study for *Truth I* (Kunsthaus Zürich, 1922/14). This work is published in Nationalgalerie Berlin (note 2), p. 304, cat. 80.

29. Later he painted out many of the shadows in the *Truth I* figure, covering them with flat, light paint.

CASADIO AND FIEDLER, *SCIENTIFIC ANALYSIS OF MATERIALS*, PP. 66–67.

1. The list includes beeswax, vegetable waxes (in particular Japan wax and cocoa butter), margarine, spermaceti, mineral wax, various drying oils (linseed, hemp, and nut oils), non-drying oils (olive and almond oils), and zinc white. J.-F. Raffaëlli, "Raffaëlli on His Solid Oil Colors," *Technische Mitteilungen fur Malerei* 20, 4 (1903), pp. 29–35; cited in Danièle Gros and Christoph Herm, "Die Ölfarbenstifte des J.-F. Rafaëlli," *Zeitschrift für Kunsttechnologie und Konservierung* 18 (2004), part 1, pp. 5–28. See also Karoline Beltinger et al., "A Technical Study of Ferdinand Hodler's Painting Technique—Work in Progress," *Preprints of the ICOM-CC 13th Triennial Meeting in Rio de Janiero* (London: James and James,

2002), pp. 388–93. Besides literary references, experimental evidence points to the widespread use of zinc white for the Raffaëlli sticks; however, some of the reference oil sticks and actual samples from Hodler's paintings have been found to also contain baryte, gypsum, and lead white.

2. Winsor and Newton was formerly the distributor of Lefranc et Cie, the manufactory that originally started the mass production of the oil sticks in collaboration with Raffaëlli over a century ago. Linseed oil is mentioned in correspondence between Raffaëlli and the production manager. Evidence that the oil may have been preheated (to expedite drying and reticulation of the film) has also been found experimentally. Pale yellow, Japan wax is obtained from the berries of the Japanese tree of the *Rhus* species, as a byproduct of lacquer manufacture. Japan wax, which has a lower melting point than beeswax and Carnauba wax, may have been used to guarantee the special workability and soft texture of the oil sticks, while the waxes with higher melting points may have been added to guarantee proper hardening of the film.

3. Zinc carboxylates (or zinc soaps) are synonyms used to describe the salts of long chain fatty acids. In this case, they may be a reaction product of the zinc white and the oil binder: the zinc white dissolves in the oil, disrupting its triglyceride structure, forming salts, and liberating free saturated and unsaturated fatty acids. They can also derive from direct reaction with the free fatty acids present in Japan wax. While metal soaps may be intentionally added to accelerate the drying of paint films, they can ultimately have a detrimental effect, forming protrusions or disfiguring exudates as is the case here.

4. Zinc stearate is a member of the wider class of zinc carboxylates, identifying a particular salt of the zinc ion and a saturated carboxylic acid with 18 carbon atoms in the chain.

HIRSH, A NOTE ON DATING, PP. 68–73.

1. All notebooks referred to here are in the collection of the Musée d'Art et d'Histoire, Geneva, which has 242 (inv. no. 1958-176). None of them were printed with page numbers, but in many Hodler (or later scholars) wrote them in. These are supplied if present; otherwise, drawings are identified by notebook number, n.pag. The Hodler notebooks are largely unpublished.

2. Extant literature on the Chicago painting is limited to four publications: Wilhelm A. Pfähler, *Der "Aarhof" in Solothurn (Beschreibung und Restaurierung)* (Solothurn: Eigenverlag, 1981); Carl Albert Loosli, *Ferdinand Hodler: Leben, Werk und Nachlass* (Bern: Verlag von R. Suter, 1921–24), vol. 4, pp. 52–161 (on all of Hodler's Truth paintings); *Exposition F. Hodler, 1853–1918*, exh. cat. (Geneva: Athénée Museum, 1950); *Vente aux enchères*, sale cat. (Moudon: Salle de la Douane, 1965).

3. Hodler's first biographer, Loosli, characterized this multicompositional, overall iconography as encompassing four themes: song, light, joy, and power. He placed *Truth* as a composition about light, thus linking it, as will also be done here, to Hodler's *Day*; Loosli (note 2), vol. 4, p. 4.

4. Bernhard von Waldkirch, *Ferdinand Hodler*, exh. cat. (Locarno: Casa Rusca, 1992), p. 39.

5. This dating is based on one of the sketchbook pages dated in Hodler's hand "October 1895."

6. Trans. by Matthias Fischer. See notebook 67, n.pag. Oskar Bätschmann, Henriette Mentha, and Bernadette Walter, *Ferdinand Hodler: Die Zeichnungen im Kunstmuseum Bern*, exh. cat. (Bern: Kunstmuseum, 1999), p. 17, fig. 9.

7. This work was exhibited in 1899 in Geneva with the title *Art*; when it was shown in Vienna in 1904 it was called *Poetry*. In 1896 Hodler continued to consider the standing figure with arms outstretched as the enlightenment woman. In a notebook dated in Hodler's hand "June 1896" there are two thumbnail sketches of the figure later titled Truth; in these she appears to the downtrodden souls who lie on the earth below her; see notebook 1976-362, pp. 1 and 11. See Nationalgalerie Berlin, *Ferdinand Hodler*, exh. cat. (Nationalgalerie Berlin, 1983), p. 293, cat. 63.

8. See, for instance, notebook 44 (labeled by Hodler "Exposition nationale 1895"), n.pag.

9. See also the drawing entitled by Loosli "Truth, Educating Youth" ("Wahrheit, die Jugend unterrichtend"); Loosli (note 2), vol. 2, p. 36, pl. 10.

10. The Plato quote was a paraphrase. See Ferdinand Hodler, "The Mission of the Artist: A Lecture Given to the Société des Amis des Beaux-Artes in Fribourg, on March 12th 1897," in Jura Brüschweiler, "Ferdinand Hodler, Writer: Introducing a Few Texts by the Artist," in Peter Selz, *Ferdinand Hodler*, exh. cat. (Berkeley: University Art Museum, 1972), pp. 119–25.

11. E.g., both the Spring woman and the figure of Poetry appear in drawings above the awakening figures of Day (see "Studies for *Day*," private collection, illustrated in Nationalgalerie Berlin [note 7], p. 122, nos. 180–81. Other drawings (such as Kunsthaus Zurich 1920/444) use Spring, now consistently posed with arms crossed in front of her, as the middle figure banishing the "genies of darkness" ("Genien der Finsternis"), so named by Loosli (note 2), vol. 3, p. 9; see Bernhard von Waldkirch, *Ferdinand Hodler vom Frühwerk bis zur Jahrhundertwende: Zeichnungenaus der graphischen Sammlung des Kunsthauses Zürich*, exh. cat. (Zürich:

(Kunsthaus Zürich, 1990), p. 163, fig. 323. In still other drawings (such as Kunsthaus Zürich 1964/54), the figure of Spring appears in the foreground while the later Truth is in the background; see ibid., p. 150, fig. 294.

12. Notebook 44 (labeled by Hodler "Exposition nationale 1895"), n.pag.

13. Although this particular drawing is not labeled *Day*, it is part of a series for which many other sketches are so labeled by Hodler.

14. Sketches in two additional notebooks that Hodler dated 1899 suggest that he had abandoned the earlier triptych format for *Day* and was focusing on a two-part composition; see notebook 69, pp. 1, 17, 23; and notebook 71, pp. 10, 20, 24.

15. Notebook 71, p. 24, holds a sketch with the upper and lower sections for *Day/Truth* still together; p. 20 was marked by Hodler "1899," and he dated p. 9 "15 Juli 1899."

16. Letter to Oscar Miller, Jan. 12, 1899, cited in Nationalgalerie Berlin (note 7), p. 121, and by Waldkirch (note 4), p. 130. The date of this letter coincides precisely with a two-part composition of *Day* (fig. 4). In this sketchbook Hodler seems still captivated by the theme of day, as he notes on another page the "influence of external nature on our memory / like the clarity of the sun" ("influence de la nature extérieure sur nos memoir[e] / comme la clarité du soleil"); notebook 66, p. 8.

17. Rudolf Schindler, in Waldkirch (note 4), p. 140.

18. See Lister, note 9.

19. One drawing that makes this abundantly clear is now in the collection of the Museum of Fine Arts, Montreal. On graphed paper Hodler lined up three figures, in all probability based on the same model; on the right are two versions of the pose so often associated in various drawings with Spring but also Day; on the left is the figure with the extended arms of Truth. See Sharon Hirsh, *La Choréographie du geste: Dessins de Ferdinand Hodler/The Fine Art of Gesture: Drawings by Ferdinand Hodler*, exh. cat. (Montreal Museum of Fine Arts, 1988), p. 61, fig. 32.

20. For more on Hodler and the Dreyfus Affair, see Marcel Baumgartner, *Ferdinand Hodler: Sammlung Thomas Schmidheiny*, exh. cat. (Kunstmuseum de Kantons Thurgau Kartause Ittingen/Schweizerisches Institut für Kunstwissenschaft, 1989), p. 76. Hodler's claim to have been influenced by the affair was reported by the Austrian critic Franz Servaes in "Der monumentalmaler Hodler," *Neue Freie Presse* (Vienna), Jan. 19, 1904. Loosli argued that Hodler had already been exploring the "pure" concept of Truth well before this, but he conceded that the Dreyfus Affair might have contributed to "an earlier and perhaps somewhat more austere realization of this 'Truth' than he would otherwise have created"; Loosli (note 2), vol. 3, p. 18. Loosli was unaware, however, of the Jan. 1899 letter in which Hodler described two paintings "representing Day." Also, it is rarely noted that Hodler's old friend the Swiss-Parisian writer Mathias Morhardt acted as a leader and spokesperson for Dreyfus defenders; see Nationalgalerie Berlin (note 7), p. 131.

21. The President of France pardoned Dreyfus in 1899, but it was not until 1906 that he was fully exonerated. It is also interesting to note that Hodler divulged the Dreyfus influence to a reporter in Vienna, just as that city's extensive Jewish population was also undergoing a prolonged anti-Semitic campaign on the part of the press. See Tobias G. Natter, "Princesses without a History? Gustav Klimt and 'The Community of All Who Create and All Who Enjoy,'" in *Klimt's Women*, ed. Tobias G. Natter and Gerbert Frodl, exh. cat. (Vienna: Österreichische Galerie Belvedere, 2000), p. 68. Klimt's work at the Paris 1900 Exposition had already been associated with the hateful phrase "gout juif" (Jew taste) by Karl Kraus in *Die Fackel* 2, 41 (mid-June 1900), p. 22. Thus Hodler's comment may have also been in support of his friend Klimt.

22. Much Hodler and all Klimt literature assumes this influence but offers no concrete evidence other than the closeness of the idea of Truth (which was a common subject in painting from the seventeenth to nineteenth century) and the frontal figure (which already existed in Hodler's sketches prior to 1898); see, for instance, Fritz Novotny and Johannes Dobai, *Gustav Klimt: Catalogue Raisonné of His Paintings* (Praeger, 1968), p. 312. Besides possibly seeing *Nuda Veritas* in Klimt's studio or exhibition, Hodler could have viewed it once it was purchased by Hermann Bahr, a Viennese critic with whom he corresponded. It was also reproduced, twice, in a photograph of Bahr's study in *Das Interieur* (vol. 2, p. 30; vol. 10, p. 163) in 1901.

23. In the drawing Klimt printed a citation by L. Schefer: "Wahrheit ist feuer und Wahrheit reden heist Levchten und brennen" ("Truth is fire and to speak the truth means to illuminate and burn"). The drawing was illustrated in the Secession's journal *Ver Sacrum* 3, 12 (Mar. 1898).

24. Like the Dreyfus Affair, the controversy over whether his erotic nudes should be allowed to remain installed in a place of learning raged between the government and the press. See Johannes Dobai, "Gustav Klimt's *Hope I*," *National Gallery of Canada Bulletin* 17 (1971), p. 7; and Novotny and Dobai (note 22), p. 325. Klimt finally withdrew the three murals in 1905.

25. See Sharon Hirsh, "Hodler as Genevois, Hodler as Swiss," in *Ferdinand Hodler: Views and Visions*, exh. cat. (Zürich: Swiss Institute for Art Research and the Trust for Museum Exhibitions, 1994), pp. 83–84; and idem, "Swiss Art and National Identity," in *Art, Culture, and National Identity in Fin-de-Siècle Europe*, ed. Michelle Facos and Sharon Hirsh (Cambridge University Press, 2003), pp.

265–69.

26. Hodler won for his entries *Night*, *Eurhythmy*, and *Day*, and Klimt for *Philosophy*, the very university painting that drew the most negative criticism when first exhibited in Vienna.

27. See Waldkirch (note 4), p. 39.

28. Indeed, the idea of Truth as a woman who has dropped all clothing in order to be "Verité mis à jour" (Truth put before the [light of] day) connects Truth with Day, just as she was in Hodler's earliest sketches, as a symbolic representation of "Truth brought to light." See Shunsuke Kijima, "Nuda veritas: Quelques réflexions sur la conscience esthétique à la fin du XIX siècle," in *Symbolisme en Europe*, ed. François Daulte, Catherine de Croës, and Danielle Derrey-Capon, exh. cat. (Takamatsu: Musée Municipale des Beaux-Arts, 1996), p. 11.

DOUGLAS G. SEVERSON, "TREATED BY STEICHEN": THE PALLADIUM PRINTS OF ALFRED STIEGLITZ, PP. 74–79.

Some sections of this article were previously published in the *Journal of the American Institute for Conservation* 34, 1 (1995), pp. 1-10. Reprinted with the permission of the American Institute for Conservation of Historic & Artistic Works, 1717 K St., NW, Suite 200, Washington, D.C. 20036; info@aic-faic.org; www.aic-faic.org.

1. William Crawford, *The Keepers of Light* (Dobbs Ferry, N.Y.: Morgan and Morgan, 1979), p. 107.

2. Georgia O'Keeffe to Daniel Catton Rich, Jan. 30, 1950, Art Institute Archives. In January 1950 the prints had already been dispersed by O'Keeffe and were at the Art Institute on approval.

3. The process requires the sensitization of paper with ferric oxalate and platinum or palladium chloride. Light exposure reduces the ferric salts, and the exposed paper is then immersed in potassium oxalate, which catalyzes the reduction of the platinum or palladium salts to the final metallic image material. Unwanted iron salts remain in the paper, however, and must be eliminated by several baths in dilute hydrochloric acid and a final water wash. The resulting print is made up of finely divided metallic platinum or palladium embedded in the matte surface of the paper.

4. Alfred Stieglitz, "Platinum Printing," in *Picture Taking and Picture Making* (1898; repr., Rochester, N.Y.: Eastman Kodak, 1905), p. 122.

5. Quoted in Sarah Greenough, *Stieglitz in the Darkroom*, exh. brochure (Washington, D.C.: National Gallery of Art, 1992).

6. For general information about Steiglitz and his circle, see Waldo Frank, ed., *America and Alfred Stieglitz: A Collective Portrait* (1934; repr., Aperture, 1979); William Innes Homer, *Alfred Stieglitz and the American Avant-Garde* (New York Graphic Society, 1977).

7. Edward Steichen, *A Life In Photography* (Doubleday, 1963), n.pag., opp. pl. 44.

8. Steichen did, however, visit Stieglitz briefly in 1941, where some reconciliation occurred, for Steichen made a touching and dramatic gesture at Stieglitz's memorial service, placing on the casket a pine branch said to be from a tree that the two planted forty years earlier. See Benita Eisler, *O'Keeffe and Stieglitz: An American Romance* (Doubleday, 1991), p. 479.

9. The Art Institute mounted several exhibitions of the Stieglitz material soon after its arrival; *The Alfred Stieglitz Collection* (Feb. 2–29, 1948, and Nov. 9–Dec. 31, 1949) was followed by *Alfred Stieglitz: American Pioneer of the Camera* (June 16–July 31, 1951).

10. Doris Bry to Douglas Severson, May 26, 1994.

11. Doris Bry, telephone conversation with Douglas Severson, Feb. 2, 1993.

12. Ibid.

13. These include 165 at the National Gallery of Art, Washington, D.C.; 31 at the Metropolitan Museum of Art, New York; 10 at the J. Paul Getty Museum, Los Angeles; 5 at the San Francisco Museum of Modern Art; and 2 each at the Museum of Modern Art, New York, the George Eastman House, Rochester, N.Y., and the National Museum of Art, Osaka, Japan.

14. See David Travis, *The Art of Photography, Past and Present, from the Collection of the Art Institute of Chicago*, exh. cat. (Osaka: National Museum of Art, 1984). The exhibition ran from October 6 to December 4, 1984.

15. For more on this, see Douglas G. Severson, "The Effects of Exhibition on Photographs," *Topics in Photographic Preservation* 1 (1986), pp. 38–42. A densitometer is a small, portable instrument that bounces a narrow beam of light off the surface of a print, enabling exact measurements to be made of any changes in density that occur over time.

16. For more on these results, see Lisha Glinsman and Constance NcCabe, "Understanding Alfred Stieglitz's Platinum and Palladium Prints: Examination by X-ray Fluorescence Spectrometry," in *Conservation Research*, Studies in the History of Art 51, Monograph Series 2 (Washington, D.C.: National Gallery of Art, 1995).

17. For more on the effects of bleaching on platinum/palladium prints, see Constance McCabe, "Reclearing Treatments used for Aged Facsimile Palladium Prints," an unpublished report for "Curatorial/Conservation Colloquy 5: Alfred Stieglitz's Palladium Portraits of Georgia O'Keeffe," held at the National Gallery of

Art, Washington, D.C., May 18–19, 1993.

18. *Georgia O'Keeffe: The Stieglitz Portraits* ran from March 5 to June 12, 1988. For a review of the exhibition, see Marcia Coburn, "Stieglitz and O'Keefe: A Lover's Portrait," *Chicago Tribune*, Feb. 28, 1988.

19. *Two Lives: O'Keeffe by Stieglitz, 1917–1923* ran at the J. Paul Getty Museum from June to September 1992. A complementary exhibition of the same title, incorporating drawings and paintings by O'Keeffe, was on display at the Phillips Collection, Washington, D.C., from November 1992 through December 1993; neither of these exhibitions was accompanied by a catalogue. For more on the 2004–2005 exhibition, see Francoise Heilbrun et al., *New York et l'Art moderne: Alfred Stieglitz et son cercle, 1905–1930*, exh. cat. (Reunion des musées nationaux/Museo National Centro de Arte Reina Sofía, 2004).

HALL AND JONES, TIME AND TIDE: RESTORING LORADO TAFT'S FOUNTAIN OF TIME—AN OVERVIEW, PP. 80–89.

Robert A. Jones, director of the Art Institute's Department of Design and Construction from 1998 to 2004, served as project director for *The Fountain of Time's* restoration. He is an adjunct professor of architecture at the Illinois Institute of Technology. Barbara Hall is the conservator for the B. F. Ferguson Fund monuments and served as conservation consultant for the project. Restoring *The Fountain of Time* involved the expertise and support of many individuals and groups; in addition to those mentioned in the text, we would like to acknowledge the following: Calvert W. Audrain, C. Lee, Timothy Lennon, Robert E. Mars, Eamon Ryan, and Michael Turnbull of the Art Institute of Chicago: William Latoza of Bauer Latoza Studio; Michael Fus, Joseph Horner, Ed Neuman, and Edward Uhlir of the Chicago Park District; J. Monroe McNulty, McNulty Bros. Company; Donald Redar of Takao Nagai Associates, Ltd.; Phoebe Dent Weil, Carol Grissom, Patrick Rice, and Norman Weiss (also associated with Wank, Adams, Slavin) of Washington University Technology Associates; and James Connolly and Arnie Johnson of Wiss, Janney, Elstner Associates.

The restoration of *The Fountain of Time* was funded primarily through the B. F. Ferguson Monument Fund administered through the Art Institute of Chicago with assistance from the Chicago Park District and Save Outdoor Sculpture, a joint project of Heritage Preservation and the Smithsonian American Art Museum supported by contributions from the National Endowment for the Arts and the private sector.

1. Lorado Taft was born in Elmwood, Illinois, in 1860 and graduated from the University of Illinois. After four years at the École des Beaux-Arts in Paris, he returned to America in 1886 and opened a studio in Chicago, where he gradually established himself as a sculptor, writer, critic, and educator. He taught at the Art Institute of Chicago and the University of Chicago and was sought after for his acclaimed public lectures on art. His *History of American Sculpture* (1903) was a seminal work for many years. For more on Taft, see Timothy Garvey, *Public Sculptor: Lorado Taft and the Beautification of Chicago* (Urbana: University of Illinois Press, 1988).

2. *Architectural Record* 28, 146 (Nov. 1910), p. 349.

3. Ibid., pp. 335–49. Olmsted gave the name "Midway Plaisance" to the narrow strip of land between 59th and 60th streets that was one mile long and 600 feet wide. It had been acquired by the South Parks Commission to connect two recently purchased parcels, Jackson Park along Lake Michigan—later to become the site of the 1893 World's Columbian Exposition—and Washington Park, further inland. Taft's plan called for a boating canal connecting the lagoons in Jackson Park to the ponds of Washington Park. The canal would be crossed by three bridges decorated with marble statues of famous men in the arts, sciences, and religion, and placed at intervals along the Midway would be 100 bronze sculptures commemorating important men of history. *The Fountain of Creation* was planned to anchor the east end of the Midway and *The Fountain of Time* the west.

4. *Inter Ocean*, May 2, 1910.; The press debut occured with "Statues for Chicago," *Chicago Tribune*, Apr. 6, 1905.

5. B. F. Ferguson Monument Fund papers, Art Institute of Chicago Archives. In his European travels, Ferguson was impressed by the age and beauty of the fountains and monuments he saw. He felt that they gave a sense of continuity and history to present and future generations and wished the same for Chicagoans. The first Ferguson Fund monument was Taft's *Fountain of the Great Lakes* (1913), installed in the Art Institute's south garden. At its dedication ceremony, Taft expressed the civic potential of public sculpture: "What Chicago lacks . . . is a background. Our traditions are all before us. . . . We need something to give us greater solidarity, to put a soul into our community—to make us love this place above others. . . . Such is the value of monuments; such is the potency of this ancient awfully permanent art of sculpture. It bears its message through the ages, reaching a hand in either direction, binding together as it were the generations of men. . . . It is immortality." Program, dedication ceremony of *The Fountain of the Great Lakes*, Sept. 9, 1913.

6. Since the subject matter of *The Fountain of Time* did not meet Ferguson's criteria for funding, Taft first suggested that it celebrate the Columbian Exposition, later proposing that it commemorate the hundred-year anniversary of the Treaty of Ghent of 1814–15, which ended the war of 1812 and led to a sustained peace between Great Britain and the United States. In doing so, he seems to have adopted a sugges-

tion made to the Ferguson Committee in July of 1912, a year earlier, by the United States Daughters of 1812. This group, deploring the commissioning of monuments recalling "the horrors of war," suggested "a monument symbolizing the blessings of peace." Art Institute of Chicago Archives, Ferguson Monument Fund papers.

7. *Concrete* 21, 6 (Dec. 1922), pp. 171–73.

8. Earley later built the Baha'i House of Worship (1932–42) in Wilmette, Illinois, and a full-size replica of the Parthenon in Nashville (1926–31), both of which have recently undergone extensive restoration. For more on Earley, see Frederick Cron, *The Man Who Made Concrete Beautiful* (Grand Junction, Colo.: Centennial Publications, 1977).

9. Holabird and Roche Architects, inspection report on *The Fountain of Time*, Dec. 30, 1926.

10. B. F. Ferguson Monument Fund papers, Art Institute of Chicago Archives.

11. Andrzej Dajnowski, "Treatment Report for *The Fountain of Time*, July 1999–2002," Apr. 2003, files, Department of Conservation.

12. The past method used to repair cracks was to cut them out. The crack was widened and deepened with chisels or a circular saw so that it could be filled with sufficient concrete to form a strong join. Many repairs done in this manner failed over time and had the added disadvantage of removing original material and expanding what was originally a very narrow crack into a large repair.

STRATIS AND ZEGERS, *UNDER A WATCHFUL EYE: THE CONSERVATION OF SOVIET TASS-WINDOW POSTERS*, PP. 90–95.

A conservation campaign of this magnitude owns its success to the enthusiastic participation of an extraordinarily talented team of paper conservators, conservation technicians, and conservation students in training. On behalf of all those who may now fully appreciate and study these posters, we thank Melissa Buschey, David Chandler, Caesar Citraro, Kristi Dahm, Margo McFarland, Christine Conniff O'Shea, and Rebecca Pollak. Equally important are the generous donors who made our work possible. We thank The Andrew W. Mellon Foundation for their support of a post-graduate fellow in paper conservation; The Fred and Susan Novy Family Foundation for their support of two paper conservators in training; Edward McCormick Blair for providing funding for necessary conservation materials; and the Legacy Committee of the Art Institute of Chicago, which underwrote the purchase of the ultrasonic encapsulator that enabled us to safely house the conserved posters.

1. These facilities were designed in 1972 by the firm of Skidmore, Owings, and Merrill. The Department of Prints and Drawings recently underwent a second major renovation to expand storage space and create a state-of-the-art paper conservation laboratory. Designed by the architectural firm of Weese, Langley, Weese, the new facility opened in 2002.

2. The Art Institute's poster collection was randomly amassed during the early twentieth century. Although American posters from the 1890s are represented, the emphasis is mainly on commercial, cultural, and political posters of European origin from the 1890s well into the 1930s. The holdings also include a good cross section of European and American posters related to both world wars.

3. An almost complete collection of the posters is housed in the Russian State Library, Moscow.

4. Ryessa D. Liberson to Daniel Catton Rich, July 31, 1942, Art Institute of Chicago Archives.

5. FBI report, n.d., Art Institute of Chicago Archives.

6. The American photographer Margaret Bourke-White, on assignment in Moscow with her husband, author Erskine Caldwell, was the first to record the making of these posters during the first weeks of the German invasion. For more, see Margaret Bourke-White, *Shooting the Russian War* (Simon and Schuster, 1942), pp. 170–75.

7. The lining papers were handmade with *chamdak* (Korean mulberry), which is characteristically long-fibered and strong. The sheets are formed in the traditional Korean manner in which fibers accumulate on the paper mould in a crisscross formation without a grain direction. Because of this, the sheets expand evenly when wetted and are equally strong in all directions. To help the fibers disperse evenly and to aid in the formation of the sheets, *hwang chok kyu*, an extract from the root of the hibiscus plant, is used as a natural sizing agent. For more information, see Hyejung Yum, "Traditional Korean Papermaking: Analytical Examination of Historic Korean Papers and Research into History, Materials and Techniques of Traditional Papermaking of Korea," Cornell University Library, Department of Preservation and Collection Maintenance (2003), http://www.library.cornell.edu/ preservation/paper/korean-papermaking.html.

8. The TASS-Window posters will be the subject of the Art Institute's upcoming exhibition *Storied Windows: TASS-Window Posters of Russia's Great Patriotic War and Their American, British, and German Counterparts*, scheduled for 2009–10.

SCHNEPP, *ON TIME: APPROACHES TO THE CONSERVATION OF FILM, VIDEOTAPE, AND DIGITAL MEDIA*, PP. 96–102.

Many thanks to Pip Laurenson of the Tate Britain, London, and Paul Messier of Boston Art Conservation, who have pioneered the conservation of these new works and very kindly offered their assistance to a neophyte in the field. Thanks also to Stephen Vitiello and Bill Brand, whose expertise was crucial to the successful preservation of Bruce Nauman's *Art Makeup, Nos. 1–4*.

1. A tape in digital format stands a much better chance of being replicated without such a deterioration in quality, but if it has been highly compressed it, too, will lose information. In theory, raw digital data can be perfectly copied but raw data files are extremely large and unwieldy in comparison to compressed ones, and compression-free formats are rather rare at present. Sony Digital Betacam is a tape format that has only a moderate amount of compression and is currently easily obtainable at this time, so it is considered a reasonable compromise at the moment.

2. Pip Laurenson, telephone conversation with Suzanne Schnepp, Dec. 7, 2000.

3. Paul Messier, "Playback Hardware and Media," section 3.0 of an unpublished manuscript.

4. To increase their information storage capacity, DVDs are read with a shorter-wave length red laser than CDs, so the pits can be more closely spaced; the disc itself is two-sided, and there can be two metallic layers on each side. DVD video usually uses the MPEG compression system, an industry standard that is unfortunately considered to have a high degree of information loss in its coding.

5. Pip Laurenson, "The Management of Display Equipment in Time-Based Media Installations," in *Modern Art, New Museums: Contributions to the Bilbao Congress, 13–17 September 2004*, ed. Ashok Roy and Perry Smith (London: International Institute for Conservation of Historic and Artistic Works, 2004), pp. 49–53.

6. An internegative is a negative made from an exhibition print. The images of these splices and the identification numbers of the original film are, of course, reproduced in subsequent copies.